NEW MEDIA IN PRINTMAKING

NEW MEDIA IN PRINTMAKING

BY JOHN BICKFORD

WATSON-GUPTILL PUBLICATIONS/NEW YORK

Copyright © 1976 by Watson-Guptill Publications

First published 1976 in the United States and Canada by Watson-Guptill Publications
a division of Billboard Publications, Inc.
One Astor Plaza, New York, N.Y. 10036

Library of Congress Cataloging in Publication Data
Bickford, John H 1926-
 New media in printmaking.
 Bibliography: p.
 Includes index.
 1. Prints—Technique. I. Title.
NE850.B52 760′.2′8 76-22481
ISBN 0-8230-3165-9

Manufactured in U.S.A.

First Printing, 1976

To Anne

ACKNOWLEDGMENTS

Throughout this book you'll find examples of prints made by many different artists and students (I'm not sure there's any difference!). Each of these people, who are too numerous to list here but whose names will be found under their work, had to learn one or more of my methods before producing the examples you find here. By working with them, I learned a great deal about my proposed techniques—the processes described in the chapters that follow have all been modified and strengthened in some way by this experience. The book would have been less instructive—and less attractive—without their contributions.

I am even more indebted, however, to three teachers who worked with me, made their classes available to me, and helped their students produce many of the examples you see here. They are Gus Mazzoca at the University of Connecticut, Frank Novack at the Norwich Free Academy, and Gail Edmonds of the Woodrow Wilson Middle School in Middletown, Connecticut. Mrs. Edmonds was especially helpful—she spent many hours learning and experimenting with my techniques herself before passing them on to her classes. I'm also in debt to the Connecticut Commission on the Arts, who supplied Mrs. Edmonds with the funds needed to purchase the materials used by her students.

I'm awed by and indebted to Janice Ulrichsen, of Union City, Connecticut, who typed, literally, a flawless manuscript; and to Gerald Treloar, of Meriden, Connecticut, who reproduced all of my photographs the way photographs used to be done before the machines took over—some 200 prints without a single scratch or doghair.

Finally, and perhaps most of all, I'm grateful to my editors, Don Holden, Diane Hines, and Ellen Zeifer of Watson-Guptill; to Don for suggesting a number of possible materials and techniques; to all for their steady encouragement and help.

And that's it! I've had a great deal of fun developing these techniques. I hope you enjoy learning them, improving on them, and adding your own. Let's get started.

CONTENTS

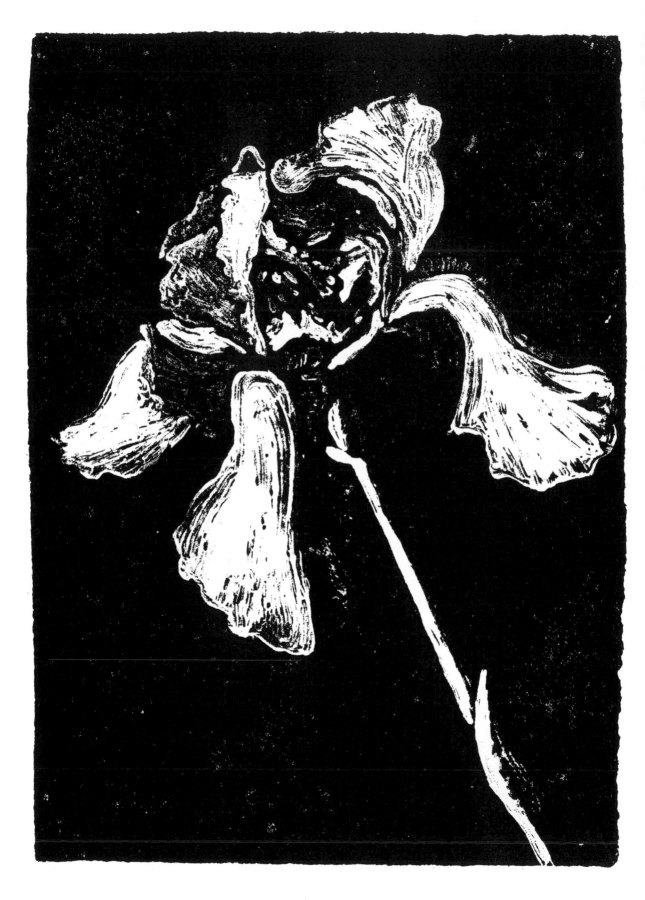

INTRODUCTION

This is a book about one of man's most important inventions—printmaking. Notice that I did not say "printing." Printing is for people who publish newspapers, wallpaper, or campaign buttons. Printmaking is for artists: for Goya, for Rembrandt, for Baskin, for Nolde, and perhaps for you. Printmaking involves the creation, by an artist, of a master plate or block from which multiple copies of an image can be made. It is an old art, and those who practice it know there is something basic about it, as basic as farming, hunting, or carpentry. It satisfies things within us that cannot be satisfied in any other way. All artists, at least, should know its potential; yet many, especially student and amateur artists, do not. I hope that this book, in a small way, can help to change that.

The artist who makes images on a two-dimensional surface has three basic choices. He can draw; he can paint; or he can print. With each of these, of course, there are many secondary choices, and there are many techniques that bridge the gaps between the three standards. But he starts with three.

He almost always does some drawing; for itself or in preparation for his other work. He inevitably tries painting, and usually settles on it as his principal technique. But only if he's exceptionally well-trained does he get deeply involved with printmaking. And even the serious amateur almost never prints. This is a mistake. He should. And this means that *you* should.

WHAT IS PRINTMAKING?

There are many different printmaking methods. In each case, the surface of a block or plate is treated by the artist so some areas will ink and others will not. In a relief print, for example, part of the surface is cut away—removed—to make the printing plate. When an ink-charged roller is run over the surface, only the uncut, raised portions will be touched by the roller and inked. In engraving or etching, part of the block is also removed, but the ink is then applied to the depressions rather than to the remaining flat surfaces. In lithography, chemical means are used to distinguish between those portions of the surface that will ink and those that will not. And there are other techniques. Any trick that makes one part of a block more receptive to ink than another portion can be used to make prints.

When the block or plate is inked, a piece of paper is pressed against it, transferring the ink to the paper, making

Iris *by Michael Augeri. Cast plaster relief, 6" x 8½"/150mm x 220mm. This relief print is rather atypical—the artist created muted tones by brushing thin coats of grease into the toned area of the flower and by scratching through the white areas with a sharply pointed tool. He then printed lightly, using only a little ink. The result is a relief print with an almost lithographic softness. See Chapter 5 for a more detailed explanation of relief printing.*

a print of the block. The process of inking the block and pressing the paper is then repeated, producing a second impression of the block that closely resembles the first.

All of these steps—preparing a block so only portions of its surface will accept ink, inking the block, pressing a piece of paper against the block to transfer the ink to the paper, repeating the process—all of these steps are essential elements of printmaking.

The print is not just a mechanized way to reproduce drawings or paintings. The various types of printmaking are basic methods of forming images that could never be formed in any other way—images, therefore, that say things the artist could never say with pencil or paint. If you find this hard to believe, look at the works of artists who have made prints *and* drawings or paintings—and see what they have said with each. Edvard Munch's paintings—though superb—are weak soup next to his powerful woodcuts of similar subjects. Käthe Kollwitz was unable to repeat with drawings what she said with lithographs. Goya's prints are unforgettable—I think some of his paintings are unforgivable! Each of these artists could express himself more powerfully in prints than in the other media.

There are, of course, many artists who express themselves much better in paint than in print. John Marin and Edward Hopper are recent examples. I'm not saying that the print is the answer for everyone—I'm merely saying it is a *separate* art medium, producing *different* results than those produced by any other method. As such, it deserves serious study by every student and amateur who wants to find the one best way to express his or her personality.

And the printmaker, unlike the painter, can have his cake and sell it, too, since he always produces more than one copy!

There are two reasons for the neglect of printmaking, I think. First: prints are often "just black and white." They can be harsh, cold, and stiff, compared to a lush painting. At least this is the image one often has of the traditional print—but this image is no longer correct. Contemporary artists have freed the print, making it an artistic form of great richness and variety.

The second objection to the print is more practical: conventional printmaking often involves expensive equipment and hard-to-obtain materials and tools. Acids are used, and knives, and heavy presses costing hundreds or even thousands of dollars. Most amateurs can't afford to buy these things; neither can many schools. Also—the special tools and materials of printmaking are only available in cities.

Modern printmaking techniques, furthermore, have become very complex and highly technical. Each basic process is under continuous development as artists try to extend its capabilities. Most books on printmaking discuss the present state of the art for each technique, leading the ama-

teur or student to believe that it's only possible to do these things the way the experts do them.

But that's not the case. In fact, as you'll learn in this book, you can make relief prints, etchings, engravings—even lithographs—in your own home or school with a handful of readily available, inexpensive materials and no equipment other than a kitchen spoon. Printmaking, in short, can be as simple, and as inexpensive, as it is satisfying.

Although I've made prints for years, I didn't always realize that I had so many options. I made linoleum cuts, primarily, and a few woodcuts; but I believed I could afford neither the time nor the money required to do etchings and lithographs. I looked for other techniques I could afford and tried cardboard prints and potato prints. I'm sure a master could produce exciting prints with techniques such as these, but I'm no master. I needed techniques that would give me enough breadth to make both realistic pictures and suitably complex abstractions.

So I searched for—and found—a number of new methods that, to my knowledge, haven't been described elsewhere. These include the plaster block methods discussed in Chapters 5–7, the lithography methods of Chapters 12–14, and the plastic techniques of Chapters 15 and 16. I also discovered a couple of substitutes for linoleum blocks. During this period I learned about the work Michael Rothenstein did with etched linoleum, and so I tried his methods. I've included variations of his technique in Chapters 9 and 10. I also developed a way to make sugar lift etchings on linoleum—this is discussed in Chapter 11.

Each of these techniques is relatively simple. It has to be to satisfy me. I'm an impatient sort; I want reasonable results in a reasonable amount of time. I won't spend years as an apprentice, painfully learning to master a difficult process. I want to buy materials at a lumberyard, a hardware store, Woolworth's, or a drugstore and come home with all the materials I need to make some prints. The techniques described in this book allow me to do that.

This doesn't mean, however, that the methods I'll show you can't be treated in a more complex fashion. I hope that some of you will see them as introductions to new materials or processes. I hope that after you do beginning experiments with me, you'll then modify, develop, and combine the techniques—with each other and with concepts of your own—to any degree of complexity that suits you. But even if you don't want to build on my experiments, my techniques will allow you to try printmaking without investing your savings account in the process. This will put the "third dimension" of imagemaking into your repertoire where it belongs, next to drawing and painting.

The book starts with a brief discussion of basic printmaking techniques to introduce you to some basic terminology. Next, there's a chapter on materials—papers, inks, a

few tools—and one on inexpensive printing presses. You won't need any press other than a spoon for any of the techniques discussed, but if the printmaking bug really bites you, sooner or later you'll want to own a simple press or two. The ones I've described cost anywhere from $10 to $100. In the fourth chapter, I tell you how to make and use a simple printing frame, which I think is the most versatile press of all.

Once these basic topics are out of the way, I'll get down to some serious printmaking. In each of the next fourteen chapters, I'll describe and illustrate one technique—one way to make a print—using a picture story approach for clarity. Relief, intaglio, and planographic processes are included. (These terms are defined in Chapter 1.)

In the final chapter I'll tell you how to develop original printmaking techniques of your own. Every artist *must* find the technical means of expression that best suits his or her personality. This is a highly individual thing—no book of instructions can ever carry you the full distance. When you've seen some of the things I've done, you'll be more aware of the vast number of things I *haven't* done—variations in my methods and/or new methods of your own. I can only get you started.

The book ends with a list of suppliers for some of the more uncommon materials discussed. Again, you can do most of the techniques included here with low-cost, readily available materials; but if you decide to become a full-time printmaker, you'll eventually want to try materials that are harder to obtain, more expensive papers, exotic inks, and so on. Some of these things can only be purchased in a few of our largest cities—so you'll need the names and addresses I have supplied.

PART ONE

BASIC CONCEPTS

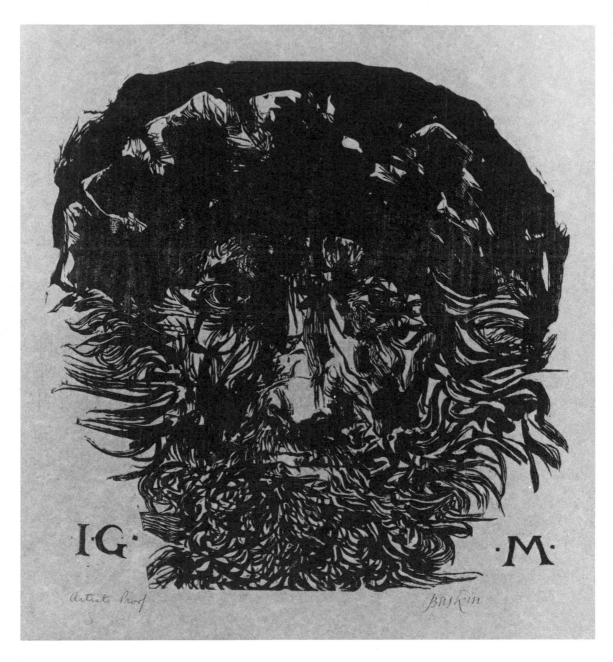

Mabusse by Leonard Baskin. Woodcut, 16¼″ x 15½″ / 412mm x 395mm, collection of the New Britain Museum of American Art. A contemporary relief print, in this case a woodcut. Although the woodcut may be the oldest of all printmaking techniques, it's still being used to produce fresh images of great originality and power. Each generation of artists has learned the basic process and then extended and modified it to suit its own message. If the artists had remained fixed to the tools and methods of their predecessors, they might still be carving medieval book illustrations.

CHAPTER 1

Getting Started

This book will show you some of the ways that you can express yourself through inexpensive printmaking, making it possible for you to produce images that you couldn't produce by painting or drawing, with tools and equipment you can afford. This is a somewhat technical book, but printmaking of necessity involves technique and process. Contemporary professional printmaking, in fact, is becoming so dependent on complex machinery and equipment that fewer and fewer artists can afford or understand it. My goal is to open your eyes to the many ways that you can make prints at home or in school with as little technology as possible and almost no equipment.

My methods are experimental. I've carried each one far enough so it's possible to use it to make a relatively simple print. Most of my techniques, as they stand, can be and have been used in the classroom; most of them can also be carried far beyond my simple suggestions. I'll have achieved one of my goals if you take the basic concepts and go on to develop modified or new procedures of your own. You'll be most apt to do this if you consider everything I say as one way to do it rather than as the only way.

I do suggest, however, that you try my way once or several times, depending on its complexity and its interest to you. Some of these techniques were arrived at only after a good deal of experimentation on my part—I think it will save you time and frustration if you start where I've left off rather than to try it wholly on your own. Besides, the procedures I'll show you are certainly valid ways to make prints.

If you're new to printmaking, then you'll learn the basic differences between such things as relief and intaglio printing and between the effects you can achieve with lithography and those you can obtain with a relief block. If, on the other hand, you've already had some experience with printmaking, perhaps the fact that my procedures are new will help you see techniques in a new light; I'll try to strip away the how-it's-normally-done aspects to reveal the fundamental concepts on which all processes in each area of printmaking are based. These insights, hopefully, will start you on basic experiments and developments of your own.

Whether you're a novice printmaker or have some prior experience, then, I hope that you concentrate on the basic concepts as you follow my demonstrations. I hope you seek and find the similarities as well as the differences between a textured wax plate and a copper mezzotint, for example, or discover the relationship between a cast plaster relief and a

woodcut. Once you see the underlying concepts, you're immediately freed from any fixed procedure, whether it's the one I teach you, the one currently being taught in the classroom, or the one you have already learned.

SOME DEFINITIONS OF TECHNIQUES

I'm going to discuss three basic printmaking processes—relief, intaglio, and planographic—in this book. Each of these words roughly defines, for printmakers, a general type of printmaking master (block, plate, or the like) as well as the printing process.

The artist also defines his products by the means used to make the master plate or block. His relief print, for example, might be a woodcut, a wood engraving, a linoleum cut, a collagraph, a cell-cut, etc. His intaglio print might be an etching, an engraving, a mezzotint, or a drypoint. Finally, the printmaker sometimes classifies his work by reference to some special process used to make the master plate. His etching, for example, might be a hard ground etching, a sugar lift, or an aquatint. The process of definition, in fact, is endless. Don't worry about this—you'll pick terms up as you need them.

There are, of course more printing techniques than the ones I discuss here, such as screen printing, photo-etching, photo-lithography, and so on. I don't care for screen printing, though, and any technique involving photography gets expensive—so I won't go into them here.

You may say, though, why so many methods, techniques, and resulting definitions? Well, remember that each combination of tools, materials, and procedures yields results that are a little or a lot different than every other such combination. Just as you can say things with a print that you can't say with a painting or drawing, so you can express yourself differently with a woodcut than with a lithograph. As you learn the techniques suggested in this book, you should pay special attention to the visual effects you can achieve with each method. This is the crux of the whole thing, the reason we try to understand basic concepts. If the first method we learn could produce any effect or image we wished, there would be no need to continue. If you learn to see these differences—and they're sometimes very subtle—and to understand how they influence the observer, you can become a sensitive printmaker.

BASIC DIFFERENCES BETWEEN TECHNIQUES

Here are some points to consider as you learn different techniques—these things often determine the differences between the results achieved by one method and those achieved by another.

The physical difficulty of making a block or print. The ef-

fort required to make or print a block always influences the results. For example, wood is harder to carve than linoleum, and, as a result, woodcuts are usually harsher, cruder, and more powerful than linocuts.

Ease of development or correction. Some types of blocks and prints can be corrected and developed extensively as you struggle to perfect your composition. With other methods, every mark you make is final. Correctable processes usually lead to careful—sometimes fussy—results; uncorrectable methods are more apt to produce impulsive, distorted prints.

Amount of detail possible. Very fine detail work is possible with some methods—engraving, for example—while other methods—sugar lift is one—give the artist relatively little control over the resulting image.

Range of tone possible. Relief prints are generally black and white with no gray tones. Many lithographs, on the other hand, are *all* tone. And tone—or lack of it—has a powerful influence on the mood expressed by a print.

Edges. The edges of shapes in a composition also make a big difference in the effects produced. Relief techniques tend to produce hard, sharp edges—no fog, motion, or uncertainty. Intaglio edges are generally softer, as are those produced by lithographic tools.

Black line vs. white line. In some techniques, such as engraving and lithography, every mark the artist makes while building the block or plate will print as a black line. In other techniques—linoleum cuts, for example—the artist's marks print white; he leaves the black areas untouched as he works on the negative spaces.

The factors above may affect your like or dislike of a given process as well as influence the results you achieve. If you prefer a lot of control and detail, sugar lift and monotype probably won't appeal to you very much. If you like bold, impulsive, action statements, you won't like engraving. There is a very strong relationship between methods, effects, message, and personality—which is why you should try as many different printmaking techniques as you can.

STEP-BY-STEP TO A PRINT

Regardless of which process you're working with, a number of basic steps are usually required, and I have listed them below. Keep in mind that this is how it's *often* done rather than how it's *always* done.

1. Conceive and develop an idea for a print.

2. Compose the idea (by sketching, perhaps).

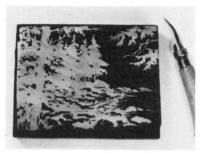

Finished Block and Cutting Tool.
I used this tool to carve out parts of the surface of what was originally a flat, light-colored block of linoleum. The areas of surface that haven't been carved (they look white in the photograph) stand in relief above the rest. These are the areas I wish to print.

Inking the Block. *I roll ink onto the block with a brayer. Since the brayer will hit only the high spots, the relief areas alone are inked. The next step (not shown) is to lay the paper on the block and rub the back of the paper with a spoon, transferring some of the ink from the block to the paper.*

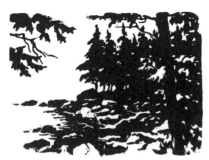

Final Print. *This is a conventional linoleum relief print. I've inked and printed the high spots on the block.*

3. Transfer the composition to a block or plate of some sort.

4. Work the block to fix and retain the composition so it won't be destroyed by the printing process.

5. Ink the block a few times, make some prints (artist's proofs), and study them.

6. Rework and develop the block to improve the results. This step is often accompanied by modification and development of the printing process as well.

7. Print as many copies as you want—the edition—when you have finished developing the block or plate.

My point in listing these steps is to emphasize the number of times you can develop or improve your work as you proceed: in printmaking, as in every other art form, development can occur at any and all stages. Many beginners feel the development is finished when the block is first cut. Not so.

Now let's look more closely at some basic processes.

RELIEF PRINTING

This is probably the oldest form of printmaking. Wood was originally used for the block and is still popular (see *Mabusse* by Leonard Baskin, page 14). Contemporary artists also use plastics, linoleum, welded or etched metal, plaster, found objects, and so on. See the illustrations of the relief printing process on this page for one way to make a simple relief print using linoleum for the block material. The process satisfies the basic requirements of printmaking—you can repeat it as many times as you like to make as many copies as you wish easily, and you change portions of a surface (by carving, in this case) so some areas can be inked during the printing process and others can't. In relief printing, the surface areas untouched by any cutting tool print black; all areas and lines cut away print white. For this reason, relief printing is called a white line process.

In time the inking process will become semi-automatic. You shouldn't have to spend hours painting on the ink to repeat the design—if you do, you don't really need a block. Preparing the block—the master—can be very time-consuming, but once the block is completed you should be able to make many copies quickly and easily.

The linoleum print on this page is a typical relief print: there are no tones; edges are hard; considerable detail is possible; the blockmaking and printing processes are relatively simple; and block correction is possible, although adding high spots that will print black is not easy. Note that the printed image is a reverse or mirror image of the block—this is true in most printmaking techniques.

INTAGLIO PRINTING

Some intaglio techniques, such as engraving, are very old yet still popular (see *Winter* by Robert Logan, page 20). As in relief printing, you can use a wide variety of materials for the block; wood, metals, plastics, and so on. I'll use linoleum, again, in demonstrating the basic steps—see the illustrations of the intaglio printing process on this page.

As you can see, tones are possible to get in intaglio printing by building up groups of fine lines or dots. You can easily make block corrections if you wish to add more tone or solid color—just scratch more lines. Removing lines is difficult but possible—you start by patching in a fresh piece of linoleum. Edges are soft (because of the way the ink is applied), and more detail is possible with this technique than with any other described in this book. This is a black line process, since the tool marks are inked and printed.

I'll get into the intaglio process in the chapters on engraving, etching (line and sugar lift ground), and mixed media.

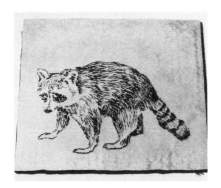

Finished Block. *As with the relief block, I used a scriber to cut into (engrave) the surface of the linoleum block. This time, however, I cut lines rather than areas. Notice that the resulting design is lower than the surrounding surface areas of the block.*

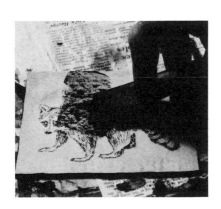

Inking the Block. *To ink the block I scrape ink across its surface with a putty knife that acts as a squeegee. This method of applying ink deposits ink in the engraved lines but leaves most of the surface relatively clean.*

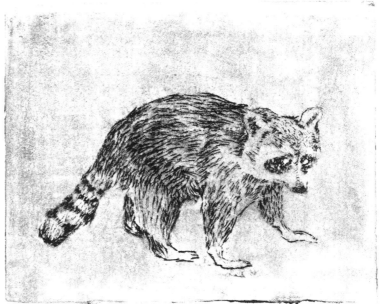

Final Print. *To get it, I put a piece of soft paper on the block and rubbed the back of it with a spoon, forcing the paper down into the engraved, inked lines in the block, transferring ink from the block to the paper.*

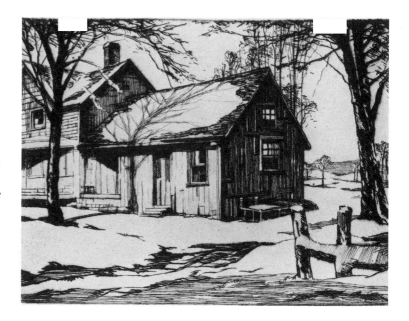

Winter by Robert Logan. Etching, 5½″ x 7½″/140mm x 195mm, collection of the New Britain Museum of American Art. This impressive print, made by the etching process, an intaglio printmaking technique, illustrates the way tones can be built from lines. There are no solid blacks or pure whites as in Mabusse on page 14; instead, there is a feeling of light and air and long winter shadows. Remember that the technique the artist chooses to use must fit his message for best results—there is certainly a good fit here.

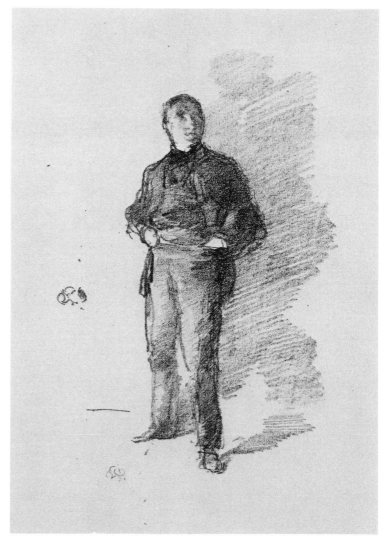

Mr. Thomas Way No. 1 by James A. McNeill Whistler. Lithograph, courtesy, Museum of Fine Arts, Boston. The spontaneity of the lithograph is one of its many attractions—I would guess that this work was performed very quickly and directly, without any transferring of image from paper to printing plate. The edges have the softness of crayon strokes (compare them with the hard edges in Mabusse on page 14)—this is hardly surprising since the image was created by drawing on the block rather than by carving or engraving. Note, too, the variety of tones, from deep black to near white.

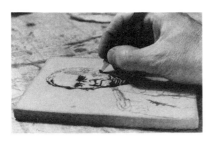

Making the Block. *I make a drawing on the block of plaster with a greasy lithographic crayon. Once the drawing is completed, I must treat it chemically to fix it on the block, so it won't wash off during the printing operation.*

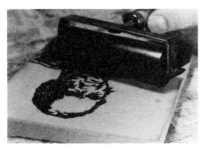

Inking the Block. *To ink the block after the image is fixed, I dampen the whole surface with water first and then roll ink on with a roller.*

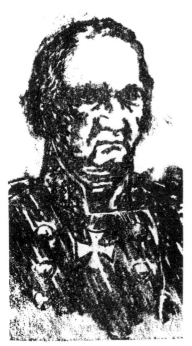

Final Print. *To get it, I laid a piece of paper on the still-damp block and rubbed it with a spoon.*

PLANOGRAPHIC PRINTING

In this book, I discuss three kinds of planographic processes—lithography, monoprinting, and transfer printing. All three methods involve printing on flat surfaces. In lithography, the primary planographic process, certain portions of the flat surface of a block or plate are treated chemically—when you draw on the block—so they will accept ink. Then, when you print, you dampen the rest of the block so it will actually repel ink. You don't cut, etch, or otherwise modify the block—only the chemicals deposited as you determine which portions of the block will accept ink and which will not during the planographic printing process.

The traditional artist's lithograph (see *Mr. Thomas Way No. 1* by James McNeill Whistler page 20) is made on a flat block of limestone, although plastic and aluminum sheets are becoming more common. I'll make mine on less expensive materials, such as linoleum and plaster. See the illustrations of the lithographic printing process on this page for a brief explanation.

Lithography, like engraving, is a black line process; edges are soft; the block is relatively easy to make and to correct; considerable detail is possible, though not as much as with an engraving; tones are possible—in fact it's pure black and white that's difficult to achieve.

Although the lithographic printing process is fairly easy, it isn't as simple as the example on this page would suggest. It sometimes takes seven steps just to fix the drawing on the block and get ready to print. See Chapter 14 for the full procedure and Chapters 12 and 13 for simpler methods.

When you do monoprints, you will paint a design on a flat surface and make a single print—the printing process destroys the painted image. Transfer printing is printing an image from one block onto another flat block, altering the impression, and printing again. See Chapter 15 for a discussion of both monoprints and transfer printing.

SOME PRACTICAL SUGGESTIONS

Before closing this introduction, I'd like to make a few suggestions that apply to all of the techniques you're going to study in this book or elsewhere.

Use appropriate design tools. If you make a sketch on paper or whatever before you begin to work on your block, then you should always design with tools in mind that reflect the ultimate results you'll achieve in print. If you're going to make a line engraving, for example, you should make your original studies in line—with pencil or pen or the like. If you're doing a relief print, you should use area tools—like brushes—for preliminary compositional studies. If you're doing a lithograph, with its soft edges and muted lines, you should do your preliminary thinking in charcoal or crayon.

If you don't match design tools to printmaking technique you'll find yourself in a jam trying, for example, to figure out why a relief block gave such a poor imitation of a great pencil drawing. If you can't come up with a satisfactory design with brush and ink, then you are very unlikely to come up with a satisfactory relief block. If line is your thing, make engravings or etchings; and vice versa, if brush is your favorite.

Work directly on your block if you can. Once you've found your printmaking technique you should at least try to work directly on the block with a minimum of preliminary studies. It always takes something out of a work of art to transfer or transpose it. Your excitement and involvement with an idea fades as you repeat it. Most of us have to resort to preliminary studies as we learn, but you should try to work more and more directly as you develop your skills.

Develop your prints. Significant art is rarely produced spontaneously. Don't be afraid to alter your images or destroy whole parts of them on the block—destruction is as important to the process of printmaking as is creation. You should change, replace, and change marks again until your mind and feelings are completely satisfied. You will, of course, make, change, and discard many sketches before selecting one from which to make your print. But remember that the development process can—and usually should—be carried beyond the compositional study stage to the final print itself.

The first copies of a print are almost always imperfect and disappointing. But the block isn't finished just because you've taken an impression. The first print is just one of many artist's proofs. Study it, rework the block, take another proof, rework some more until you produce a really satisfying print. Then, and only then, run your edition (i.e., make a lot of identical prints).

Sometimes your attempts to correct will destroy the block. Even if you spoil it, you'll have learned more than if you had passively accepted the first print. Your new knowledge makes it possible for you to make a much better print next time. And besides, you usually won't have to destroy a block to correct it.

It is true that some printmaking techniques, such as relief on wax, produce blocks that are easy to correct, while others, such as lithographs, produce blocks that are difficult or impossible to correct. In the latter case, all of the development must come before you make the block, or you will have to make your block over and over until it's right.

A surprising amount of development is required within the *printing* process each time you make a new print. Every idea is best expressed by a magic combination of the right paper, the right printing pressure, the right ink (stiff, soft, applied thickly or thinly), and the like. So many variables

are involved, in fact, that major artists often turn the printing over to skilled professionals. You may not be able to do that, but you *can* remember not to accept the first results as final. Development is the key to quality. I'll get into printing variations in many chapters, especially the one on transfer printing.

Try it more than once. You can't get full results from any new process the first time you try it. You must explore a bit, try variations, use different tools, and combine the new techniques with others you've learned in the past before you can really tell if a given process offers something for you. Give each method a real chance; you'll be surprised what a difference that makes.

Don't bury the world in prints. Don't feel that you have to make dozens of impressions each time you print. Make as many as you want, but treat printmaking as a way to make new images, not just a way to make multiple copies. I often stop after the first one or two good ones. That way I have more time to make other blocks!

PRINTMAKING—THE FRONTIER

A few decades ago, painting was the major frontier of the visual arts; new images, new schools, new techniques, arrived in bewildering numbers. Now, some of the centers of activity in the art world have switched to printmaking, with current emphasis on photographic and machine processes, including the use of computers. Through printmaking, artists are finding all sorts of technical aids in their search for fresh images. Major artists such as Rembrandt, Goya, and Lautrec have always made some prints, but now, perhaps for the first time in history, many of the men who dominate the art scene are using printmaking as a major art form—Rauschenberg, Oldenburg, Warhol, Dine, Johns, Stella, Lichtenstein, and so on.

Because of the highly technical nature of this frontier printmaking, the amateur and student have been left behind. But you can make all sorts of prints with inexpensive, readily available materials, as I'll show you in subsequent chapters. You can even invent your own methods.

Before we get into that, however, let's look at some common tools, materials, and low-cost presses that will help you become printmakers.

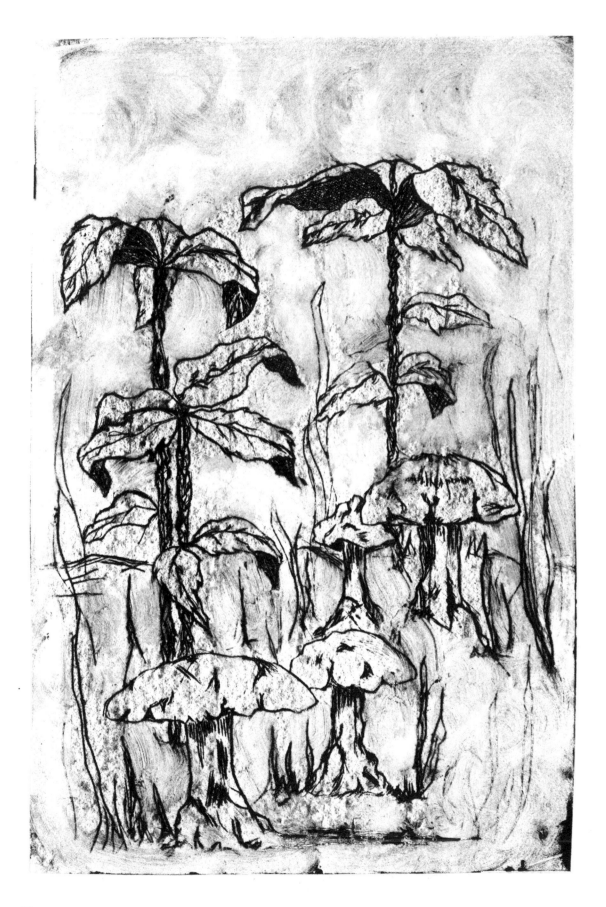

CHAPTER 2

Tools and Materials

Anthropologists once claimed that the use of tools helped them to distinguish a man from an ape. Although it may seem unnecessary to find such a specific definition—there seem to me to be *several* differences between most men and some apes—the anthropologists needed that to differentiate between the remains of an ape-man and those of a man-ape. Then, unfortunately, Jane van Lawick-Goodall, working in Africa, spotted a chimpanzee making and using a tool to catch termites for his lunch. So now the anthropologists are looking for another definition.

Personally, I think that the use of *printmaking* tools is the only thing that separates us from the apes. The other differences are just incidental! But I may be biased.

Anyway, in this chapter I'll discuss some of the tools and materials you'll need for the printmaking techniques described in this book. Let's get started!

BLOCK MATERIALS

Some of the block materials (materials to print with) I use in this book are unconventional—plaster and wax, for example—and are not widely used for printmaking. Even though others are more conventional, I want to define all of them briefly at this point and to describe the type of store in which you might be able to buy them. Names and addresses of manufacturers of the materials are listed in *Supplies and Suppliers* at the end of the book; most of these companies will supply you by mail if you can't find what you're looking for in your own town.

Linoleum. You can use linoleum for engravings, etchings, and lithographs. Standard artist's linoleum is best, although you can use the floor variety if it doesn't have a strong pattern or texture.

Artist's linoleum comes in several configurations these days. You can buy it unmounted or mounted on wood (making it approximately type high, as in printing type) and unpainted or coated with lacquer. We'll use all kinds in this book, since each offers certain advantages.

When you buy wood-mounted linoleum, try to get the kind that is mounted on plywood. Linoleum always used to be mounted on plywood, but lately some manufacturers have been mounting it on an artificial composition board instead. This is perfectly acceptable if you're making conventional linoleum blocks, but composition board isn't suitable for printing processes involving water—like lithog-

Mushrooms *by Ann Lebejko. Linoleum engraving, 6" x 9"/ 140mm x 230mm. This is a print in which multiple lines— crosshatching—establish tones. It's difficult to get a dark tone like that under the upper leaves without leaving so much ink on the plate that it blots in the printing process, but Ann Lebejko managed it by wiping the background carefully after scraping the ink off. See Chapter 8 for an explanation of this method.*

raphy or etching. As composition wood softens and swells when it gets wet, you can use this type of mount only if you give it one or more coats of paint before you begin, which is a nuisance.

One way to avoid this problem is to buy unmounted linoleum and glue it to plywood yourself. (Be sure to use plywood, not plain wood—the latter warps too readily.) Use Duco cement or the equivalent, and place a few books on top of the linoleum after you glue it to the plywood for a few days to weigh it down.

Plaster. You'll use plaster as an artifical stone for lithography and to cast various types of relief blocks. But be careful when you buy it. I've had no success with conventional plaster of Paris, the kind of plaster that everyone sells. Instead, I recommend Por-Rok cement and Hydrostone. Por-Rok cement is a fine-grained cement—as fine as plaster of Paris—but it's much stronger and shrinks much less as it dries. It's normally used to repair broken or reworked concrete. You can buy it in places that sell building supplies, such as hardware stores and lumber yards. Hydrostone is sometimes sold as casting plaster. It seems to be as hard as Por-Rok, is whiter (which is a help in lithography), and is much less expensive. Hydrostone's only drawback is that it usually comes in 100 lb. bags. (You can buy Por-Rok in quantities as small as a 1 lb. box.) Hydrostone can be obtained from masonry supply stores or from some large art supply stores.

Plastics. I'll use two plastics in this book: flexible vinyl plates sold by Hunt Manufacturing Co. for printmaking (although I'll use them in a way they hadn't intended); and polyester resin, normally used to repair dents and holes in automobile bodies. You could use other polyester resins and some of the epoxies also, but I don't enjoy working with them and so didn't include them in the book.

Wax. I use Rigidax. This is an industrial wax with fiberglass and other fillers. It comes in pellet form, can be melted in a double boiler on your stove, and is completely nontoxic. You have to buy it from the manufacturer (see *Supplies and Suppliers*) who is ready and willing to sell small quantities to artists. In Chapter 17 I'll show you how to use Rigidax to make a substitute for a linoleum block.

TOOLS, INKS, AND SOLVENTS

Most of the tools and materials I use to cut the blocks, ink them, and prepare them for printing are described in the following pictures.

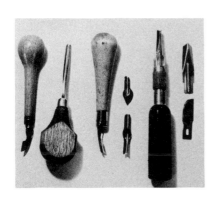

Wood and Linoleum Cutters. You can purchase these in most art supply stores—they come with blades and gouges,

some interchangeable and some not. My favorite is the Speedball type, pictured third from left with a few extra blades—these cutters last forever without sharpening. I use them on plaster, plastics, wax, and linoleum. I have tried more expensive woodworking tools, but I don't like them as well as the Speedball. (I might feel differently if I worked on really large blocks; but 8″ x 10″/205mm x 255mm is my normal size limit.)

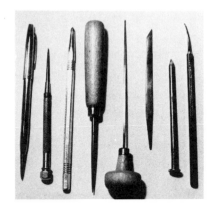

Tools for Engravings or Line Etchings. All of these tools have one thing in common—a hard, sharp point. You can work with any tool with such a point—these are just the ones I use. They are, from the left: a machinist's scriber with a tungsten carbide point; a steel scriber; a scriber with a diamond point; a printer's awl; a scorper (used for metal or wood engraving); another type of blade for metal or wood engraving; a sharpened nail; and a broken (but sharpened) dentist's tool. You can buy scribers and awls in hardware stores or in machinist's supply stores. My favorite tool in the collection above is the tungsten scriber; I bought it at Sears, Roebuck for a couple of dollars.

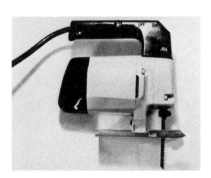

Saber Saw. Power tools of all kinds like this saber saw can be used to carve or work blocks, although it takes strength and skill to achieve controlled results. The saber saw sells for under $10 and is especially useful for cutting blocks of plywood, plaster, or mounted linoleum—it makes a clean cut that is perpendicular to the front surface of the block. The cut blocks can readily be mounted in a printing press and locked up with type. Most other inexpensive power saws, such as jigsaws, make a cut that is *not* always perpendicular.

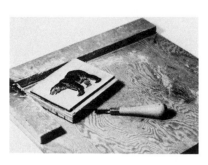

Bench Hook. This device for holding the block while you carve it is a must if you are going to make carved relief blocks. Speedball makes an inexpensive one of metal. I made the one shown in this photograph from a sheet of plywood and three strips of pine. Two strips hold the block as you cut away from yourself with the cutter shown. The third strip, underneath the front edge, is not visible—it butts up against the edge of the worktable and holds the bench hook in place.

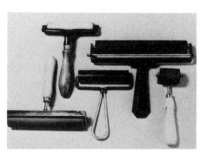

Brayers. You'll need one or more of these small rollers for rolling ink onto relief or lithographic blocks. If you can only afford one roller, buy a relatively soft one—they can be used for all kinds of prints. When you really get going, however, you'll find that a collection of rollers of different lengths and hardnesses will be useful. Starting from the right, the first, last, and middle rollers are all made by Speedball (the middle one is hard, the other two soft). The second roller from the right, sold in photographic supply houses for

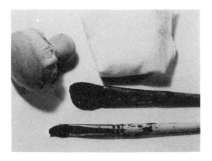

squeezing the water out of photographic prints, is on the soft side and works well as a brayer. The second roller from the left is fairly hard.

Brushes and Daubers. You won't always use a brayer to ink a printing block. Sometimes you'll use a brush like either of the ones shown in this photograph. Any kind of brush will work, although each will produce different results. The Japanese make special brushes for this purpose. You can also daub ink onto the block with a pad of cloth (top right) or with a chamois-covered dauber (far left).

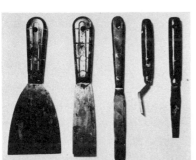

Knives. You'll use putty knives, such as the two on the left, to ink intaglio blocks in Chapters 8 and 10. These knives will also come in handy for some of the cast plaster techniques described in Chapters 5–7. The two sawed-off palette knives on the right will also be used for cast plaster printmaking. I made these by snapping the tips off regular palette knives with a pair of pliers and then filing the broken ends slightly to remove the sharp edges. I use the unmodified palette knife in the center to mix and spread ink onto the ink plate or palette.

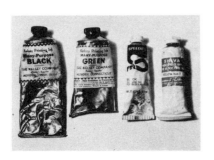

Inks for Relief Printing. The Kelsey inks on the left are made for commercial printers—they make very good relief inks. Speedball, Shiva, and other companies also make block printing inks, water-based as well as oil-based. They are softer than the commercial inks, and I don't like them as much. They're often easier to find, however, since most art supply stores carry one or more brands. Incidentally, ink comes in cans as well as tubes. Don't buy cans unless you're going to be doing a lot of printing. Tubes last forever, but cans dry out easier unless kept wet by pouring a layer of water over the top—which is a nuisance.

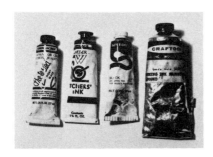

Inks for Intaglio Printing. Inks for intaglio work differ from relief inks. My favorite is artists' oil paint, like the Grumbacher tube on the left. Oil paint makes a good print and is *much* easier to clean from the surface of the block than other intaglio inks—you'll learn the importance of this in Chapter 8. Speedball ink, third from left, works fairly well for intaglio prints. The Weber and Craftool etching inks included above are made specifically for intaglio work—they work much better than oil paint or Speedball ink if you're printing with an etching press, but I find them harder to deal with when spoon printing.

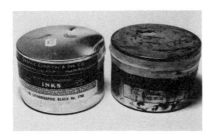

Lithographic Inks. This kind of ink differs from both relief and intaglio inks—it contains varnish rather than plate oil. I've been unable to print a lithograph with anything but "the real thing," as relief and intaglio inks smut the lithographic block very rapidly. I've never seen litho ink in tubes, but it may be available. For some reason, however,

litho ink doesn't seem to dry in a can as rapidly as relief and intaglio inks do.

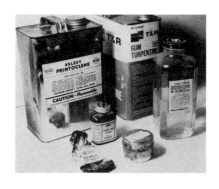

Solvents and Mediums. Sometimes you'll want to mix something with the ink to change its characteristics. The Kelsey tube in the foreground contains a compound that speeds up the drying process. The small can to its right contains an anti-picking compound, which is a help if you're printing large areas on a press. Anti-picking compound is a sticky, waxlike material used by commercial printers to eliminate white spots—spots where ink doesn't stick to the paper but is "picked off" by the press—when printing large areas. You won't need it for spoon printing. The rest of the materials shown—plate oil, Printoclene, gum turpentine, and varnish—are all used to dilute oil-based inks for wet effects. Varnish and plate oil are safer to use than Printoclene (a type cleaner) or turpentine, both of which can stain the paper, but all these liquids work. You can also use Printoclene and turpentine for cleaning blocks, tools, hands, and working areas.

EQUIPMENT

There are a few other items, not shown in the photographs, that are useful around a printshop. One of my favorites, for example, is an old ice cube tray. I fill this up halfway with type cleaner or turpentine and use it to clean brayers and press rollers.

You'll also need ink plates to roll out your ink before inking a block. I use a paper palette—the shiny, waterproof kind made for acrylic painters. I tape the edges of the palette down with masking tape before using it, so the brayer doesn't pick up the top sheet. The advantage of using a paper palette is that you don't have to clean it when you're through printing—you can just throw it away. Many printmakers, however, prefer a permanent ink plate, such as a heavy sheet of glass, the marble top of an old table, or the equivalent.

Finally, paper towels and old rags are also a must for cleaning everything—your hands, your press, your tools, your ink plates, etc.

PAPER—THE PRINTMAKER'S CANVAS

You can make prints on many types of paper, from the cheapest to the most expensive. Generally speaking, you'll use different types of paper for relief prints than you will for lithographs or for intaglio work. While the following chart should give you some idea of the types used for each technique, the chart isn't complete. Try whatever you can get your hands on—you'll find that each type of paper gives different results than all other kinds. If you become a serious printmaker, send for some of the more exotic ones and

PRINTING PAPER CHART

Relative Cost	Relief Paper	Intaglio Paper	Lithography Paper
Inexpensive	Cardboard Construction paper Kraft paper (brown paper used for paper bags, etc.) Shelf paper Tracing paper Typewriter (bond) paper	Construction paper Newsprint Typewriter paper (cheap)	Construction paper Typewriter paper (cheap)
Moderately Expensive	Bristol paper Cameo paper Drawing paper Illustration board Japanese rice paper such as Mulberry Rubbing paper Speedball block printing paper Tableau paper	Bristol paper Japanese rice paper Rubbing paper Speedball block printing paper Thin drawing paper Utility cover stock	Basingwerk Fiesta cover stock Rubbing paper Soft drawing paper Speedball block printing paper Tableau Utility cover stock
Expensive	Arches printing paper (French) Rives BFK or heavy-weight printing paper (French) Torinoko paper (Japanese)	Arches printing paper (French) Copperplate Fabriano Murillo Rives BFK or heavy-weight printing paper (French)	Arches printing paper (French) Copperplate Rives BFK or heavy weight printing paper (French)

try those. They're wonderful to work with. Sources of printmaking paper are listed in *Supplies and Suppliers* at the back of the book.

I have divided the three types of papers you'll need or may want to try for relief, intaglio, and lithographic printing by relative cost in the chart below. Almost any kind of paper, except perhaps the lightest tissue papers, works for relief printing. Intaglio printing requires a paper that is lightweight and pliant so the printer can force it down into the cuts in the block to reach the ink. Some tissue paper is soft enough to use for this purpose without special treatment, but most paper has to be dampened before it can be used for intaglio work. (I explain how later on in this chapter.) Lithographic printing requires a fairly soft paper, though not as soft as intaglio paper.

DAMPENING

There are several ways to dampen paper for intaglio printmaking, the simplest one of which is to spread water over one side of the paper with a large, soft brush a few minutes before making the print. Brush the water right to the edges of the paper to minimize wrinkling, and then let the paper start to dry. It's ready to use when it's cool but not shiny—that is, when it has dried enough so it no longer glistens but is still wet enough to feel cool if held against your cheek.

Professionals wet paper by a far more elaborate procedure, (which I usually use for my final prints). You soak some of your printing paper in a tray, sink, or bathtub the day *before* you plan to print. After the paper has soaked for ½ to 1 hour, stack it in a pile, placing one sheet of *dry* printing paper between each pair of wet sheets. Cover the resulting pile completely (on all sides, above, and below) with sheet plastic or a plastic bag to prevent the edges of the paper from drying too rapidly, and weigh the whole thing down with a sheet of glass or plywood. The paper will be ready to use the next day.

Be sure and use it soon. If wet paper sits too long—for more than one week in winter or two days in summer—in this damp sandwich, it will mildew.

There are a lot of variations on this technique. Some printmakers place dry paper between wet blotters; some place wet paper between dry blotters; some place only wet sheets between plastic (and blot them between blotters right before they print). The main thing is to let the stack of wet paper sit long enough so the water becomes distributed uniformly throughout all the sheets.

BLOTTING PAPER

Sometimes when you take your paper out of the plastic wrap in order to print, the paper is still very wet—it glistens. Should this happen, put the paper between blotters before

you lay it on your inked block, and roll a rolling pin or press a paper towel over the top of the blotter. Then go ahead and use the paper to print.

DRYING PRINTS

You must dry fresh, damp prints very carefully, or they will wrinkle. One way of doing this is to lay each damp print on a piece of cardboard, Masonite, or another flat surface and tape its edges down all around with masking tape or the equivalent. This is fine if you're only making a few prints, but it's a nuisance if you're making a lot of prints. A more common method of drying prints, therefore, is to lay your fresh print on a dry blotter larger than the print (larger to prevent the edges of the print from drying too fast). Then lay a sheet of clean newsprint on top of the print (to keep your blotter from becoming full of ink), and cover it with another blotter. Lay your next print on top of the second blotter, add a sheet of newsprint and another blotter. Keep doing this until you're finished printing. Then weight the whole pile down with a sheet of glass and let the prints dry slowly in this "press."

It usually takes several days to a week for prints to dry in the blotter press. The longer it takes, the less apt they are to wrinkle—but the more apt they are to mildew. It's necessary, therefore, to remake the pile once a day, each time using fresh, dry blotters and newsprint. This will guarantee that you get flatness without fungus!

If your ink is very thick, you might try putting a piece of glassene—a thin, shiny paper—over the print under the newsprint. The ink would stick to the newsprint, but it won't stick to glassene. Change the glassene along with the blotters whenever you remake the pile.

Since photographers also use blotters to dry prints, photographic supply stores usually carry them. You can get them already made up in "book" form, with tissue papers between every pair of blotters (the tissue takes the place of the newsprint but not the glassene). You can also buy large blotters at the local variety store, Woolworth's, or the equivalent.

All of this blotter business can be a nuisance if you're making prints to develop a block or to experiment. Under these circumstances your prints may not be worth saving. If you don't care whether or not they wrinkle, just set the fresh prints on your drying rack (see below) and let them dry and wrinkle. If you decide later that one of the prints is good enough to save, rewet it with a brush—taking care not to crease the wrinkled paper—and then redry the print carefully between blotters as described above.

WHERE TO DRY PRINTS

You can lay fresh prints on a table or floor while the ink is drying (for about 24 hours or so). But if you're printing a large edition, you'll find it useful either to string up a clothesline and hang the prints from that with clothespins or to use a drying rack of the type illustrated on page 33. This rack is made from strips of wood (1" x 2"/25mm x 50mm furring strips are ideal). I use old canvasboards (16" x 20"/405mm x 510mm) for the removable shelves. When I print, I set a canvasboard beside my press, load it up with prints, and then set it in the rack. If I'm still printing, I start to fill another. It's all very convenient.

I have a strong preference for the drying rack (it holds a blotter press as easily as a print), but many printmakers claim that the clothesline approach takes less room and holds more prints. String the clothesline indoors, of course. You can buy nice small clothespins from a photographic supply house, since photographers often dry prints the same way. You might want to put little pieces of paper or thin cardboard between your prints and the clothespin to avoid ending up with a dent or dents in your dry prints.

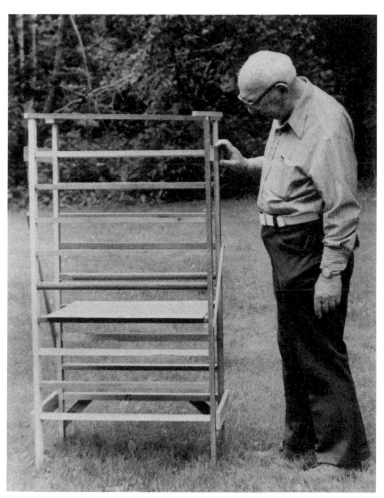

Low-Cost Printing Presses

In every printmaking process a piece of paper must be pressed against a block or plate by either the artist or a press to make a print. Sometimes the pressure required is only light; more often, however, heavy pressure is needed for an acceptable impression. Since it's hard work to generate heavy pressure, man has invented a number of tools and machines to help him. These devices amplify the relatively small force produced by a man into the high pressures required.

Most of the mechanical amplifiers man has invented for machinery in general—levers, gears, screws, wedges, hydraulic cylinders, etc.—have at one time or another been incorporated into a printing press. In fact, the desire to print things—books as well as pictures—was one of the main incentives behind the development of machinery in general. Man devoted his early mechanical talents to machines of special importance—to windmills, textile and farming machinery, weapons, and printing machines. So the history of the press is long and complex.

The modern, high-speed, commercial press reflects this long development; it's an awe-inspiring machine, revealing the contributions of generations of designers. Presses used by artists, however, are often very simple. As pointed out in Chapter 1, the effects achieved in a print are strongly influenced by the means used to print the block. Although presses, like printmaking techniques, can be grouped into families, *each* type of press produces different results and/or can be used to produce different effects. In consequence, early presses don't become obsolete when improved or different presses are developed. You may be able to do things with the new press you couldn't do with the old, but you can usually do things with the old you can't do with the new. So the old remain useful and are still found in artists' studios everywhere. Even in this era of multilith (a commercial lithographic process) and xerography, Benjamin Franklin would probably be very much at home with some of the presses in a college art department.

A CATALOG OF PRESSES

The presses I'll use in this book are very simple. Our primary tool will be a kitchen spoon; its curved bowl amplifies the forces we can produce by concentrating these forces on a very small area of contact between spoon and paper. Moderate force, concentrated on a small area, produces a

Landscape by Margaret Roberts. Lithograph on plaster, 6" x 8"/150mm x 205mm. A lively drawing, with almost as many dots as lines. Note the lack of background tone. If you make a heavy black (not light or gray) drawing on plaster, keep the block wet when you print, and build up the ink layer slowly, you'll develop a contrast between black line and white background that rivals that of the relief print. But—an important difference— the edges of the lines will usually be softer than the edges of carved relief lines. See Chapter 13 for a description of this method.

relatively high surface pressure—force per square inch—and that's what we need to transfer ink from the block to the paper. I estimate that a 10 pound force produces pressures of 1,000 pounds per square inch or so in spoon printing. That's a lot of pressure!

In addition, I'll sometimes need help in holding the paper and in positioning it in relation to the block. This is especially true when I overprint two or more blocks in multicolor or multimedia prints. My favorite tool for this is a printing frame—I'll show you in the next chapter how to make one.

But first, here is an illustrated catalog of some of the low-cost presses that are available on the market. (See *Supplies and Suppliers* at the back of the book for where to buy them.) Each press has its place; each can be used with one or more of the blockmaking techniques to be described in this book (although most are best for relief prints). If the printmaking bug really bites you, I'm sure that you'll build up a collection of presses to extend the capabilities of your printmaking shop. In line with the general theme of this book, I've included only relatively inexpensive presses in this list. Some will cost you nothing; others will cost $100 or so. These latter may seem expensive, but there are many presses that cost over a $1,000 and a few that cost over $4,000. For information on these expensive presses, I suggest you look at Ruth Leaf's *Intaglio Printmaking Techniques.*

This is not a complete catalog of inexpensive presses—others are available. These are merely typical of the kind of thing you can buy or improvise. Any method of holding the paper and generating pressure on a block is "legal" if it results in an acceptable print. I'm sure that you'll think of other possibilities after reviewing these.

Your Hand. This is the simplest press of all. Just place a piece of paper on the block and rub the back of the paper to make the impression. This works well with heavily inked relief blocks and with any technique that involves very wet or oily ink.

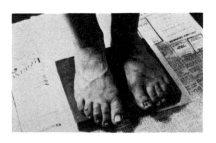

Your Feet. You can use your feet to generate slightly higher printing forces than your hand: textiles are often printed this way (not commercially of course). To use your feet for printing pressure, place the inked block upside down on the surface to be printed and then stand on the block. It's best to do this barefoot. Be careful as you get on and off the block—don't move the block and smear the print.

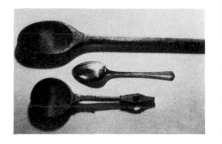

Spoons. You'll usually need higher printing pressure than you can generate with your hands or feet. The simplest way to get high pressure is to rub the back of the printing paper with a spoon instead of with your bare fingers. You can use all kinds of spoons: metal spoons are more convenient for

small blocks; wooden ones are usually better for large. If you oil the bottom of a wooden spoon lightly, it will travel smoothly over the paper without sticking. The spoon is a versatile press. As you'll see, you can use it for relief, intaglio, and planographic prints.

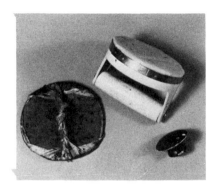

Barens and Drawer-pulls. Here are some other round-bottomed tools to use instead of a spoon for manual printing. From left to right: **(1)** A Japanese baren, a disk made of bamboo fibers. You hold it with your fingers and press it against the paper with the heel of your hand. This is the traditional press of the Japanese woodblock artist. Like a wooden spoon, it works better if you oil it lightly before use. It contacts a larger area of the paper than a spoon does, and therefore produces less pressure. As a result, it can only be used for relief prints. **(2)** A commercial version (by Speedball) of the Japanese baren. Again this baren is only useful for relief prints. **(3)** A drawer-pull. Anything with a hard, rounded bottom, such as this drawer-pull or any doorknob, will work for all types of prints.

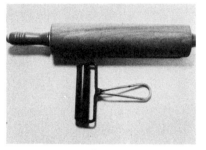

Rolling Pin and Brayer. Either of these can be used to apply printing pressure for relief printing. Like spoons, rolling pins and brayers work because they have a relatively small area of contact with the paper— a line of contact in this case instead of a spot. Rolls from old-fashioned washing machines or anything similar would work just as well.

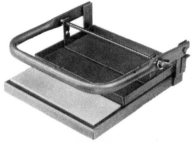

Speedball Model B Press. This is an inexpensive press—it sells for approximately $20—for relief blocks 7"x7"/180mm x 180mm in size or less. It's intended for linoleum but will also work with blocks of wood, plaster, plastic, and so on. It uses a lever system (the U-shaped handle) to amplify the forces produced by the operator. (Photo courtesy of the Hunt Manufacturing Co.)

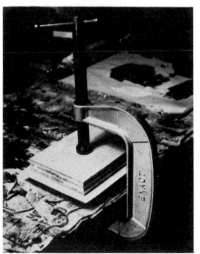

Homemade Press with Screw. The screw in this press supplies the force amplification. To use it, you ink the block to be printed and place it near the edge of a table or workbench. Lay paper on the block and put a second block (a piece of plywood, for example) on top to complete the pile. Screw a large C-clamp—from your local hardware store—in place to apply pressure. Again, this press is only useful for relief prints of relatively small sizes.

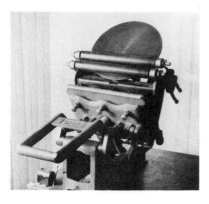

Commercial Clamshell Letterpress. This press uses levers to amplify the forces produced by the operator, just like the Speedball Model B press. In this case, however, there is a more complex lever, or toggle, system that gives very high amplification. You can use this press to print any relief block that is approximately type-high (roughly ¾"/20mm). By combining the blocks with metal type of all kinds, you can print words as well as pictures. Also, the press automatically inks the block—you don't have to ink by hand.

This type of press comes in various sizes; the one shown will print anything up to 5" x 8"/125mm x 205mm and costs about $100. It's a very convenient press to use to make large editions of hundreds or thousands of prints.

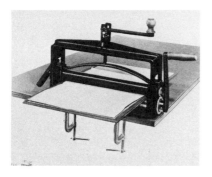

Speedball Printmasters Press. The block and paper pass through a pair of rollers like a shirt passing through the wringer of an old-fashioned washing machine. The rollers and a spring mechanism generate the high pressure. You can print blocks of up to 12"/305mm in width and of almost any length. I have never used one of these machines, but I think it could be used to print lithographs or intaglio prints as well as reliefs. It sells for approximately $100. (Photo courtesy of the Hunt Manufacturing Co.)

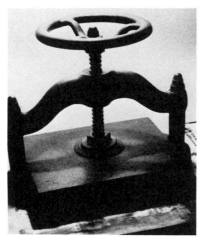

Letter Duplication Press. This press, which uses a screw to amplify input forces, was designed for offices to duplicate letters before the copying machine was invented. Every office had one, and there are still a lot of old ones around—I bought mine at an auction for $5. I use it for relief blocks and for bonding linoleum plates to plywood. The press shown will print blocks up to 8½" x 11"/212mm x 280mm—this is probably the most common size, considering the initial use, but there are other sizes as well. This type of press is still manufactured. A new one, 11" x 16"/280mm x 405mm in size, sells for approximately $100.

Proofing Press. Commercial printers use this press to check a block of hand-set type for errors before mounting the type in a clamshell press or the equivalent. Blocks, as well as type, can be mounted in this press. You must ink the block by hand, lay paper on top, and then pull the roller (manually) across the top of the block to make the impression. The model shown will print blocks up to 9" x 11½"/230mm x 295mm and sells for about $100. It's intended for relief work but might be acceptable for intaglio and planographic prints. (Photo courtesy The Craftool Company.)

Wringer Press. Intended for relief prints, engravings, and lithographs on metal plates, this press would undoubtedly work with the lithographs on cardboard, plaster, and linoleum discussed in Chapters 12–14. The press has an 8" x 10"/205mm x 255mm chase, which means that it will accommodate blocks of that size or smaller. It sells for about $75. (Photograph courtesy of The Craftool Company.)

Inexpensive Engraving and Etching Press. This low-cost press will also print relief blocks. It's small, costs about $40, and is generally used with 4" x 5"/ 100mm x 125mm blocks—it can get you started with metal engravings and metal etchings when you're ready for them. Please note that you'll have to buy some sort of blanket (felt or wool)— among other things—to use as a cushion between the roller and the metal plate. (Photograph courtesy of The Craftool Company.)

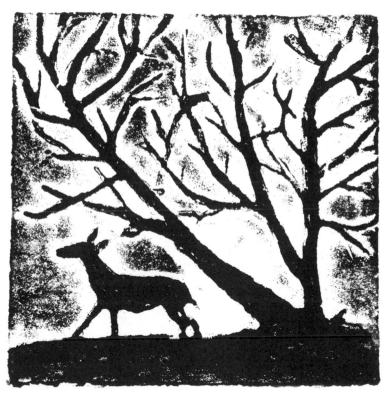

The Deer *by Sharon Noglow. Etched linoleum, 6" x 6"/150mm x 150mm. See Chapter 10 for a description of the method used to make this print.*

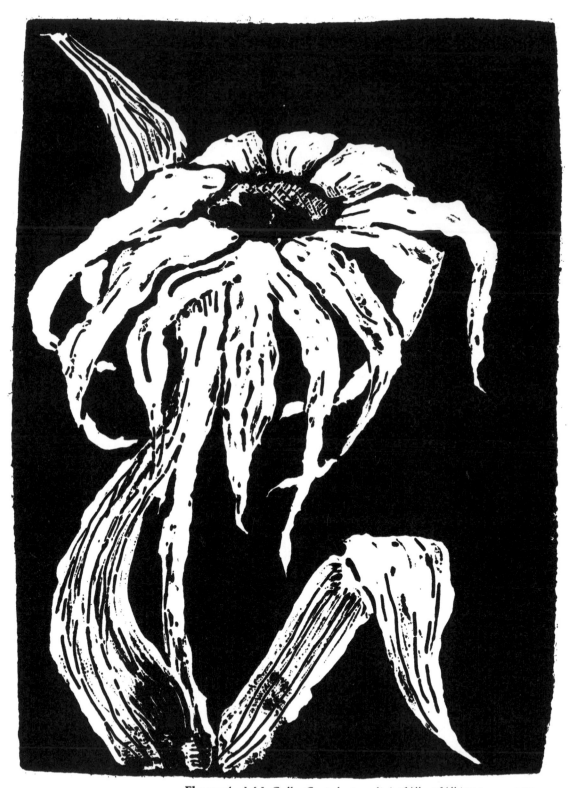

Flower by M.J. Gallo. Cast plaster relief, 5¼″ x 7½″/132mm x 195mm. The textures in this print—all produced by the handle of a brush—are used with restraint to make the drawing intelligible. They shade portions of the design and separate one section from another rather than add texture per se. See Chapter 7 for a detailed explanation of this method.

CHAPTER 4

Printing Frames

Most of the printing presses described in the last chapter can be used with only one or a couple of printmaking techniques, usually relief. Only the spoon, perhaps, is versatile enough for all types of relief, intaglio, and planographic printmaking—at least as far as applying pressure to the paper is concerned. But there's more to printing than applying pressure. You'll want to hold the paper against the printing block—without moving it—during the printing operation. And you'll often want to locate the paper in some exact position with respect to the block, especially if you're doing multi-impression work (prints involving several colors or mixed techniques). It would be nice if you had a low-cost press that was as versatile as the spoon and that also provided some of the features of the more expensive machines described in Chapter 3. The printing frame is your answer.

Strictly speaking, the printing frame is not a press. It's a substitute for those portions of a press that hold the block and allow you to place the paper in some fixed relationship to the block. The actual pressing is still done with a spoon or baren of some sort—the frame makes spoon printing easier, more accurate, and more versatile. Unfortunately you can't buy a printing frame, but they're easy to make. You don't have to have a frame for the techniques described in this book, but if you really get involved in spoon printing, you should make one.

MAKING A PRINTING FRAME

Here are the steps involved in making a printing frame.

Printing Frame. This fairly simple device consists of a couple of framelike members—the top and the chase—that are connected by a hinge and sit on a plywood base. Blocks to be printed are clamped by screws or by quoins in the chase; printing paper is held and located by the top. I'm going to show you two different ways to make a frame starting with the type I generally use. Then I'll show you how to make a less expensive frame. (My "expensive" one would cost you about $25.)

Chase. The chase is the key piece of the printing frame—it holds the block and/or type. You can see the metal screws that pass through one side and one end of the chase. When you put a block in the chase, you can tighten these screws to hold it in place. Since commercial clamshell presses (see Chapter 3, page 38) have chases, you can buy them. They

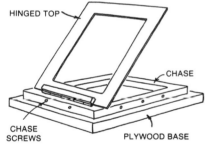

HINGED TOP

CHASE

CHASE SCREWS

PLYWOOD BASE

come in different sizes: 3″ x 5″/75mm x 125mm, 5″ x 8″/ 125mm x 205mm, 6″ x 10″/150mm x 255mm, 9″ x 13″/ 230mm x 330mm, and so on. These dimensions refer to the size of the largest block the chase will hold. I use a 9″ x 13″/ 230mm x 330mm chase that I bought from the Kelsey Company for about $10. As purchased, this chase is complete—you don't have to do anything to it.

Materials to Make a Printing Frame like Mine. All of the materials—except the glue—are shown here: a 9″ x 13″/ 230mm x 330mm metal chase; a sheet of ¾″/20mm plywood 12½″ x 16″/320mm x 405mm; a sheet of ⅛″/4mm tempered Masonite 12½″ x 16″/320mm x 405mm (¼″/ 7mm plywood can be used instead); a can of shellac or paint; four ½″/15mm long wood screws; a 7½″/195mm long strip of pine ½″ x ¾″/15mm x 20mm; an 8″/205mm long piano hinge ½″/15mm wide on each side; a good wood glue, such as Elmer's glue or Duco cement (not in photograph).

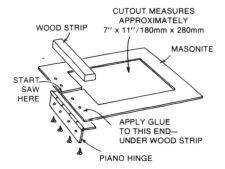

WOOD STRIP

CUTOUT MEASURES APPROXIMATELY 7″ x 11″/180mm x 280mm

MASONITE

START SAW HERE

APPLY GLUE TO THIS END— UNDER WOOD STRIP

PIANO HINGE

ASSEMBLED

Printing Frame with a Metal Chase. To make a printing frame like mine—with a metal chase—begin by cutting a square hole with a jigsaw in the center of the thin plywood, which will be the top of the frame. The hole created will expose the area where the block will be mounted in the chase. You can start the saw cut in the center of the hinge side as shown—the hinge will later hold this end of the Masonite together. When you finish sawing, glue a strip of wood to the top side of the Masonite and then fasten the hinge to the Masonite with wood screws driven through the Masonite into the wood strip. Next, paint or shellac the finished top and the plywood base to protect them from the water you'll use for lithography. And that's all there is to it! Your printing frame is now complete and ready to use.

Furniture. When you start to use the printing frame, you'll also need a collection of wooden or metal furniture, blocks and strips of metal and wood used to lock printing blocks and/or type into the chase. You can buy a font of furniture from a printing supply house for a few dollars, or you can make your own out of wood. Metal furniture—like the half a dozen little pieces shown near the lower center of the photograph—is a convenience but not a necessity. All furniture is ⅝″/18mm high—and mine vary in thickness from about 1/16″ to ⅝″/2mm to 18mm and in length from 2″ to 8″/ 50mm to 205mm. I paint or shellac my wooden furniture before use to prevent it from swelling when it gets wet. To prevent damage to the wood, you should always place two strips of steel, such as those shown at the bottom in the photograph, between the chase screws and the furniture—any purchased chase comes equipped with them.

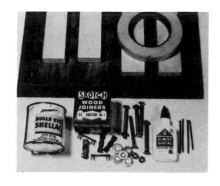

Materials to Make an Alternate (Wooden and Cardboard) Printing Frame. The printing frame just described was built around a purchased metal chase and a Masonite top. There are other ways to build a usable frame if you don't want to buy a chase or Masonite or if you want a frame that will handle larger blocks. I'm going to demonstrate by building a 10″ x 11″/255mm x 280mm wooden chase that will hold blocks measuring 10″ x 11″/255mm x 280mm or less. I'll also build a cardboard top to go with it. You can follow the same procedure to build any size you wish. All of the materials you'll need for this alternate frame except the quoins are shown in the photograph: two 12″/305mm long pieces of 1″ x 2″/25mm x 50mm white pine; two 14″/360mm pieces of 1″ x 2″/25mm x 50mm pine; one piece of ¾″/20mm plywood 15″ x 17½″/380mm x 445mm; one sheet of heavy cardboard (the back of an old sketch pad is excellent) 14″ x 16″/360mm x 405mm; a roll of masking tape; a can of shellac or paint; 12 Skotch Wood Joiners or the equivalent; 3 printer's quoins (not shown) or 5 bolts, with washers and nuts (most types of heads are good as long as you don't use carriage bolts); good wood glue, such as Elmer's glue or Duco cement; and 4 finishing or box nails, 2½″/65mm long.

Making an Alternate (Wooden) Chase. The wooden chase is like a simple picture frame. You can miter the corners of the pine strips if you're a carpenter, or you can make them square as shown. Use lots of glue, 1 nail, and 3 corner fasteners on each corner for strength (the third fastener goes underneath). Paint the finished chase and the plywood base to protect them from water. Next, screw in the 5 bolts (the equivalent of the chase screws)—position a washer and nut on the inner end of each bolt to provide a threaded surface so you can tighten the bolts. You'll have to hold the nut with pliers or a small wrench until the bolt is partially tightened. Instead of bolts you can use 3 printer's quoins (see illustration). These small wedge clamps, available from Kelsey and other printing supply houses, fit between the block and frame and expand to clamp the block. You'll find they do a much better job than the bolts.

Making an Alternate (Cardboard) Top. Here's an alternate top section of the printing frame. It's made of two pieces of heavy cardboard and a tape hinge. Be sure to leave a space of ⅛″/4mm or so between the two pieces of cardboard when you tape them together so the hinge will work properly. You can use this top with a purchased metal chase, just as you can use the Masonite top with a wooden chase. When you get really serious about printmaking, you should go to the trouble of making a Masonite top, as it's better than the cardboard one. But for now, if you have completed a wooden chase and a cardboard top, your alternate frame is done and ready to be used.

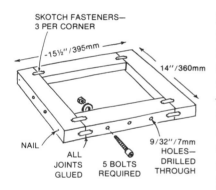

SKOTCH FASTENERS—
3 PER CORNER

15½″/395mm

14″/360mm

NAIL

ALL JOINTS GLUED

5 BOLTS REQUIRED

9/32″/7mm HOLES— DRILLED THROUGH

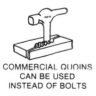

COMMERCIAL QUOINS CAN BE USED INSTEAD OF BOLTS

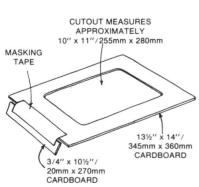

CUTOUT MEASURES APPROXIMATELY
10″ x 11″/255mm x 280mm

MASKING TAPE

13½″ x 14″/ 345mm x 360mm CARDBOARD

3/4″ x 10½″/ 20mm x 270mm CARDBOARD

Alternate (Wooden) Printing Frame. This is a photograph of the finished wooden frame with a block mounted in it, ready to be printed. (You'll find photographs of printing frames with metal chases in Chapters 8 and 14.) Note that I've used quoins instead of screws to clamp the block and wooden furniture in place. I've placed a sheet of paper between the frame and its black plywood base so you can see the block, furniture, and quoins more clearly.

USING THE PRINTING FRAME

Now that you've built a printing frame, let's use it. The instructions that follow show one procedure—I'm sure that as you start to use your frame, you'll think of variations in its use to accomplish special effects. I'm going to demonstrate the use of the frame with a metal chase and Masonite top—the procedure is essentially the same for the alternate frame with the wooden chase and cardboard top.

Securing the Hinge. I slide one end of the hinge down between the metal strip and the furniture. I began by placing the chase on top of the plywood and positioning the block to be printed in the middle of the chase. Then I surrounded the block with strips of wood—the furniture—until the block was hemmed in on all sides. I placed metal strips between the furniture and the chase screws.

Set-Up Printing Frame. Here's what the printing frame looks like after the hinge, furniture, and block are locked into place by tightening the chase screws. I've taken the whole thing off of the plywood base so you can see the furniture more clearly. Notice that the top stands up—it rests on the strip of wood that backs up the piano hinge. This is very handy. (The cardboard top will not sit up, but it will fold back out of the way.)

Inserting the Tympan Paper. Next, I tape a piece of typewriter paper across the cut-out hole in the frame top. This paper, which is called a tympan paper, will protect the back of the printing paper. I'll rub the tympan with the spoon to apply pressure to the printing paper underneath, on top of the block. I'll be less apt to damage the printing paper this way, and—more importantly—I'll be less apt to move the printing paper as I rub with the spoon. (Note that the frame has been placed back onto the plywood base.)

Inserting the Printing Paper. After I ink the relief block, I lay a piece of printing paper on top of it. Then I close the frame gently so the motion of the top won't blow the paper off the block.

Rubbing with a Spoon. I rub the upper surface of the tympan paper with a spoon to make the print. I move the spoon in several directions to avoid leaving white streaks on the print—first I rub up and down, then from side to side, then in circles. This is a good procedure to follow whenever you are spoon printing, whether or not you are using a printing frame. When I finish rubbing, I lift up the Masonite top and remove the printing paper slowly from the block. Please note that I could—and sometimes will—use brayers, barens, doorknobs, and other means of applying pressure in place of the spoon to print.

REGISTRATION

If you wish to locate the printing paper in exact register with the block, as you must do for multiple impression prints (such as multicolor work), you have to provide some means of positioning the paper. This positioning system has to be adjustable so that you can—by trial and error—find the exact place to position the print over a second block to register the impression of that second block with the impression made by the first block. Since this isn't necessary unless you're doing multi-impression work, I've left it until last.

CARDBOARD GAGE PIN
(3 PIECES—GLUED TOGETHER)

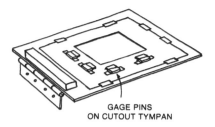

GAGE PINS
ON CUTOUT TYMPAN

Positioning the Gage Pins. I tape the tympan to the top as I did before. This time, however, I cut a hole in the tympan that just exposes the block I'm going to print. Next, I lay a piece of printing paper on top of that tympan paper and tape small pieces of cardboard—a printer would call them gage pins—to the tympan to locate one side and one end of this printing paper (as shown). Then I remove the printing paper. You can buy real gage pins from a printing supply house, if you prefer, but the homemade ones work.

COMMERCIAL GAGE PINS

Registration Set-Up. I now tape one end of a second piece of tympan paper to one end of the frame, so that it can be raised and lowered separately from the first piece—you can see the block through the hole in the tympan paper. Please note that the tympan paper is about the size of the printing paper that is going to be used. This printing frame is now set for accurate registration printing. The cardboard gages on the first tympan paper will locate the printing paper with respect to the block.

To use the frame set up for registration, I open the top and ink the block as before. Then I close the top part way and place a piece of printing paper against the registration stops (cardboard gage pins) on the tympan paper taped to the top of the frame. I can tape the printing paper in place if I wish. Next, I carefully lower the top the rest of the way, bringing the printing paper down against the inked block. I lower the upper tympan paper down onto the printing paper and rub with a spoon as before.

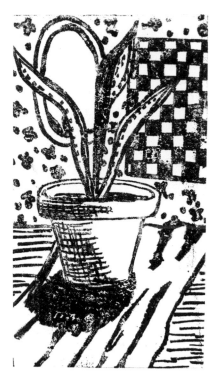

Still Life *by Deirdre Butash. Lithograph on linoleum, fragment, 4″ x 7″ / 100mm x 180mm. A busy design in which line patterns and directions establish horizontal and vertical surfaces, depth, and value while still respecting the picture plane. This print was taken fairly early in the edition and isn't fully inked. The resulting textures in the shadow and grid areas break up the darks and give them an affinity to the linear patterns that predominate. See Chapter 14 for a description of this method.*

When I'm through rubbing, I raise the upper tympan paper and then remove the printing paper by raising the frame top gently while holding the printing paper tightly against the top. I do as many prints with the first block as I want and then dry them. (I make more than enough, actually, in case some of the registered copies don't turn out correctly.) A few days later, when the ink is dry, I set up the printing frame again with the second block and a new sheet of tympan paper with a hole cut out that just exposes the block. I place a copy of the first impression on top of the second block in what I think will be the correct position for proper registration. Using the edges of the first impression paper as a guide, I place gage pins in the new tympan paper.

Then I raise the top of the frame, remove the first impression paper (leaving the tympan and gage pins in place), and ink the block. I replace the first impression paper in the gage pins, lower the top of the frame, lower the top tympan paper, and rub the back of the top tympan paper with a spoon. When this is done, I raise the top tympan paper and lift the frame top as before to remove the printing paper—which now has a double impression. Usually, the second impression isn't located exactly where I planned, so I decide how far the second impression should be moved with respect to the first, move the gage pins accordingly, and take another print. This is always a trial and error process, but I can usually get the alignment I want after two or three attempts.

The hinged Masonite top is rigid enough to make registration easy and accurate. The cardboard top will work also, but you must be careful as you raise and lower the cardboard not to twist it or to push it sideways. With proper care, you can get good registration.

PART TWO

PLASTER RELIEF TECHNIQUES

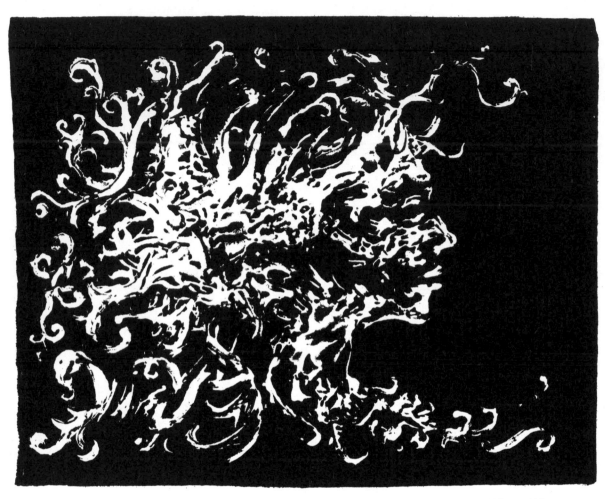

Medusa *by Nancy Greco. Cast plaster relief, 7½″ x 9½″/195mm x 245mm. This free and lively work shows the fluidity of design that's possible with the cast plaster technique. The artist used a mixture of oil-based printing ink and grease to make a brush drawing on a sheet of glass. Then she made a plaster casting of the drawing using the technique described in this chapter to form the relief block from which this print was made.*

CHAPTER 5

Cast Plaster Relief Printing

It is fitting that we start our study of new printmaking techniques with a relief process. Man has invented many ways to make images, but none are as uncompromising and as powerful as the relief print. Here black is black; white is white. Edges are sharp. Textures are usually coarse. Shapes are bold. The overall effect is hard, often harsh. But if you feel strongly about something, there's no better way to express yourself.

The traditional way to make a relief block is to carve into the surface of the block with knives and gouges. The muscle power required may influence the strength of the final design—carving a wood block requires the patience, skill, and strength of a sculptor. When the design is complete, the printmaker rolls ink onto the carved surface, inking those portions of the surface that haven't been cut away. Each cut he makes, therefore, prints white—it doesn't get inked.

In this chapter I'll show you how to make a relief block by making a plaster casting of an ink drawing. With cast relief blocks, you can forget the gymnastics of gouging and concentrate on the design. Like traditional relief methods, this technique is a white line process—every ink mark in your original drawing will print white. At first, this is a little difficult to understand, but if you think of your drawing tools as knives and gouges, I think you'll soon get the hang of it. You'll see that making cast plaster relief blocks is an easy process, far easier than cutting into a block. Making the casting is easy, too—it's easier to mix plaster than to mix a cake.

The cast relief print itself can be as simple or as complex as you wish. The more detail in your drawing, the more in your block and print. Correcting the grease-ink drawing copied from the original drawing is especially easy—you can change it endlessly before casting. And since the drawing process required is a little awkward, the final print will retain some of the crude strength—the accidents, if you will—of a carved block. Finally, printing a cast block is no more difficult than printing any relief block such as linoleum—in fact, you'll use the same tools.

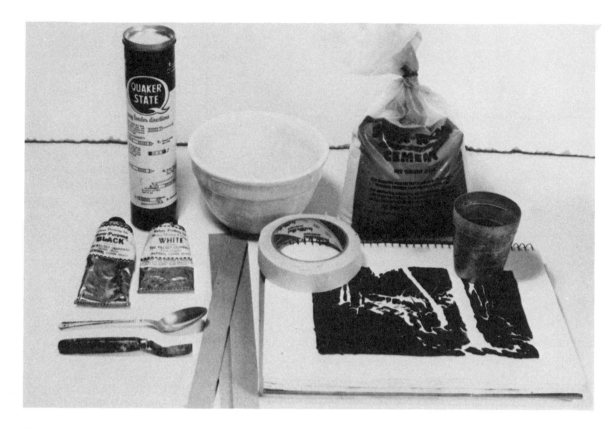

Tools and Materials. *I'll use these to make this cast plaster relief block and print (from bottom left and moving clockwise): sawed-off palette knife; spoon; tubes of white oil-based ink and black relief printing ink; tube of automobile grease; mixing bowl; bag of Por-Rok cement; my preliminary sketch, a brush drawing of woods—this is an area drawing rather than a line drawing because relief prints are area prints; measuring cup; roll of masking tape; and cardboard strips 1"/25mm wide.*

TOOLS AND MATERIALS

To prepare the block
A sheet of window glass or transparent plastic
Tube of white oil-based ink or paint
Multi-purpose automobile lubrication in a tube or can
Putty knife, palette knife, or a collection of brushes
Strips of cardboard 1"/25mm wide
Por-Rok cement or the equivalent
Mixing bowl
Masking tape, drafting tape, freezer tape, or the equivalent
Piece of wire screen (optional)

To make the print
Relief printing ink (see Chapter 2)
Paper palette or ink plate
Brayer
Spoon or the equivalent
Relief printing paper (see Chapter 2)

PROCEDURE

Now that we've assembled the materials, let's make a plaster relief block and print. First I'll show you how I do it, and then I'll suggest some simple modifications to the basic procedure. In the next two chapters, I'll show you other cast plaster relief techniques. But first, here's the basic process.

Step 1. I started by placing my drawing under the glass and

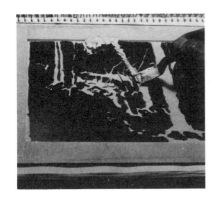

defining the borders of the print on the top surface of the glass with a line of masking tape. Now you see me making a copy of this drawing on the top surface of the glass using the sawed-off palette knife and a mixture of white oil-based ink and automobile grease (about ten parts grease to one of ink). Grease-ink has more body than ink alone, and it never dries—I can work on my drawing for a longer time—for weeks!—before casting it. Grease-ink is also cheaper than pure ink. However, pure ink (or pure grease) can be used without problem, and some people prefer it.

The whole process is analogous to carving a linoleum block—I'm cutting my block by laying down white grease-ink. Please note that you can use brushes, putty knives, sticks, and your fingers, as well as sawed-off palette knives, to lay down the drawing.

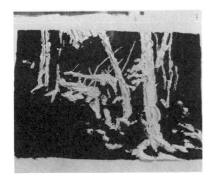

Step 2. The grease-ink drawing is complete—I have pulled away the masking tape, trimming the edges of the grease. The glass is still sitting on top of the original sketch. When the drawing is finished, the ink layer should be as thick as a dime at the edges and much thicker near the center of large areas of glass where you'll need greater relief in the final block. Thinner layers work too, but they generally print as textures instead of pure whites.

If I lose my way during this process, I can hold the glass and drawing up to a strong light in order to see the errors. I can scrape the glass clean at that point, and draw that area again more carefully. As you'll see, its much easier to correct this ink drawing than to correct a carved relief block.

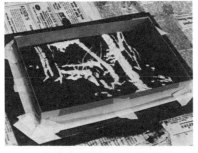

Step 3. Now I take 1″/25mm strips of cardboard and build a wall around the grease drawing with masking tape. I tape the cardboard wall to the glass, using masking tape, freezer tape, or the equivalent. When you do this, be sure to tape it down at all points so water you'll use later can't leak under it. Pay attention to the corners—I always finish by adding two or three extra pieces of tape at each one.

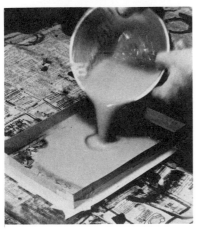

Step 4. When the wall is finished, I mix my plaster until all the lumps are gone—I use my fingers for the final stirring—and then I pour the plaster into the cardboard frame over the grease drawing. I don't dash it in from a great height, but I don't have to be extra cautious either. The plaster flood won't wash away my grease drawing.

I prefer Por-Rok cement as plaster because of its strength and hardness, and because it shrinks much less than conventional plasters. The mixture must be watery in spite of the manufacturer's instructions to the contrary. I use 1 cup of Por-Rok powder and ½ a cup of water for each 20 square inches/13,000 square millimeters of drawing (approximately). My cardboard wall in this case encloses an area measuring 6″ x 8½″/150mm x 220mm (51 square inches/33,000 square millimeters), so I use 3 cups of powder and 1½ cups of water.

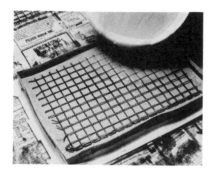

Step 5. This next step is optional. I use it only when I expect that the final block will have to stand a lot of abuse (if it's going to be handled and/or printed by a large class, for example). I mix about two-thirds the amount of plaster I would have mixed in the previous step and pour it into the box as before. I wait half an hour and then lay a piece of wire screen on top of the still-wet plaster. Next, I mix the other third of my plaster and pour it over the screen. The screen imbedded in the block gives the block extra strength.

Whether I use the screen or not, I let the block sit for two or more hours after the final pouring. If the weather is cool or damp, I set a gooseneck lamp over the block to bake it gently. This speeds drying but isn't essential—the block will dry eventually without heat. Don't move the block during this period. Let your plaster settle down quietly over the grease and glass.

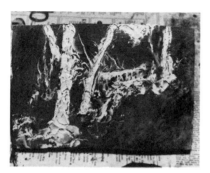

Step 6. When the plaster is hard, tear off the tape that holds the cardboard in place and pull the block away from the glass. Sometimes it sticks a little, but it will come. Turn it over. The photo shows what mine looks like—it's a mess, coated with grease and ink. But—wherever there is oil-based ink or grease, there is a depression in the surface of the water-based plaster. The plaster didn't displace the ink, so my drawing has been reproduced.

I use a palette knife or spatula to scrape most of the grease from the block. The grease goes back in the can. Even though it's mixed with white ink, I can reuse the grease I save for my next block and for many more after that. Be careful not to scrape away details in the plaster—be gentle.

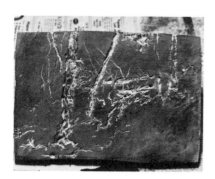

Step 7. Here is the cleaned block. After I salvaged as much grease-ink as possible, I used first paper towels or a cloth and then solvent to wipe more grease from the block. Type cleaner or turpentine is best, but waterless hand cleaner also works. It's not necessary to get all the grease off, but it's best to remove most of it. As a final step, I washed the block with dish detergent and warm water, peeling the cardboard away from the edges of the block at the same time. I used my fingers to break any sharp edges of plaster around the border. When you get to this point, be sure to do this—if you don't, plaster pieces will break off and stick to your brayer when you ink the block. And inking is the next step.

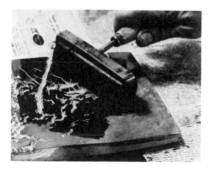

Step 8. I use a brayer to ink the block. If you find that ink is deposited on supposedly cut-out areas or spots you want to keep clean, use wood or linoleum tools to cut away portions of the plaster. These tools allow you to correct the block by "adding white." You can also use them to carve fine details or textures in the casting.

When the block is inked, I lay a piece of paper on it and rub the back of the paper with a spoon or baren. The first

print may be a little faint—it sometimes takes two or three inkings to break in a new plaster block. But I think that you'll find that the printing process is as easy as brushing crumbs off your stomach.

Step 9. Here's the final print. It's not an exact copy of my original drawing, but there's certainly a family resemblance. The print is black and white (like a relief print should be!), while the drawing had some gray areas. But I've made enough prints to know that the best ones are not copies of drawings—they're printlike prints! I don't see the need for any carving here, so the block is done.

One final point of interest. This print is *not* a reversal of the image of the original sketch that I taped to the back of the glass. Rather, the design in the poured plaster block is really a mirror image of the *drawing* on the glass; and the impression I have just taken on paper is a reversed print of the *block*. This double reversal gives me a final print that faces the same direction as the original drawing, another reason why plaster prints are easier to visualize and control than more conventional relief prints on linoleum or wood.

FURTHER SUGGESTIONS

None of the techniques described in this book is fixed and final—there are different ways to do most of these processes. I'll try to suggest alternate procedures and/or extensions of the basic process/at the end of each chapter to open your eyes to some of the other possibilities. Here are a couple of things you can try with plaster:

1. Copy a photograph or found object instead of a drawing.

2. Draw directly on the glass—instead of placing a design under glass and then copying it, as I did with the example, try taping a piece of plain black paper to the glass. Then, create a drawing on the glass without having a preliminary sketch to guide you. Remember, every ink mark you make is the equivalent of a knife cut in a linoleum block. This direct approach is more difficult than the one I used in the demonstration, but many artists feel that a preliminary drawing steals some of the life and directness from a relief block. With plaster, of course, you can correct your drawing before casting the block.

CHAPTER 6

Plaster Collagraphs

There are many things you can do with cast plaster besides the simple, basic process described in the last chapter. Here's another basic technique—the plaster collagraph—in which you'll use the plaster to bond together a number of found objects to make a printing block.

The collagraph is the printmaker's version of the collage. The artist who makes a collage collects things—pieces of paper, cloth, found objects—and glues them to a canvas or board to make an image. I believe that the cubists were the first to do it; it's been part of the art world ever since. The printer who is making a collagraph collects the same kind of objects and materials as the collagemaker and glues them down. But he then inks and prints the resulting surfaces, using either relief or intaglio methods, to produce the final image. In this chapter I'll use plaster instead of glue to hold the objects to be printed, but otherwise the results I obtain will be similar to those achieved by conventional collagraph procedures. You can also combine techniques for making plaster collagraphs with other plaster techniques to obtain prints that could never be achieved with conventional collagraphs.

Collagraphs can help us escape from ruts we have fallen into. As you probably know, there are places in the West where the wagon tracks of the 49ers can still be seen. Everyone going West followed the same tracks until the ruts became deep enough to last 125 years. We behave like that as artists, too. We find a design or technique we like, and we repeat it until it becomes our style, then our formula, then our rut. If we don't periodically break our own patterns, we become permanently mired in our ruts and cease to develop as artists.

When you begin collecting interesting objects for their own sake, without a definite composition in mind, you'll find your eyes reopening to new images. You haven't started designing yet—you're just collecting, relaxed and unbiased. As you assemble and manipulate the objects, play with them—you'll see compositional possibilities that you would probably never have found by imagination alone. Chance, accident, nature, whatever, are forcing you off your normal path. Even if you don't make collagraphs regularly, they're invaluable once in a while as an exercise—they jog the mind out of those ruts.

The plaster collagraph, as opposed to the glued type, helps you print awkward things, such as very small objects, very irregular objects, and objects of vastly different

Composition *by Michael Augeri. Cast plaster collagraph, 5" x 7½"/125mm x 195mm. This print illustrates a second way in which cast plaster can be used to make printing blocks. A number of found objects and jigsawed pieces of wood were placed upside down on a piece of grease-covered glass and were bonded together with wet plaster. When the plaster hardened, the objects were inked and printed as a single block. This technique makes it possible to assemble and print objects of widely varying thickness.*

heights, that you could never print by conventional colla-graph methods using glue. Plaster allows you, for example, to assemble and print metal or wood type alone or in conjunction with other objects without a printing press.

TOOLS AND MATERIALS

I'll use most of the same material I used in Chapter 5 (see page 50) for this demonstration, since this is still a cast plaster process. One item that I will not need, however, from the material in that chapter is the white printer's ink. I'll use plain grease this time.

PROCEDURE

I'll use three objects to demonstrate the plaster collagraph technique. Each object is a graphic object, and each, to some extent, is manmade. I want you to realize, however, that you could use the same process to combine and print all sorts of things—rocks, bottle caps, pieces of rubber, nails, cloth, and so on. Since the plaster process makes differences in thickness between objects irrelevant, and since the plaster will grab hold of any object regardless of its shape, you can use the technique with almost anything you want to print.

The print I'm going to make as a demonstration won't live up to the speech I've just made on ruts. The collection of objects I'm about to work with is not, I'm afraid, very imaginative. But I think it's always best to keep demonstrations of basic concepts fairly simple. I have assembled a thick blocky object, a thin object, and loose type for this print—they should give you sufficient scope to try almost anything.

Now let's go ahead and make a plaster collagraph.

Step 1. First, I assemble the objects I'm going to use—the picture block on top made by the cast plaster technique described in Chapter 5, a collection of metal type held together by an elastic band, and a fir twig glued to a piece of jigsawed plywood. The twig was too thin to cast directly; hence the plywood base. The objects have different heights and are irregular in shape. They are made of wood, metal, and plaster. Yet they'll end up as one homogeneous relief block.

Step 2. After outlining the borders of my print on a sheet of glass with masking tape, I use a putty knife to coat the entire surface of the glass within the tape with a fairly thick layer of grease. Since the grease must be thick enough to prevent the wet plaster from reaching the front surfaces of the objects to be printed, its thickness depends on the depth of relief in the objects. I'll need about ¼″/7mm of grease here. Note that I'm using plain grease—it's not necessary to mix the dark grease with white ink this time, as there's no danger that I'll get lost while drawing.

Step 3. I set my objects upside down in the dark grease, pushing the picture block and the fir twig down by hand until they touch the glass. I use a block of wood to push the type down so that each piece of type will end up level with the others. I should mention that I previously determined the approximate placement of the objects by making some rough compositional studies. One way to do this is to print each object separately in advance, arrange the separate, crude prints on a piece of paper again and again until you find a desirable design, and then proceed with making the plaster block.

Step 4. This is my final block—to cast it I followed the same procedure illustrated in Chapter 5, Steps 3–7. The only difference was that I used a 1½"/40mm cardboard wall this time because of the height of the type—otherwise the process was the same. I removed the masking tape from the glass, taped a cardboard wall to the glass, mixed and poured the plaster over the grease and my three objects, let the plaster dry for a couple of hours, removed the block from the glass, and cleaned it. Note that the three objects are all on the same level in the final block because they were all pushed down against the same glass surface before casting. This is one big advantage of the plaster collagraph over the glued kind, where levels that vary a lot are difficult to print.

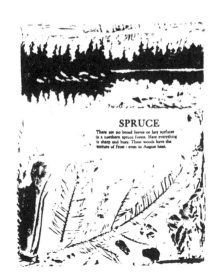

Step 5. Here's my first print. I used a brayer to ink the block, and there are several things I don't like about the resulting print. Too many spots show in the background—perhaps I should have used more grease to produce deeper relief. Also, the partial border wasn't part of my intended composition. The fir twig hasn't printed at all well—the brayer didn't do a good job of inking this irregular surface. Furthermore, the paper slipped as I made the print, blurring the type. So—I have a lot of work to do.

Step 6. Using a linoleum gouge, I cut away some of the high spots in the background, including the border. The fresh plaster carves just as easily as a linoleum block, so this repair work is easy to do. After correcting the block, I'll try to develop the printing process a little in order to eliminate some of the other problems uncovered by my first proof.

It's not at all uncommon for the first proof of a new block to be unsatisfactory. The block—and the printing process—almost always requires development. This may come as a surprise to you—the finished block seems so final, I suppose. But blocks can and usually should be altered and improved to achieve the results you were after in the first place.

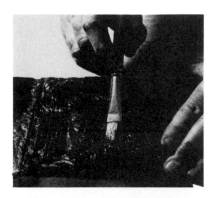

Step 7. When I'm ready to take another print, I ink the fir twig with a brush, first mixing some Damar varnish with the ink to thin it to the consistency of watercolor. I ink the rest of the block with a brayer, as before. After I finish, I wipe portions of the background that are still picking up ink. I will cut these areas away later, but I want to take another proof first.

Step 8. I lay a sheet of paper down on the block, supporting one end of the paper on a pile of blocks. By leaning on one end of the paper this way as I lay it down, I am less apt to move the paper as I handle it, and am therefore less apt to blur the type. This, incidentally, is a good procedure to follow for any spooned print.

Step 9. I use my fingers to print the fir twig, molding the paper down, into, and around the needles to get a more intimate contact than I could with a hard spoon. Since the twig has been inked with very soft, thin ink, light pressure is sufficient. I print the rest of the block with the spoon. During the whole process, I clamp the paper against the block with my right hand, as shown in the photograph, still guarding against slipped paper and a blurred image.

SPRUCE

There are no broad leaves or lazy surfaces in a northern spruce forest. Here everything is sharp and busy. These woods have the texture of frost - even in August heat.

Step 10. Here's my next print—not a masterpiece, but certainly an improvement over the first print in Step 5. It's difficult to get a perfect print of type on a block when you're printing with a spoon, but with care you can get an impression that's good enough for most purposes. It's easier, incidentally, if the type is surrounded by other printing surfaces—other materials—rather than isolated as in this print. This particular block would also have been easier to print if I had mounted it in the printing frame—the frame helps reduce the slipping problems, as you'll see in Chapter 8.

When I am through with this block, I can break the plaster apart with a hammer and screwdriver or chisel and recover the metal type for use in another block without too much difficulty.

Mask *(Above) by John Bickford. Cast plaster collagraph, 6"x 8"/150mm x 205mm. I used a jigsaw to cut shapes from several different materials to form the block from which this print was made. I cut the headpiece from a plate of linoleum—I've printed the burlap back of the plate. Then I made the jaw from a piece of plastic with a pebbled texture. The right-hand cheek is a piece of old wood with a very coarse grain. The items were assembled upside down on lightly greased glass and then bonded together by casting them all in plaster. To add additional texture, I printed the block on a sheet of newspaper.*

The Mountain *by John Bickford. Cast plaster collagraph, 6" x 8"/ 150mm x 205mm. Collagraphs are normally used to produce geometric or abstract prints, but they don't have to be used for nonfigurative images. The coarse-grained wood that formed the cheek of my* Mask *above becomes a sky in this print; the pebbled plastic used for the jaw becomes the shoulder of a mountain. The blacks are plain glass (where there wasn't any grease). The pure whites on the mountain are formed by laying plain grease on the glass as in Chapter 5.*

FURTHER SUGGESTIONS

Here are some other things you might try to make your collagraphs more interesting:

1. Cast the impression of an object rather than the object itself. In Step 3, I pushed the three objects down into a layer of grease and left them there to be cast in place. Instead, I could have pushed them down into the grease until they touched the glass and then removed them from the grease before pouring the plaster. I would then have cast and printed the *impression* the objects had made in the grease, rather than cast and printed the objects themselves. Most objects won't reproduce very accurately this way, but the accidents and textures produced by casting an impression are often exciting distortions of the real thing.

2. Cast found objects separately; then assemble and cast them again to form a single block. You can cast anything you can build a wall around, from the surface of a sidewalk to the bark on a fallen tree. If you can't tape a cardboard wall to the found object, surround it with a thick ribbon of grease and embed your cardboard wall in that. The grease will prevent the watery plaster from leaking under the wall. This way you can cast all sorts of found objects and textures you couldn't bring into the studio, assemble them separately, and cast them again on a single piece of glass. Just press the castings into a thick layer of grease on top of the glass and pour on the plaster—the plaster will hold the previously cast blocks together.

Goat by John Bickford. Cast plaster relief, 7″ x 8″/180mm x 205mm. I created the textures here with a brush and brush handle—I was able to work on the design for hours since grease-ink is a very workable medium and never seems to dry.

Creating Textures on Plaster Relief Blocks

CHAPTER 7

Now that you've used some basic plaster techniques, you're ready to try something more complex, such as manipulating the grease-ink drawing on glass with different tools to get tones. Each tool or process leaves a distinctive mark that is faithfully reproduced in the cast plaster. By spotting, wiping, daubing, scraping, painting with sticks, knives, pieces of cloth, fingers, and brushes—and so on—you can produce rich and satisfying blocks and prints. In this chapter I'll show you a few of the possibilities. Then, since this will be the last chapter devoted to plaster relief printing, you'll be fully launched.

TOOLS AND MATERIALS

In addition to the materials listed in Chapter 5, page 50, you'll need a few more to make the design—rolled paper stumps, typist's correction fluid, and chapstick.

PROCEDURE

You can simulate tones to some extent in relief prints by casting and printing a variety of textures. I'll show you how in this chapter. Remember, though, that these processes never produce muted or subtle tones—they always have the strength and boldness that is associated with relief prints in general. You'll see what I mean when I print the demonstration block. I don't mean to imply that there's anything wrong with bold textures, delicate tones, or any effect. I just don't want you to spend a lot of time trying to cast and print delicate tones with relief blocks—the two don't go together. The plaster is too soft and grainy to support fine textures, and its relative softness forces us to use relatively crude relief printing techniques. If you want soft tones, you should use the intaglio and lithographic printing methods described in later chapters.

Now let's see just how much tone you can get with texture in a relief process. I'll show you how to make different sorts of textures with the additional tools mentioned above, and then, once your grease-ink design is completed, you'll cast the relief block following the procedure described in Chapter 5, Steps 3–7. Then you'll roll ink onto the cast surface and print any spot, line, or area that's high enough to touch the inked brayer. Everything that prints will print a

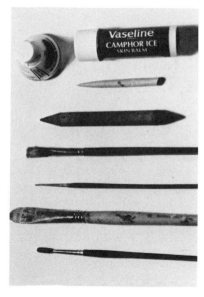

Tools and Materials. *Besides the basic tools and materials shown in Chapter 5, page 50, I'm going to use the things shown here for this demonstration (from top to bottom): large chapstick (Vaseline Camphor Ice); bottle of typist's correction fluid; 2 rolled paper stumps normally used to blend charcoal or pastel drawings; and various brushes.*

61

full-strength black—unless you use diluted ink, you won't get gray tones.

Step 1. Here's my preliminary drawing—I had an awful time making this. My original sketch was too simple; dull. I corrected it repeatedly by gluing pieces of clean paper to certain sections and redrawing them, by using white tempera and bits of paper to add small white touches, by darkening other areas with charcoal and ink, and so on. The result is a mess—it's three or four layers deep in some places. But one of the nice things about printmaking is that much of the strain and struggle of composition is invisible in the final product—take a look at the final print in Step 13.

Step 2. I've taped my preliminary study to the back of a sheet of glass and placed masking tape on the front surface of the glass to define the boundaries of the final print. In this photograph I'm drawing the foliage with grease-ink and a soft, round brush in the upper left corner of the front surface of the glass, using my preliminary sketch as a guide. I lay down a fairly heavy coating of grease-ink here because I want an untextured white for this section of foliage.

Step 3. Dipping the bristle brush in the grease-ink, I daub it repeatedly against the glass, leaving a relatively thin but textured layer of grease to establish the foliage in the upper center of the drawing. I must be gentle—if I stab too hard, I leave a thin, flattened coating of grease with little or no texture which will print all white or all black depending on the height of surrounding areas and on the type of brayer used.

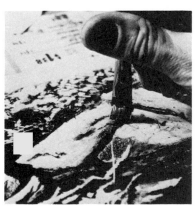

Step 4. Now I'm making the texture that will establish the shadow areas in the rocks, using the same bristle brush and grease-ink I used in Step 3. This time, however, I manipulate the brush differently to produce a finer texture. When you draw with grease-ink, you must become aware of the *upper* surface of the grease-ink coating you produce on the glass. This is the surface that will be cast and printed. If it's smooth, the casting will be smooth; if rough, the casting will be rough. By varying the pressure of the brush, the amount of grease-ink on the brush, and the motion of the brush—daubing, twisting, dragging, etc.—you can leave many different textures in the grease. So don't just stab—look!

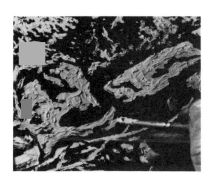

Step 5. After creating the shadows on the rocks, I lay a heavy layer of grease-ink over the white areas, using the soft, round brush again. I bring the heavy layer over the edges of the shadow areas and make it thinner to avoid a dark line at the point where shadow meets light. Remember—plain glass prints black. I always follow this sequence before putting in the lights after doing the textured areas. (The textured areas of grease in the shadows are relatively thin—for this reason they don't show in this or in the following photos, but they're really there.)

Step 6. I use a chapstick to draw the reflections of the large rock in the water. The greasy chapstick leaves a castable mark if I rub it back and forth several times. Even then it doesn't leave a very strong mark, so it's well suited to reflections. You can see now that you aren't restricted to grease and ink—you can use any material that sticks to glass but not to wet plaster for the drawing.

Step 7. Here's another drawing material—typist's correction fluid. I'm using it to make some of the finer branches and sticks in the water. I have to repaint each stick a couple of times as one coat is too thin to make a clean white mark in the final print, and all the coats must be dry before you pour on the plaster. But it's easier to paint fine lines with this material than with grease. Artists' oil paint would work well for fine lines like these sticks also.

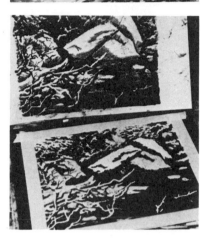

Step 8. When the drawing on the glass is nearly complete, I remove my original sketch from the back of the glass and compare it to my grease-ink drawing. (I have placed a sheet of black paper under the glass to help me see that drawing.) Now I can easily find small differences between the two drawings and can correct the drawing I'm going to cast. As you can see, the grease-ink drawing (bottom of the photograph) is a reasonable copy of my original sketch (top).

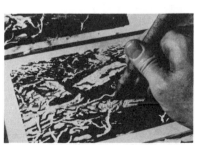

Step 9. Rolled paper stumps are good for removing grease-ink from the glass to make any corrections. I'm using a large (dirty!) stump here to reduce the width of some of the fallen branches. You could use a spindle made of facial tissue or paper towel wrapped around a brush handle instead of the stump, but the stump does a superb job. After I finish correcting the design, I use a brush handle to scratch some lines for texture into the larger logs lying in the water. Then, when I'm satisfied with my grease-ink drawing, I build a cardboard wall around it and cast it—see Chapter 5, Steps 3–7 for directions. This time my drawing measures 7″ x 8½″/180mm x 220mm, so I need 3 cups of Por-Rok cement and 1½ cups of water.

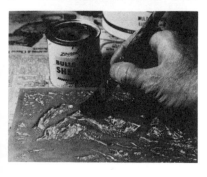

Step 10. When the plaster is clean and dry, I give it a coat of shellac to produce a harder surface, which protects some of the finer textures. The shellac, however, may also fill in some of the finer details, so this step is a calculated risk. It's not essential, butI think it's a good idea for a textured print.

Step 11. I let the block set for several hours—several days is even better—so the plaster and shellac harden. Then I make my first print—here it is. As usual with my proofs, there are several things I don't like: the shadows in the rocks aren't dark enough; the white areas in the rocks are flat and uninteresting; and there's a black band, containing no foliage, that outlines the rocks. As a result of all this, the rocks are isolated from the rest of the composition; they're like a couple of marshmallows floating in a puddle of ink on a textured background. Also, most of the water reflections aren't strong enough to be useful in the composition. I didn't apply a deep enough layer with the chapstick (and/or I partially buried this texture with the shellac). So—I must develop the block, which is normal procedure.

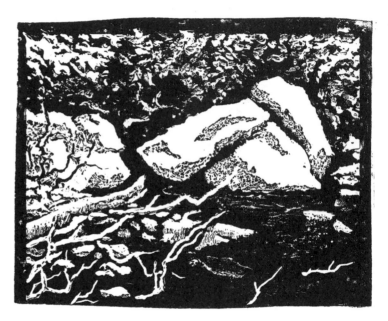

Step 12. To make the rocks more interesting, I must add black areas as follows. First I clean the block and let it dry. Then I mix ¼ cup of Por-Rok cement with ⅛ cup of water and use a spoon to puddle a little wet cement into the rocks. I don't fill the holes completely—I just make them shallower. Then I wipe a little fresh plaster over the shadow areas in the rocks with my finger, partly filling the textures there. After adding the wet plaster and before it dries, I drag the edge of a piece of cardboard across the surface of the block, wiping away any wet plaster that sticks above the original surface.

When the fresh plaster in the rocks is dry, I carve a texture in it with linoleum cutting tools, since I don't want to make the white rocks black—I just want to add some texture. I also use linoleum tools and scribers to strengthen some of the water reflections and to add some foliage around the rocks, breaking up the black border that isolates them.

Step 13. Here's my final print. As you can see, the rocks are now textured. This makes them more interesting and helps to tie them, visually, to the rest of the composition. The rock shadows are darker, too. Wiping them with plaster helped, but I also used a narrow (1″/25mm wide) brayer to add some extra ink to this area after inking the entire block with a large brayer. The extra ink partially fills these textures so they print darker. Incidentally, I've also masked the black border around the block before making this final print.

The result is a relief print with a fair amount of texture and detail. The work done in correcting and developing both the original study (Step 1) and the cast block was of critical importance in achieving the final image. When you make your block, don't give up too soon and neglect this hard part of the job. Also, please note that all the texture does *not* add any softness to the print—it's still strong and bold.

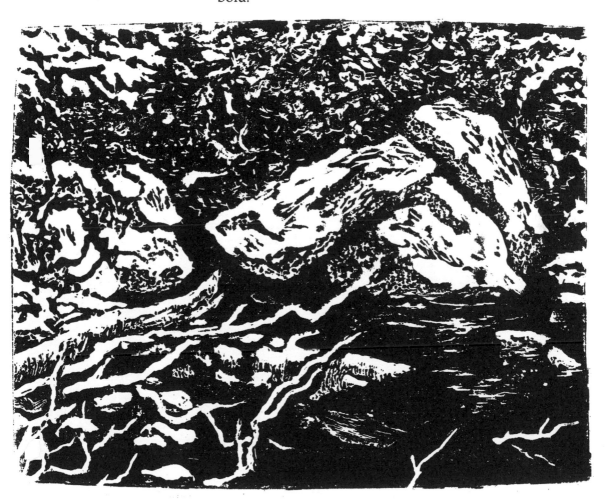

Growth *by Gail Edmonds. Cast plaster intaglio, 6″ x 8½″/150mm x 220mm. The artist made a plaster block that she wasn't happy with. To develop the work, she tried different methods of printing, arriving finally at this interesting result. To make this print, she used a putty knife to scrape white oil paint into the depressions in her block (a techinque described at length in Chapter 8).*

FURTHER SUGGESTIONS

If you've followed my previous suggestions, you've now cast both simple and complex drawings; you've embedded found objects in plaster and printed collagraphs; you've cast the impressions left by found objects; and you've assembled and cast separate castings into one block. There's not much more I can suggest. I first used cast plaster in printmaking a few months ago, and I've told you about most of the tricks I've had time to try. I'm sure that there are hundreds of other materials and methods that could be used to make the drawing from which the block is cast—finding them is up to you. Here are some ideas:

1. Anything that will stick to glass and will either dry (as the typist's fluid did) or not mix with the water-based plaster (like theegrease, ink, or chapstick) is castable. Try various types of paint or glue, rubber cement, Plasticene, and clay. If you glue pieces of cloth or paper to the glass, you'll probably have to oil them lightly after gluing them down to prevent them from sticking to the plaster.

2. You can get some very interesting textures if you use a leaf, a bunch of grass, or a fir twig as a tool. Just dip them in grease-ink and daub and wipe them on the glass. Use other found objects the same way.

3. Try heavy liquids such as oil, molasses, or tusche—or anything else you can think of. You should be able to take cast plaster relief printmaking a lot farther than I have.

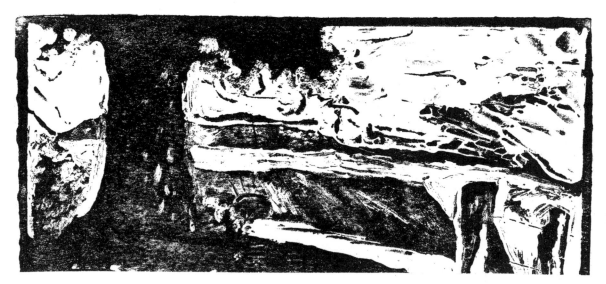

Landscape *by Micahel Augeri. Cast plaster relief, 4″ x 9″/100mm x 230mm. Another lightly inked plaster relief. This one, I think, has an almost Gauguinlike feeling caused by strange shapes that derive their texture from the surface of the block. The general proportions and the border that nearly—but not entirely—encloses the composition add to the Gauguin effect, I suppose. And how dull it all might have been if it weren't for the construction marks in the sky!*

PART THREE

ENGRAVING AND ETCHING TECHNIQUES

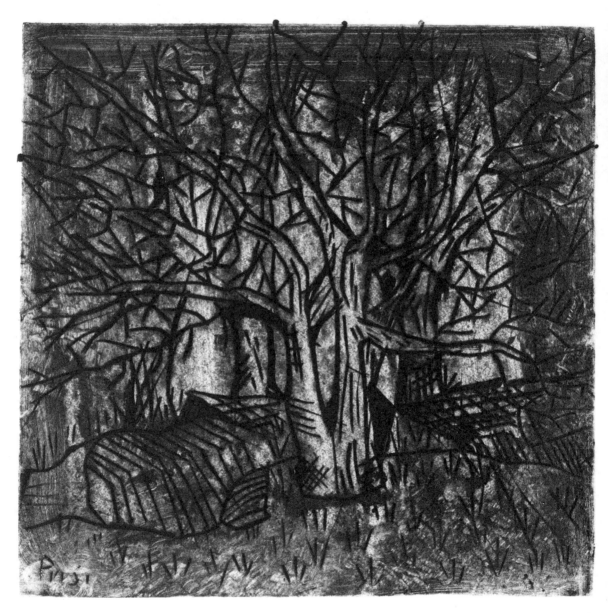

Trees and Rocks by Priscilla Ballaro. Linoleum engraving, 6″ x 6″ / 150mm x 150mm. I've selected this work for your introduction to intaglio printmaking because it's a tonal work, a departure from the examples in the previous chapters. The tones depend on clusters of lines and on the amount of ink left on the block by the printmaker. A considerable range of tone is possible, as the examples in this and the next chapter show.

CHAPTER 8

Engraving on Linoleum

In the previous chapters you cast designs into plaster, inked the raised surfaces of the final block, and printed. In this chapter you'll try a new block material— linoleum —and a new printing technique—intaglio. The results will be entirely different from those achieved with plaster and also from those you may have achieved in the past with conventional linoleum blocks.

Essentially, engraving—an intaglio process—means scratching lines into the surface of a plate or block. You fill in the scratches and cuts in the surface of the block with ink and wipe or scrape the areas between the lines (the surface of the block) clean. Then you apply pressure to force the paper down into the lines to capture the ink trapped there. Intaglio printing is basically the opposite of relief printing, where you ink the top surface of the block and keep the cuts and low areas clean.

The engraving process is easier to understand than most of the other methods discussed in this book. Just remember that the one main difference between drawing an engraving on a block and drawing with a sharp pencil on a piece of paper is that the tools used to draw an engraving have sharp metal points and scratch the surface of the block rather than just leave a mark on paper. The result—when you use a light-colored linoleum block— is a series of dark cracks and crevices in the light (painted) surface that describe almost exactly the image that will appear on the final print.

You may find intaglio printing a little more difficult than relief printing, but the results—which are entirely different—justify the effort. The typical relief print is a very bold proposition with lots of heavy black areas, no shading or gradations, and sharp edges. If there are black lines, they tend to be chunky and coarse. The typical engraving, on the other hand, has fine lines like wires or threads and areas of tones built up with lots of lines placed side by side or scrambled together. Because of the tones and the nature of engraved lines, these prints have a delicacy—and often a precision—not often found in relief prints. Unlike relief, engraving is a black line process, where every cut prints black and uncut areas print white.

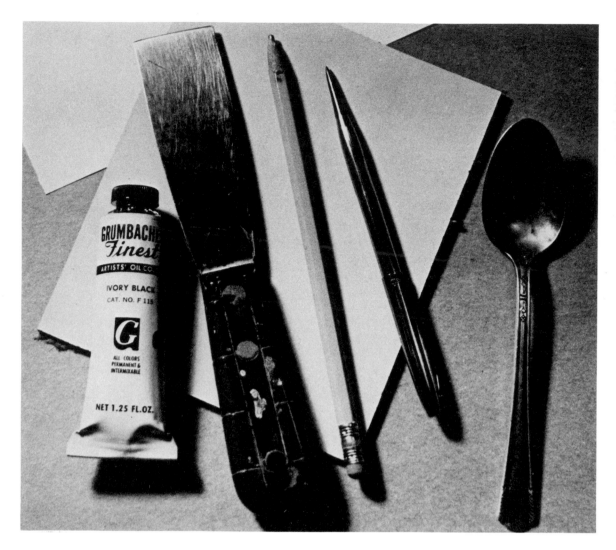

Tools and Materials. *Here are most of the things I'll need to make and print an engraving on linoleum (from left to right): typewriter paper (bond); artist's linoleum, painted and unmounted; artist's oil paint; putty knife; a tungsten scriber; and a spoon.*

TOOLS AND MATERIALS

To prepare the block
Sheet or block of artists' linoleum with yellow (lacquered) surface
Pencil and drawing
Tungsten carbide scriber or another sharp instrument
Camel's hair brush
Elmer's glue or the equivalent
Piece of plywood same size as the piece of linoleum

To make the print
Putty knife
Spoon or an engraving press
Artists' oil paint (used instead of ink)
Paper palette or ink plate
Kleenex
Intaglio printing paper (see Chapter 2)
Soft brush
Printing frame (optional)

PROCEDURE

Now watch as I make a linoleum engraving, using the tools and materials I've just listed. I'll do a portrait study.

Step 1. I'm dressing, i.e., preparing, my putty knife by holding the blade vertically and dragging it across a piece of fine emery cloth a few times to remove any burrs that might leave streaks of ink on the surface of the block later. Please note that flexible knives work a little better than rigid ones but either can be used. And a 1"/25mm width is ideal—wider knives don't clean the block as well.

Step 2. Here's my drawing of a head on a piece of artists' linoleum that was coated with yellow lacquer so I can see what I'm doing as I draw and scribe fine lines. I could have used a block—linoleum mounted on plywood—but I prefer to work on sheet material and glue it to wood later.

When you do this, don't try to show every line in your preliminary drawing on the block. An engraving contains so many lines it would be tedious, if not impossible, to make an exact transfer of each line. Draw the main outlines, indicate the shading, and do the rest with scribers.

Step 3. I'm scratching fine lines into the surface of the linoleum with a tungsten carbide scriber. See Chapter 2 for other possible "line" tools—engraving is a line process and the design tools should be compatible with the cutting tools. I hold the tool with one hand while I push it along the plate with the forefinger of my other hand. This trick prevents the tool from jumping ahead suddenly so there is less chance of error. I clamp the linoleum to the table with the heels of my hands while I engrave it—there's no need for a bench hook or vise. For free-hand textures, just scratch away with the tool held in one hand.

Step 4. My block is now partially engraved. When it's finished, I'll brush a camel's hair brush over the surface to remove the chips. Then, since I'm going to use a printing frame, I'll glue it to a piece of plywood with Elmer's glue or the equivalent. As I mentioned earlier, the printing frame isn't essential—I could print this plate as is. The printing frame just makes the process easier and less tiring.

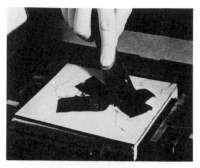

Step 5. After I clamp my engraving in the printing frame, I spread a heavy coat of artists' oil paint with the putty knife as if I were spreading jam on a piece of bread. Oils are *much* easier to clean from the block than printer's ink. The whole secret of linoleum engraving lies in the process of inking the block: if you don't leave enough ink, or paint, in the lines, they won't print (or will actually print white); and if you leave too much ink on the flat (relief) surfaces of the block, the background tone will be too dark and will conceal printed lines. You must learn to leave just enough ink.

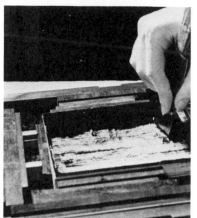

Step 6. Holding the putty knife erect, I scrape most of the ink from the surface of the block. I wipe the putty knife on the palette once in a while to recover most of the ink originally spread on the block in order to use it for subsequent prints. Once I've cleaned most of the ink from the surface, I go over the block again, this time bearing down hard. Be sure to hold the blade of the knife nearly vertical to pick up the ink—you'll be surprised at how much you can remove from a cleaned plate if you really try. If all you get is streaks, dress the knife some more on sandpaper or emery cloth (see Step 1).

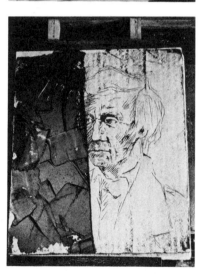

Step 7. Here's my block after half of it has been scraped. The image I've scribed in the surface is now clearly visible again. When I finish scraping, I will be able to print. However, the scraping process leaves the background mottled. Since I don't like this background texture, which is caused by faint irregularities in the surface of the linoleum, I'll remove that mottled effect before printing the block.

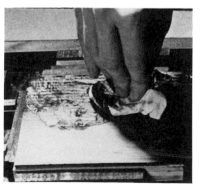

Step 8. I wipe the surface of the block with a paper towel gently—you could use Kleenex, your fingers, or a combination—to produce a more uniform background tone. If I'm too rough as I wipe, I may leave the finer lines gray and the heavier lines white. By the time I've finished gently stroking the surface of the block, I can see every line—and almost every tone—I'm striving for.

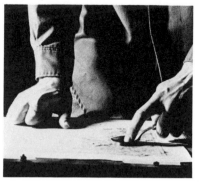

Step 9. Here's my block, ready to be printed. It resembles the print it will make closely, although the block will almost always be a little darker than the print and the image on the print will be reversed. At this point, I'll lay a piece of dampened printing paper on the block, put a piece of tympan paper on top of that, and close the printing frame. When you do this, if you don't use a printing frame, just lay a piece of dry newsprint over the printing paper. Please note that lightweight paper, such as typewriter paper or Japanese rice paper, works well—you must dampen all paper except tissue-like Japanese paper before printing an intaglio. Either follow the directions in Chapter 2 to do this or use a soft brush dipped in water.

Step 10. I rub the back of the tympan paper (or the newsprint if I don't mount the block in a frame) with a metal spoon, somewhat as if this were a relief print. This time, however, I must push down hard and rub until my finger starts to smoke! The printing paper must be forced down into those fine lines to reach the ink. It won't get there unless the paper is soft and pliable (hence the use of dampened paper) and unless I push hard. I could also use an engraving press (see Chapter 3, page 39)—most of the other inexpensive presses discussed in that chapter will not work well here.

Step 11. Here's my first print. It matches the wiped block from Step 9 closely—and you can see that the print is a mirror image of the block. Note the ways in which this engraving differs from a typical relief print—look, for example, at the intersections and groupings of fine lines and at the toned background. Since it's difficult to wipe all of the ink from the relief surfaces of the block before printing, intaglio prints often have a toned or softened background—which I think is one of their most attractive features.

Frankly, I don't like this print very much. Like many artists' proofs, it reveals weaknesses in the block. The darks aren't dark enough, the chin needs further work, and the background is overly dark. I'll have to work on the block some more and do a little more wiping next time.

Step 12. This is a later print, after further development. There's now an acceptable contrast between lights and darks, which I achieved primarily by selective wiping of the background and lines and also by scribing additional lines for shading as needed. To improve the contrast further, I reduced the intensity of the lines that define the clothes and the top and back of the head by wiping these areas heavily with a paper towel. I also wiped the figure's left cheek by dipping my forefinger into a little ink before wiping to soften and blend the lines and darken the cheek. The result is a much wider range of tones and a much softer print than I could have obtained with conventional relief techniques.

Note the extent to which this final print has been im-

proved by alterations in the printing procedure as well as in the block. Nothing distinguishes advanced printmaking from the linoleum-block school level printing as much as this sort of attention to process. By manipulating ink, pressure, paper dampness, and inking tools, the artist extends and enriches his design.

A final word—as I used damp paper for the demonstration, I must now use one of the techniques described in Chapter 2 to dry the print, so it won't buckle.

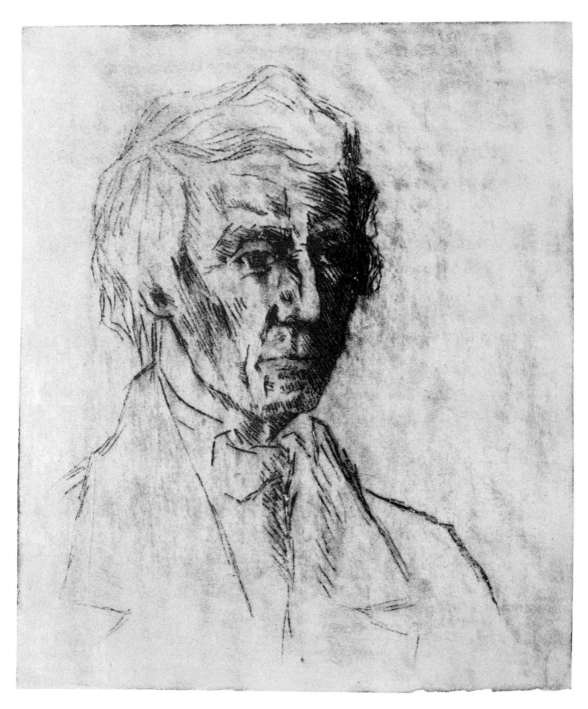

Untitled *(Above) by Priscilla Ballaro. Linoleum engraving, 6" x 6"/150mm x 150mm. Don't forget that your intaglio plates can also be printed by relief methods, as this one was. Tiny scratches won't print if you ink the plate too heavily, but you can print line patterns if you're careful, as this delicate print shows. The artist intended to print this work as an intaglio and did so, but the results were better, I think, when she printed it as a relief.*

FURTHER SUGGESTIONS

So much for the basic engraving technique. As in previous chapters, there are many alternate procedures you might use. Here are a few of the things I have tried.

1. Dampen the printing paper with an ink solvent, such as turpentine or type cleaner, instead of with water. You'll get some very wild and fascinating effects as the printed lines bleed and soften.

2. Use white printers' ink and print on black, dark brown, or dark blue paper. Prints made this way often have a striking resemblance to photographic negatives. Also, combining positive and negative impressions in one multi-impression print can be very interesting.

3. Use the same tools as before—scribers, linoleum gouges, etc.—but make dots (stipple) instead of lines. The results will be much different than those achieved by lines. You can produce textures this way, combining dots with lines.

4. Use the basic techniques of this chapter to engrave other materials such as Masonite and Lucite. You want a surface that is hard enough to stand the scraping but soft enough to scribe.

Classical Head *by Karen Hargreaves. Linoleum engraving, 6" x 6"/150mm x 150mm. An exceptionally clean print, made on a hydraulic press, that uses a classical line to treat a classical subject. The artist, like most of those represented in this chapter, was a student at the Norwich Art School in Norwich, Connecticut. This school has a hydraulic press, and, since printing on a press is significantly easier than spoon printing, many of the students use it.*

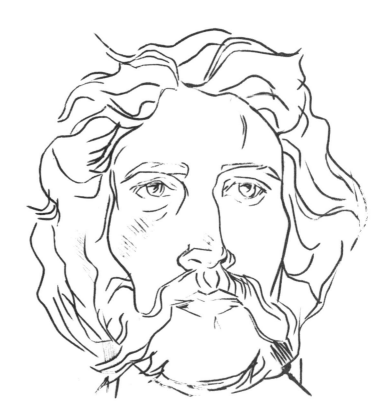

Composition *by Marian Vitali. Etched linoleum, 9″ x 9″/230mm x 230mm. This University of Connecticut student scribed her design in a piece of old floor linoleum, and, after etching it, she found it very hard to wipe off the ink before printing. As a result, she didn't produce a satisfactory print until she ran the plate through an etching press under considerable pressure. The press rollers not only blotted the ink, but they also spread it as the plate moved through the press—producing the larger shapes seen in the print. These shapes differed somewhat from one print to another but were always located generally in the same place. I find the results very interesting.*

CHAPTER 9

Etched Linoleum

In this and the next two chapters I'm going to show you how to make etched linoleum blocks that can be printed by either relief or intaglio methods. We'll start by making a line etching. This is a simple process, very similar to the line engraving process of Chapter 8. Because of the simplicity, line etching will serve as a good introduction to the more complex etching techniques I'll show you in Chapters 10 and 11. And line etching is worth doing for its own sake. The results, though similar to those you obtained with line engraving, are different enough to add new effects to your graphic repertoire.

We carve, we cast, we scratch, we cut—now we etch. Why? Because we're after graphic effects we could obtain no other way. Casting plaster gave us bold blacks and whites and relatively coarse textures. Engraving gave us relatively tight line patterns with a simple background tone. Textures were possible, but were rather mechanical groups of scratched lines.

You'll see that etching gives us new tone and texture possibilities combined with lines (in this chapter) and/or areas (in the next two chapters). In other words, we can express ourselves differently with etching than with other graphic techniques—or there wouldn't be any point in learning to etch.

There's another dimension to etching that shouldn't be overlooked. To some extent it's unpredictable: accidents happen frequently; shapes become distorted and lost; lines broaden and fuse. Sometimes this is disastrous, but often— our imaginations being limited—these accidents lead to astonishing results our minds would never have conceived. Thus the etching bath participates in the design of the block.

Finally, there are practical reasons for making line etchings as opposed to the very similar line engravings. Etched lines are deeper, broader, and more rectangular (in cross section) than the V-grooves made by an engraving scriber. Etched lines, therefore, are easier to ink and print. Etching also smooths the unattractive surface texture of linoleum, which further simplifies the printing process. So—while an etched block is a little more difficult to make than an engraved block, the printing process is a little easier.

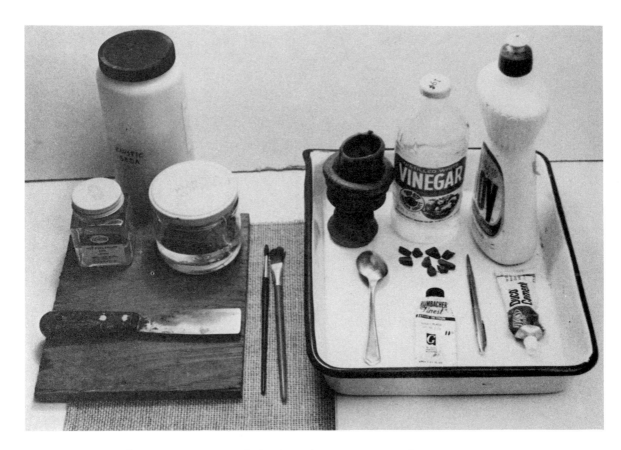

Tools and Materials. *To make a line etching I'll use (from top left moving down and then to the right): large bottle of caustic soda flakes; small bottles of butyrate model airplane dope and alcohol-based varnish; putty knife; piece of ¾"/20mm plywood on top of the linoleum (its backing looks like burlap); 2 brushes; an enameled photographic tray sitting on top of a piece of printing paper; large candle; bottle of white vinegar; Joy; spoon; pebbles; tube of black oil paint; tungsten scriber; and glue.*

TOOLS AND MATERIALS

To prepare the block
Pencil and drawing
Piece of yellow or white lacquered linoleum
Tungsten scriber or another sharp instrument
Piece of ¾"/20mm plywood cut to the size of the piece of linoleum with a saber saw
Duco cement
Screw press (optional)
Butyrate airplane dope
Candle
Inexpensive brushes for applying wax and airplane dope

To etch the block
Enamel photographic tray, enamel oven tray, or glass baking dish
Handful of pebbles or a pad of cloth that will just about cover the bottom of the photographic tray
Measuring cup
Water
Caustic soda flakes or Drāno (see Chapter 10)
Joy or another dish detergent
White vinegar

To print the block
See Chapter 8, page 70, for the materials you'll need.

PROCEDURE

Like engraving, etching is an ancient and honorable block-making technique. It's usually done on metal—copper or zinc—but you're going to do it on linoleum, which is a lot cheaper. The results you get won't be the same as those you'd get on hard metal plates, but your blocks will be genuinely etched.

The first step in making a line etching is to make a pencil drawing on a block of artists' linoleum coated with yellow or white lacquer. Then you scratch your lines through the lacquer with a sharp metal tool wherever you wish to have a black line in the final print. This is just what you did to make an engraving, but this time your scratches needn't be deep enough to print—they should be just deep enough to expose the linoleum under the lacquer.

When the drawing is finished, you'll place the block in an etching bath which eats away the exposed linoleum, enlarging and deepening the lines you've scratched until they're strong enough to print by the intaglio process used in Chapter 8. Most of the linoleum won't etch because it's protected by the lacquer. The chemical bath acts as a gouge, carving away the lines scratched through the lacquer.

Here's a step-by-step demonstration of how to make and print linoleum etchings.

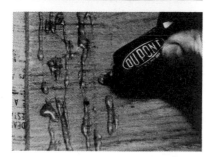

Step 1. Here's my finished line drawing on the linoleum, sitting in the branches of the roots I sketched. Linoleum is a wonderful drawing surface—it has enough tooth to develop a strong line, but it's so tough that you can erase and redraw endlessly without affecting the surface at all. It's great for those who have to struggle, as I do, to produce a reasonably successful drawing.

Step 2. Next, I engrave the drawing in the lacquer surface of the linoleum with my tungsten scriber, using the pencil sketch as a guide. I don't have to scribe as heavily as I did for a successful engraving, but I do cut through the lacquer in order to be sure that I've exposed the linoleum. Please note that I scratch only the heavy and mediumweight lines in the drawing. As the etching process will enlarge all scribed lines, I leave the finest lines untouched. I'll scribe those *after* etching the block, leaving them unetched and fine.

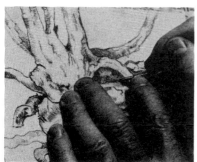

Step 3. As the linoleum should be mounted on plywood before I place it in the etching bath to make it easier to handle and to reduce the chances that I'll get my fingers burned by the bath, I spread a generous quantity of Duco cement on one side of the piece of plywood. Then, I press my scribed linoleum plate down into the glue and set the whole thing in a screw press (see Chapter 3, page 37) for a few hours. If you don't have a screw press, just clamp the block under a pile of books until the glue sets.

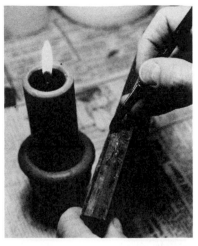

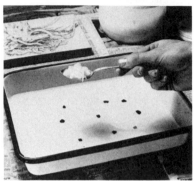

Step 4. For some reason or other the etching bath likes the back of a sheet of linoleum even more that it likes the front. If I don't prevent the bath from working its way in between linoleum and wood, the plate will peel away from the ply-wood and may be damaged. So I coat the sides of the block—linoleum and wood—with model airplane dope. Then—and this step is essential—I paint the joint between linoleum and plywood with molten candle wax. In my experience only wax is effective enough as a resist to seal this joint. It's not hard to apply the wax. I light a large candle—1"/25mm or more in diameter—and wait until a puddle of molden wax forms around the base of the wick. Then, I dip an inexpensive camel's hair brush into the puddle and paint the wet wax on the block. It doesn't take much wax to seal the glued joint.

Step 5. Next, I prepare the etching bath in a 9"x12"/230mm x 305mm enamel photographic tray placed on a level surface. I scatter half a dozen small pebbles around the bottom and add plain water (keeping track of how much I use—I need about 1½ cups here) until the pebbles are ⅛"/4mm or so below the surface of the water. Then, I place my block in the tray upside down, resting on the pebbles. I check to see that the entire front surface of the block is under water while the back of the block is still out of the water so I can handle it without wetting my fingers. If necessary, I adjust the level of the water in the tray.

When the water level is correct, I remove the block from the bath and add several heaping teaspoons of caustic soda flakes—6 tsp. for each cup of water used (9 tsp. for the bath in this demonstration). I stir the bath gently with a spoon or glass rod until the caustic flakes are all dissolved. You'll notice that they tend to stick to the bottom of the tray, but they'll eventually disappear. As the caustic flakes dissolve, the bath becomes warm, active, and to some extent dangerous. If you get some on your hands, you should wash them as soon as possible—though this isn't an emergency situation. If you get the caustic solution in your eyes, you should flush them with water immediately and get medical attention right away. This is an emergency situation!

Step 6. When the bath is ready (all the caustic flakes have disappeared), I set the block upside down on the pebbles again to start the etching process. I pick the block up again every five minutes or so, moving or rotating it slightly to avoid having pebble marks in the linoleum. I let the block etch for a total of 20 minutes.

Step 7. At the end of 20 minutes, I take the block out of the bath, place it in another tray, and carry it to the kitchen sink. I hold it under the tap and rub gently with my fingers to clean away the "mud" produced by the etching process. Once in a while I squirt a few drops of Joy onto the surface to help the cleaning process.

When I'm finished rinsing the block, I set it aside to dry. While I'm waiting, I add white vinegar to the etching bath— 1 tsp. of white vinegar for every teaspoon of caustic flakes added earlier. The vinegar neutralizes the bath so I can pour it down the sink or flush it down the toilet. Finally, if in spite of my precautions, the linoleum has started to come off the plywood, I glue the two together again after they have dried.

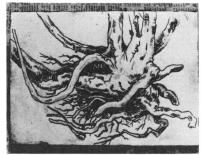

Step 8. Here's my etched block. The etched lines are deep and square-sided in cross section. The original pencil sketch is still visible, and now I'll use the scriber to cut the finer lines or to add lines or textures if the block needs further development.

Note the faint mottling in several places near the edge of the block. The etching bath started to attack the lacquer on the linoleum. If I had left the block in the bath for a longer period of time, the entire surface would have become mottled, the line drawing would have become more and more distorted, and it would have eventually disappeared.

Step 9. I used the intaglio process described in Chapter 8, Steps 6–10, to ink and print the etched block.

Here's my first good print. It's a fair reproduction of my original drawing, but notice how the lines broaden in the etching bath. I could stop here if I wanted just a line etching. However, I'm going to etch this block a second time to give you additional insight into the etching process.

I made these prints on a very hot, dry day—a good drying day. But as I made my first print (not the one pictured here), the ink dried on the surface of the block. When I rubbed the damp typing paper with a spoon, the paper dried too. As a result, the paper stuck to the surface of the block and tore when I removed it. Thus I had to add some plate oil to the paint I used for ink. I also switched to Speedball Printmasters paper to get a tougher surface.

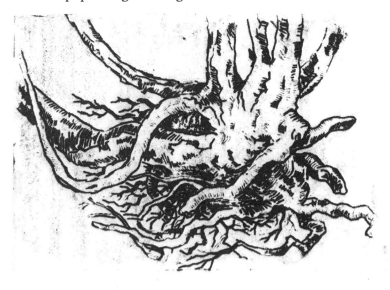

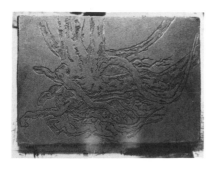

Step 10. After I cleaned the ink from the block, I put the block back in the etching bath for an additional 15 minutes. As you can see from the photograph, the bath removed all of the lacquer from the surface of the entire block and etched a texture into the linoleum. This will have a drastic effect on the appearance of the print.

Step 11. Here's my final print. I used the intaglio process again to ink and print it. Notice how the rough, textured surface of the linoleum traps a considerable amount of ink, giving the print a dark, mysterious quality that appeals to me. You might find a "dirty" print of this sort confusing or obscure. In any case, this final step should give you an idea of what happens if you etch long enough to destroy the original surface of the linoleum—and what etched areas look like when printed.

One final word about this process. If the lines you scratch in the linoleum are very faint and/or your etching bath is too weak, the lines may not etch deeply enough to hold sufficient ink. You'll get a very faint print—or no print at all. If this is the case, you'll have to rescribe some or all of the lines and etch the block again.

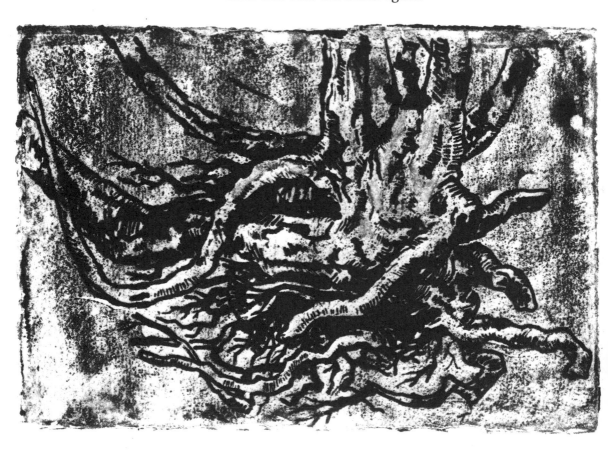

FURTHER SUGGESTIONS

1. The lacquer finish on the linoleum won't resist the etching bath very long. This limits the length of time you can etch the block, which in turn limits the possible depth of the etched lines or textures. If you want a deeper etch, make your pencil drawing and then give the entire block a coat of alcohol-based varnish, such as Magna varnish made by Bocour. Scratch your lines through both the varnish and the yellow lacquer to expose the linoleum. The lines will etch a lot deeper (and broader) before the surface as a whole is attacked.

2. Apply the varnish to selected areas of the block, rather than to the entire surface. The etching bath will attack the unvarnished areas faster than the varnished ones, so some areas will end up textured and others will not.

3. Stab or scratch textures into the lacquered and/or varnished surface before etching. You may have done this to texture an engraving, but this time the results will be different—the etching bath will broaden and fuse the marks you make, and the marks will print under the background tone.

4. Try printing your line etchings as relief blocks instead of intaglios—the results are markedly different.

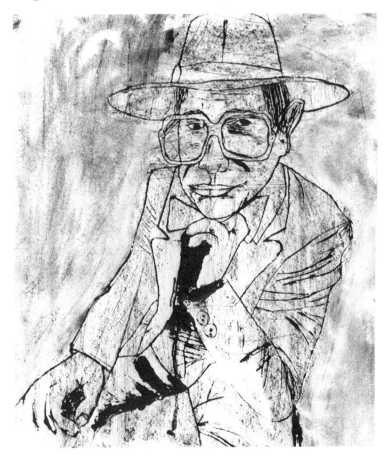

Seated Man *by Michael Garofalo. Etched Linoleum, 6" x 7" / 150mm x 180mm. A very sensitive line drawing, with psychological overtones. Before printing with a spoon, the artist—a middle-school student—wiped the areas around the figure with his finger but left the figure itself mottled by scraping it only. Also, he avoided blots in the dark areas by using a paper stump to clean most of the ink from the wide cuts.*

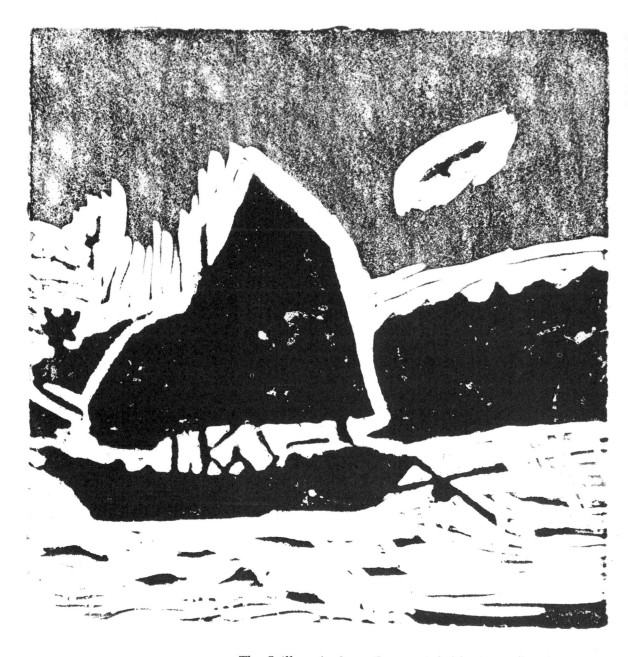

The Sailboat *by Steven Duncan. Etched linoleum, 6″ x 6″/150mm x 150mm. The artist painted his design (the black areas) onto linoleum with model airplane dope and then etched the plate to produce a relief print. For some reason—I suspect that the brush he used was contaminated—the dope started to separate from the linoleum after 30 minutes. This wasn't enough time to establish a deep enough relief, so it was necessary to carve portions of the block away with linoleum cutters. The sky shows the texture etched in the uncarved linoleum. It makes a nice contrast to the uncarved, unetched blacks and the carved whites.*

CHAPTER 10

Relief Etching with Linoleum

You learned one etching process in the last chapter. The results were like those you achieved with the simpler engraving process described in Chapter 8, but you now know how to carve linoleum with chemicals rather than with knives. As a result, the door is open to other, more interesting etching techniques, such as etching a relief block with linoleum.

As you know, the caustic soda etching bath will attack unprotected linoleum of any shape or size. In the last chapter, you exposed the linoleum to the bath only where you scratched lines through the lacquer that coated the surface. So—only lines were etched. In this chapter you'll expose a large surface area to the etching bath—made this time of Drāno, which consists primarily of caustic soda flakes. Since the whole thing will etch, you can make relief blocks by painting a resist design onto the surface of the uncoated linoleum and then etching the plate, eating away the unpainted background areas. The etching bath acts as a direct substitute for the linoleum cutters you'd use if you were making a conventional linoleum relief block. When the bath has finished its work, the painted design stands in relief against the etched (lowered) background. You can ink this raised design and print the block by conventional relief methods.

In addition to being one of the simplest methods to be described in this book, relief etching with linoleum is also one of the most direct. You draw on the linoleum and then merely dip the linoleum into its bath to convert the drawing into a printing plate. Your only tool is the drawing tool. No carving, no casting, no lengthy step-by-step procedure: you don't even have to transfer anything from one surface to another if you draw directly on the linoleum. You must, however, draw with paint. Pencils, crayons, inks, and so on don't resist the caustic bath well enough. But you can use any painting tool you wish—brushes, fingers, sticks—as long as you apply the paint liberally.

You can produce very loose, fluid works with this technique. Dribbles, spatters, and spots of paint reproduce as well as careful brush strokes. Action prints are possible—Jackson Pollack might have liked this technique. It's a great medium for children, too. The caustic bath is a little dangerous, but probably less so than linoleum cutters.

Because the background areas are etched, they are textured like the final print in Chapter 9. And since the depth of the relief is very shallow, you can ink and print the background to add tones to your prints if you want them. If you

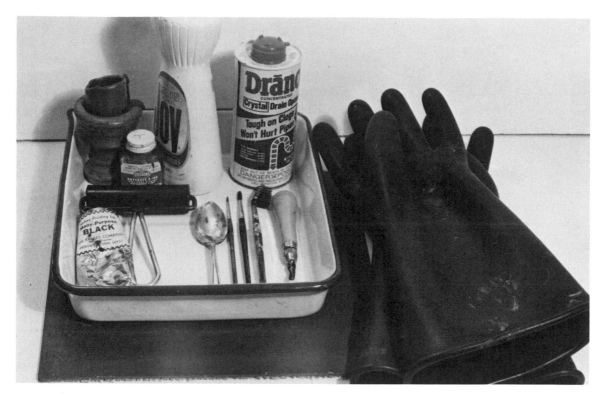

Tools and Materials. *Some of the things I'll use to make relief etchings with linoleum are in the enamel photographic tray: candle; Joy; Drāno; small bottle of butyrate model airplane dope; tube of oil-based ink; hard rubber brayer; spoon; small brushes; toothbrush; and linoleum cutter. The rubber gloves to the right of the tray will protect my hands from the bath, since I'll be etching an unmounted, uncoated linoleum plate (placed under the tray) instead of a block.*

don't want tones, you can carve away the larger background areas partially with linoleum cutters, or you can wipe the ink from them before printing the block. I'll do some of these things in my demonstrations.

TOOLS AND MATERIALS

To prepare the block
Piece of linoleum, unmounted and uncoated
Small brushes
Toothbrush
Candle
Linoleum cutter (optional)
Butyrate airplane dope

To etch the block
Spoon
Drāno
Enamel photographic tray or glass dish
Water
Measuring cup
Rubber gloves
Nylon bristle brush

To print the block
Spoon
Oil or water-based ink
Hard rubber brayer
Paper palette or ink plate
Relief printing paper (see Chapter 2)

PROCEDURE

I'm going to make and print two blocks this time. The first will be a non-objective dribble painting—to show you the marvelous freedom possible with this technique.

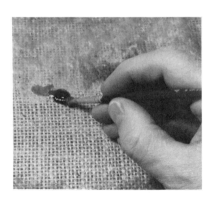

Step 1. I'm starting to work on the first block—the design will be action composition—you won't hurt my feelings if you call it a dribble painting! To begin, I paint the back of a 6″ x 8″/150mm x 205mm sheet of unmounted, uncoated linoleum with wax to protect it from the etching bath. I also paint the sides with wax. Note that I paint the entire back this time—in the last chapter I painted only the sides because the linoleum was mounted on wood which protected the back. This time I must paint the entire back or the bath will attack the exposed burlap—faster than it will attack the linoleum!

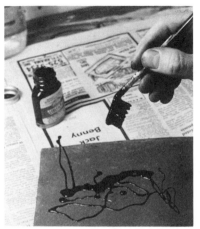

Step 2. When the linoleum is ready, I dip a toothbrush into the bottle of airplane dope and dribble a pattern onto the front surface. There are many tools I could use to do this, but I prefer the toothbrush. The paint clings to it less than it would to a paintbrush—and therefore it dribbles more readily. I can also flick the bristles with my thumbnail to produce spatters.

Using a conventional brush, I'll also paint a border around the four sides of the plate. This will protect the outer ¼″/7mm or so from the etching bath, so the final plate will have a relief surface around the drawing. The raised border will support the ends of the inking brayer, helping me keep the background of the plate clean as I ink the plate.

Step 3. While the dope is drying, I prepare an etching bath, following the procedure described in Chapter 9, Steps 5–6. This time, however, I use 6 heaping tsp. of Drāno, instead of caustic soda flakes, for each cup of water in the bath. Then I place the linoleum upside down in the bath.

I lift and examine the linoleum plate every 5 or 10 minutes to see how deeply it has been etched. To do this, I put on the rubber gloves, lift the plate out of the bath, and rub it gently with a glove-covered finger. If you don't have rubber gloves, you can take the block out of the bath and turn it over with a pair of tweezers or tongs. Then rub the surface—gently—with a nylon bristle brush (brushes made for acrylics work well).

Step 4. At first, rubbing the linoleum with a glove or brush won't show any results. After the plate has etched for 20 or 30 minutes, however, a brown sludge will have formed on the surface and will start to come off when I rub. At this point, I'll carry the plate to the kitchen sink on an old newspaper, in old dish, or in another pan, so I don't drip caustic solution onto the floor. Then, I'll wash it gently in tepid water and dish detergent to flush away the sludge.

I check the depth to which the background of the plate has been etched after rubbing. When this depth about equals the thickness of my thumbnail (about 0.015″/.4mm for the scientists among you) the plate is ready for the next step. If the linoleum hasn't etched this deeply yet, I return it to the bath. Check and rub it again every 5 minutes and wash it again after another 20 or 30 minutes until it has etched enough. Here's my etched plate, after the final cleaning—the relief is so shallow it's hardly visible in the photograph. Even the finest dribble lines are still intact, not eaten away.

Step 5. This is my print. Because the relief was so shallow, I inked the plate with a hard rubber brayer (I used regular relief ink) and printed with a spoon, the usual linoleum block procedure. The resulting print, however, doesn't look much like a linoleum block, does it? Instead of the sharp angles and edges of a carved block, I've got curves, spots, tones, and dribbles. Like it or not, this kind of thing has its place in the visual world. In the hands of a Pollack, it could be very exciting.

The background has picked up some ink, but there's enough difference between design and background for the print to be intelligible. I could wipe the larger background areas with a rag or paper towel after inking and before printing the block if I wished the background to be still lighter.

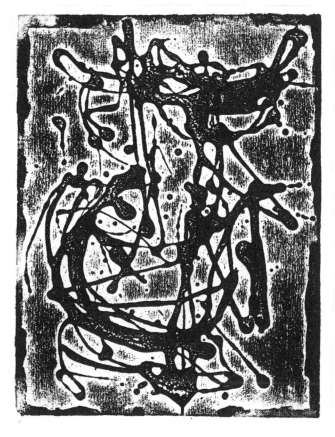

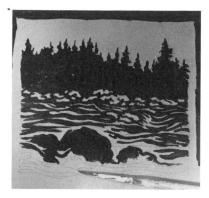

Now I'll do a linoleum landscape; fairly typical, except that it will be etched, not carved. Because I will paint the design on rather than carve it out, the line quality will be different, more fluent.

Step 1. Now I'll show you that relief etching can also be used to produce realistic prints. I'll do a landscape—trees, sky, rocks, and even a river!—while you watch. I've transferred my drawing onto another piece of unmounted, uncoated linoleum—after waxing the sides and back as before. Here I paint my picture using dark gray model airplane dope (any color will work).

If I make a mistake, or want to make any changes, I can use a knife blade, or better yet a scratchboard knife, to remove some or all of the dope after it has dried. Then I can repaint that part of the composition. Since the linoleum makes a very tough drawing surface, I can work the plate again and again endlessly before etching.

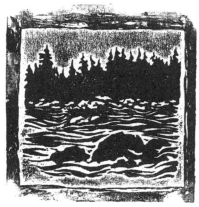

Step 2. After etching the plate the same way I etched the last block (in a bath of the same strength), I pulled a print. In this case I etched the plate for 55 minutes, examining it every 10 minutes, and washing it once before returning it to the bath. When it etched to the point where some of my finest painted lines came off as I gently rubbed the plate, I stopped etching it. I cleaned and dried the plate and printed it the same way I printed the dribble design earlier. The background is toned because the relief is so shallow. The border I painted around the drawing (to help support the brayer) has also printed.

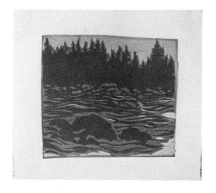

Step 3. I want the larger background areas to be pure white—since they are inking and printing as tones, I must lower them further. The simplest way to do this is to carve them away with a conventional linoleum cutter, a fast process since all of the detail carving has been done by the etching bath.

I also cut a paper mask from an early print to cover the inked borders of the block when I print. The mask is shown, in place, in the photo. Thus, by a combination of cutting and masking, I isolate the shallow relief areas I wish to print.

Step 4. Here's my final print. It looks something like a linoleum block, but it's subtly different. Edges are a little softer than a carved block; there is some texture in the relief areas because the dope painted on the surface is not perfectly flat. I've concealed this almost entirely by applying a fairly heavy layer of ink to the plate. If you want to show this kind of texture in your own etchings, ink them lightly. Notice that I've also carved some fine wavy lines near the distant shore with a linoleum cutter. As in any etching process, I had to put the fine lines in *after* etching the plate, because the etching bath will widen any line it encounters.

Zebra by *Leila Bickford. Etched linoleum, 8½" x 10" / 220mm x 255mm. My daughter didn't want any tones in the background—she used a jigsaw, therefore, to remove all of the etched linoleum around the figures. She used linoleum cutters to deepen the relief in the larger internal areas (between the legs, for example). All of the details, however—the stripes, faces, and general outlines—were established entirely by the etching process. She could have masked the background instead of using a jigsaw, but she also wanted to separate the figures so she could print them one at a time in different arrangements.*

Moonlit Landscape by *Michael Macdermott. Etched linoleum, 6" x 6" / 150mm x 150mm. The artist didn't carve this block at all. The etch is rather shallow, but the black areas in the print started to break down a little in the bath. This gives those areas a mottled appearance that could have been concealed by a heavier application of printing ink. The tone and texture produced by the mottling, however, add interest to the simple black areas and tend to unify the composition.*

When I'm finished, I pour the etching bath down the toilet (where Drāno was intended to go!). It's not as strong as the caustic flakes bath, so I don't have to add vinegar before throwing the bath out.

FURTHER SUGGESTIONS

1. For a deeper etch, use hot wax as the resist. Simple resists, such as dope or enamel, will hold up during the hour or less that the linoleum is in the etching bath. Conventional carving tools can then be used to lower large background areas. You can, however, eliminate the carving altogether, even if large areas are involved. After all, the linoleum will keep etching as long as it's in the bath. The difficulty is to protect the areas you don't want to etch when exposure times are long.

The techniques developed and reported by Michael Rothenstein and Trevor Allen in England (see *Relief Printmaking* by Rothenstein in the bibliography) use hot wax as the resist rather than enamel or airplane dope. These artists clean the surface of the linoleum very carefully before applying the wax and then heat the wax in a double boiler instead of using a candle. Hot wax applied to a super-clean linoleum will resist a caustic bath for many hours. This allows a much deeper etch, better relief, and more accidents-on-purpose to liven up a design.

2. If you're using a long etch, leave several areas unprotected at the start and let them all etch for awhile. Then clean and dry the block, apply new coatings of resist to additional areas, and etch the block some more. This leads to variations in depth of relief from one etched area to another. You can print each depth in a different color or tone if you apply the ink properly. Rothenstein describes all of this very well.

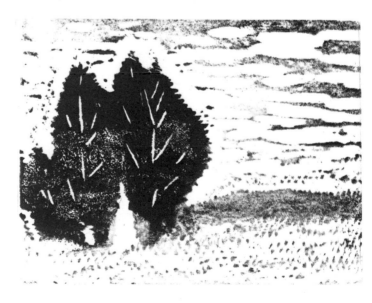

Trees *by Jean Cochrane. Etched linoleum, fragment, 3½" x 2½" / 90mm x 65mm. I think this simple composition is very appealing. The basic carving, including the texture in the foreground, was done by the etching bath. The artist established the textures by painting areas, lines, and dots onto the linoleum. To obtain the variation in tone between background and foreground, she wiped most of the ink off of the background before printing.*

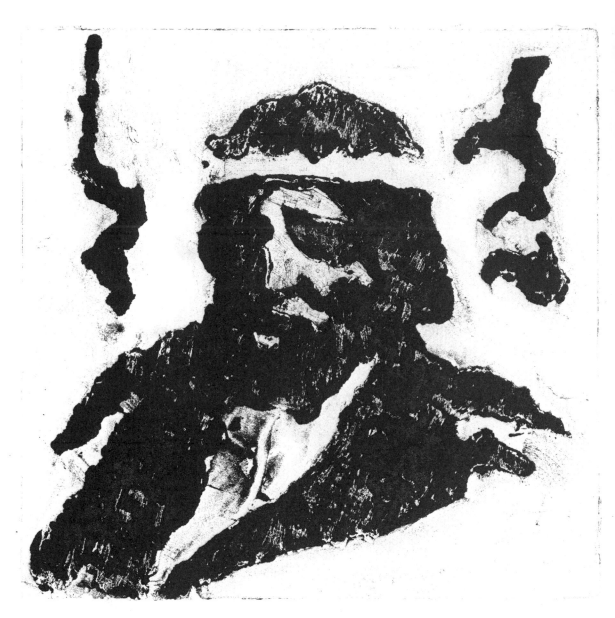

Ancient King by John Bickford. Sugar lift etching on linoleum, 6″ by 6″ / 150mm x 150mm. Like Classical Head on page 75, this is a portrait and an intaglio print taken from a linoleum plate. But there the resemblance ends. The engraving process you learned in Chapter 8 can be used to produce careful, detailed linear compositions; the sugar lift process you'll learn in this chapter is almost an ink blot technique, with sometimes more accident than design in the results. Nevertheless, it's a fascinating process, about as unusual as any you'll encounter in the art world, and well worth learning.

CHAPTER 11

Sugar Lift Etchings on Linoleum

In this final chapter on etching I'll show you one of the more unusual processes in printmaking—sugar lift. It's a simple technique, producing rather crude results. Even the crude can be powerful, however, if your message fits the means. I'm sure the technique will have special appeal to younger students, too—there's something a little magic about it. You make a painting, later wash the painting off the block, and end up with a block that retains the image of the painting.

In a sense, sugar lift is the inverse of the process of relief etching, where you etched every part of the linoleum surface except those areas on which you had painted your design. With sugar lift, only the design is etched. If you printed a sugar lift as a relief, therefore, it would be a white line process—the painted marks would print white. This is well worth trying—painting your whites rather than carving them gives a measure of fluidity that produces new results.

In this chapter, however, I'll print a sugar lift as an intaglio. Since the ink will be held by the etched areas, where I originally painted the plate, this will be a black line process—my painted marks will print black. Black line processes always make things easier to visualize, I think. Besides, I want you to see that etched area blocks and plates can be printed by either relief or intaglio methods. This holds true for relief etchings like the plate made in the last chapter as well as for the one made in this.

A relief plate printed by intaglio methods always has a certain ink blot or monoprint look because the large areas of depressions hold a lot of ink. Since it's not possible to produce fine detail with the sugar lift process, it's appropriate to print sugar lifts as blots. There's a natural affinity, in other words, between sugar lift and intaglio printing—and not between sugar lift and relief printing. You should always look for relationships of this sort—your final results will be strengthened if there are natural relationships between your subject, your tools, and your methods.

Alexander Cozens, one of the early (18th century) pioneers of lift ground etching on metal, realized this relationship. He called his sugar lifts "blots" and recommended the process as a means to force accidents—and hence new images the mind alone would probably not conceive—while remaining in basic control of the composition. As you'll see, sugar lifts on linoleum printed as intaglios have this same accidental character.

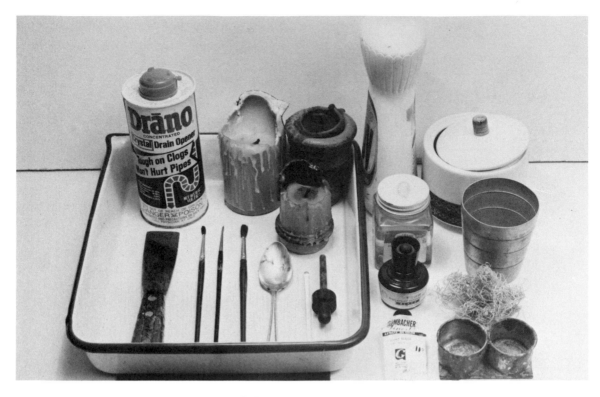

Tools and Materials. *The materials needed for sugar lift etchings are similar to those used in the last two chapters. In the enamel photographic tray, which sits on top of a piece of uncoated, unmounted linoleum are: Drāno; candles; putty knife; small brushes; spoon; glass rod; and medicine dropper. To the right of the tray (from the top and moving down) are: Joy; a bowl of sugar; butyrate airplane dope; measuring cup; India ink; steel or plastic wool; tube of oil paint; and a pair of palette cups.*

TOOLS AND MATERIALS

To prepare the block
Piece of linoleum, unmounted and uncoated
Palette cups
Granulated sugar
Joy or another dish detergent
India ink
Medicine dropper
Glass rod
Candles
Small brushes
Butyrate airplane dope
Steel or plastic wool

To etch the block
Drāno
Spoon to measure out the Drāno
Enamel photographic tray
Water
Measuring cup
Rubber gloves
Nylon bristle brush

To print the block
Spoon
Oil paint
Putty knife
Paper palette or ink plate
Intaglio printing paper (see Chapter 2)

PROCEDURE

We're going to use linoleum again, although metal is used more often for sugar lift. You paint your design on the surface using a mixture of sugar, ink, water, and detergent as the paint. When the painting is dry, you coat the entire block—sugar marks and all—with a resist, a liquid (that hardens) that will not mix or dissolve the sugar solution. When the resist dries, you wash the block in warm water. As the sugar swells and bursts through the coating of resist, you wash away both the sugar solution and the resist that covers it to expose the block underneath the painted design. The rest of the block remains coated with resist. When you put the block in its etching bath, therefore, only the places on which you painted the sugar solution will etch. The resulting block can be printed either as a relief or as an intaglio.

Step 1. I mix sugar lift paint in a palette cup with a glass rod. The paint is made of 1 tsp. granulated sugar, a dozen drops of India ink (for color), 3 or 4 drops of Joy, and a medicine dropper full of water. My linoleum plate measures only 7″ x 9½″/180mm x 245mm, so I don't need much paint—if you need more, just double or triple the amounts of the ingredients. The resulting mixture is a very thick, syrupy paste—rather than a liquid—that's gritty with undissolved sugar. In spite of all this, it spreads as easily as heavy paint.

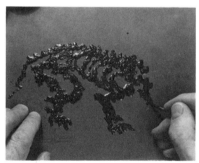

Step 2. After I wax the back and sides of the linoleum, as in Chapter 10, Step 1, I transfer the outlines of my drawing—the skeleton of a prehistoric animal—onto the linoleum with carbon paper. Then I paint my design onto the linoleum with the sugar mixture, using a small, inexpensive brush. Any kind of brush will do—the sugar won't hurt it. I apply the sugar paint liberally, building a layer that's about as thick as a nickel. The stiff mixture stays where I put it without slumping or flowing. Note that my design is fairly bold—crude. You can apply the sugar solution to small areas or to reasonably fine lines, but these areas and lines are more difficult to remove when you wash the solution off. Therefore, I'm restricting myself to large, simple shapes.

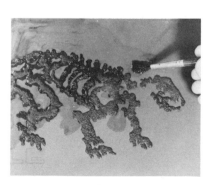

Step 3. I let the sugar solution dry for about an hour. Then I give the entire surface of the plate—sugar marks and all—two generous coats of model airplane dope. I let the first coat dry about 15 minutes before applying the second. I'm using clear dope—again, the butyrate variety has more resist power than other kinds. I could use colored dope, instead of clear—the gray I used in the last chapter would work—but you'll get a better view of what I'm doing if I use clear.

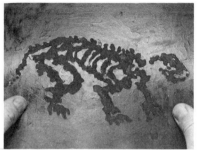

Step 4. When the second coat of dope has dried, I wash the front surface of the linoleum gently in the sink with warm (not hot) water, rubbing the sugar marks with a piece of plastic wool—which is abrasive enough to rub off the sugar marks but not abrasive enough to cut through the resist that covers the rest of the plate. At first nothing happens, but as the sugar warms, my painting starts to peel away from the linoleum. I keep rubbing until most of it has come off.

Step 5. I dry the block and remove any remaining sugar by scraping gently with a scratchboard tool or a knife point. Large areas of sugar generally wash off, but fine lines often must be scraped. This photograph shows my plate following removal of all of the sugar. As you can see, the area originally covered by my design is dull, while the rest of the plate is shiny. This is because the linoleum is now exposed wherever there was a painted mark, but the rest of it is still coated with the shiny dope. The linoleum is now ready to be etched, and I mix the etching bath exactly as I did in the last chapter—6 tsp. of Drāno for each cup of water (I used 2 cups this time). When the bath is ready, I place the linoleum in it upside down. I remove the plate every 10 minutes and rub its surface (see Chapter 10, Step 3) to see how deeply it has been etched. Every 30 minutes or so I wash the linoleum in tepid water and detergent to remove the sludge.

Step 6. Here's a close-up of the etched plate, ready to be printed. As in Chapter 10, I've settled for a shallow etch, fingernail deep. Since the dope hasn't been attacked by the bath yet, I could continue to etch this block if I wanted a deeper relief. However, the smaller, isolated relief areas— between the ribs, for example—would probably be etched away and lost if I did this. Besides, I'm planning to print this as an intaglio—a deep relief would make that more difficult.

Step 7. Here's my print. This is not an accurate reproduction of my original sugar painting, but the sugar lift process is not at fault. If I had printed this as a relief, I would have obtained a perfect—but negative—reproduction (white replacing black and vice versa). However, I used the intaglio printing process illustrated in Chapter 8, Steps 6–10, applying oil paint with a putty knife, scraping the relief surfaces clean, wiping them, and printing with a spoon. I didn't have to use much pressure this time, since it's easy to force the paper down into the large inked areas. The combination of these large areas and the intaglio process resulted in the ink blot effect I mentioned earlier. I like this. I can, by applying less ink, get a more accurate reproduction, but I prefer the accidental monoprint quality of a heavily inked intaglio.

FURTHER SUGGESTIONS

1. Apply the caustic solution (the etching bath) to selected areas of the linoleum with a nylon brush instead of immersing the entire block in an etching bath. This way you'll etch only selected areas of the block, and you won't have to protect fine details—presumably carved—in other areas. This is one of Michael Rothenstein's suggestions in *Relief Printmaking*.

2. Combine linoleum etching techniques with other linoleum procedures. Notice that I suggested above combining etching sections of the plate with carving details. You can combine relief, engraving, line etching, and even the lithography I'll discuss in Chapter 14 to some extent because they're all done on the same base material. As you learn the methods in this book and elsewhere, I hope you'll look for—and use—combinations of all sorts to produce richer and more exciting graphic images.

Two Tyler II's *(Above) by John Bickford. Sugar lift etching on linoleum, 6" x 6"/150mm x 150mm. Labrador puppies are good subjects for an ink blot printmaking technique. I did a series of quick brush drawings, from which I selected the two shown here. I used carbon paper to transfer them to linoleum and sugar lift to etch them. If I were more skillful, I could probably have sketched them directly onto the linoleum with the sugar solution. (I could have washed any bad sketches off again and again until I produced one worth etching.)*

T. Nelson Downs *by David Bickford. Sugar lift etching and engraving on linoleum, 5" x 6"/125mm x 150mm. The main figure, a magician, in this print was established by the sugar lift process. Since the lines produced by sugar lift tend to be broad, my son elected to carve rather than etch the lines that define the hands surrounding the head. The plate was printed by the intaglio process. By combining etching with carving, you can produce a wide variety of lines, effects, and textures.*

PART FOUR
LITHOGRAPHY

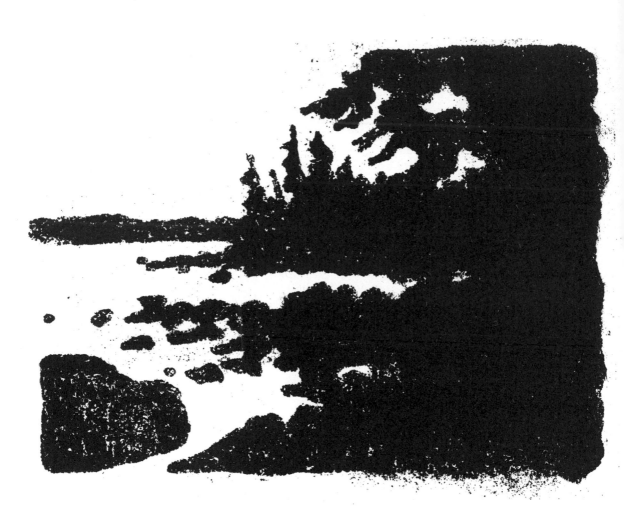

Lake at Dusk *by John Bickford. Lithograph on Bainbridge board, 4¼" x 5¼"/107mm x 132mm. The process I'm going to show you in this chapter is a simple black and white technique that produces prints that bear some resemblance to linoleum relief prints. The process lends itself well to silhouettes, like the one here. But there are important differences between a lithograph on Bainbridge board and a linoleum cut: the edges of the shapes in the lithograph are always soft and broken; the blacks are rarely solid; and the background is apt to have a soft tone, especially in prints made late in the edition. All of this tends to give the lithographs a muted quality that suggests atmosphere or night, as you can see from most of the examples here.*

CHAPTER 12

Lithography on Illustration Board

As I pointed out in Chapter 1, to make a print you do something to the surface of a block or plate to make certain areas of the surface accept ink and others refuse it when you print. In all of the printmaking processes discussed so far, you controlled the level of portions of a plaster or linoleum surface, so some areas were higher or lower than the rest. Then you inked and printed the highs (in relief) or the lows (in intaglio). In lithography, however, you won't change the surface level of your plate at all. You'll be making planographic prints—all on one plane—and the results will reflect this significant change in procedure.

I don't know who first carved or scratched a block to make a print, but for centuries afterward mankind made prints in no other way. New methods of altering surface levels—such as etching—were conceived, but printmakers were completely hung up on "level change" when it came to making printing blocks and plates. Then along came Aloys Senefelder.

This Bohemian gentleman—I think it's reasonable to call him a genius—gave us another basic approach. After centuries of printmaking, this was quite an achievement. He discovered how to use water and grease to determine which portions of a flat surface will ink and print. No carving, no etching, no scratching. You just draw and print. Or almost.

I described and illustrated the basic process, briefly, in Chapter 1. You make water-repellant marks of some sort on a surface that can be wet with water; you fix those marks so they won't be washed away as you print; you wet everything on the surface and the marks repel the water; and then you ink and print the marks.

Aloys Senefelder's invention wouldn't have been a success if it were just another way to make prints, because it's a more difficult process than its predecessors. Artists soon realized, however, that lithography made all sorts of new effects possible—179 years of development have still not brought us to the end of the story. We know now that we can print marks made by pens, brushes, pencils, chalks, fingers, rags—almost any art tool you can name. Delicate washes are possible and so are heavy blacks or emphatic colors. The subtleties of photographs can be reproduced this way. Nothing, in short, seems beyond the scope of lithography. Many of the books and magazines you read are printed by photo-offset, a commercial lithography process,

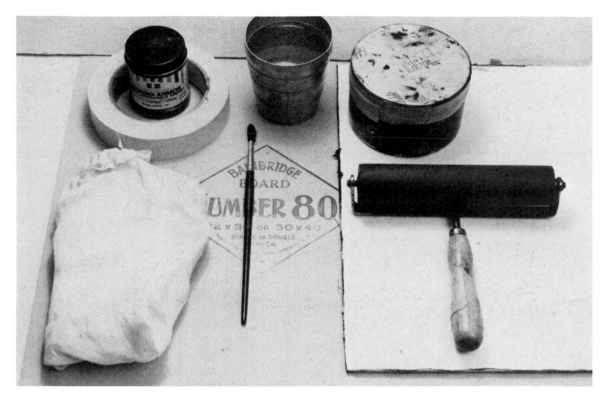

Tools and Materials. *Some of the things you'll need for lithography on illustration board (from top left, moving down and then to the right): piece of No. 80 Bainbridge illustration board; masking tape; glossy enamel paint, the regular household kind; old handkerchief; brush; cup of water; waterproof palette on which to roll out the ink; can of lithographic ink; and soft rubber brayer.*

so it's probably safe to say that lithography dominates the printing world today.

The lithographic techniques you'll learn in the next few demonstrations will not, unfortunately, allow you to do all of the things a professional lithographer can do. Although the prints you'll make will be genuine lithographs, they'll be relatively simple compared to the real thing. But they're more complex than the prints you've done in previous chapters, and they'll help you decide if lithography is or isn't the right technique for you.

TOOLS AND MATERIALS

To prepare the block
Drawing, carbon paper, and hard pencil or soft pencil and/or Conté crayon
No. 80 Bainbridge illustration board
Matknife
Masking or drafting tape
Glossy enamel paint and brush
Razor blade or scratchboard knife

To print the block
Handkerchief or rag
Cup of water
Lithographic ink
Soft rubber roller
Waterproof ink plate or palette
Lithographic printing paper (see Chapter 2)

PROCEDURE

Now you'll learn the simplest lithographic process of all—so simple, in fact, that some purists may deny it is lithography. But I think it's a good place to start—this method reduces the number of variables you'll have to deal with. It's also a good technique to know if your time is limited (by a classroom situation, for example)—or if you're dealing with young children. This is the only lithographic technique you'll try that doesn't include acid, gum solutions, powders, etc., which are a little dangerous and very messy. So let's go—with lithography on illustration board.

Step 1. I use a matknife to cut a piece of No. 80 Bainbridge illustration board about 2"/50mm larger in each direction than my design. (Since my print will measure 5" x 7"/ 125mm x 180mm, I've cut a 7" x 9"/180mm x 230mm piece.) This photo shows me protecting the edges of the board from water by folding masking tape over them in order to increase the durability of the board during the printing process. You could instead cut your board even larger and try not to get the edges wet as you print.

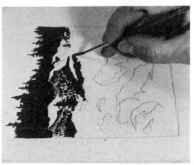

Step 2. I trace my design from a previous sketch onto the board using carbon paper and a hard pencil, being careful not to bear down too hard as I draw. If I'm too heavy-handed, I'll indent the surface of the board—these depressions will probably print as white lines and can ruin the print. You could also use a soft pencil or a Conté crayon and draw directly on the board. In either case, avoid erasing anything. Carbon or pencil lines won't print anyway, so just ignore mistakes at this point.

Step 3. When I'm satisfied with the design, I paint over it, applying a thick coat of enamel paint with any convenient brush. This is a black and white process (wash tones aren't possible) and a heavy layer of paint will ink and print more readily than a thin film. I must be careful to eliminate any air bubbles in the paint. These often dry as slight bumps in the surface, and they'll print as black dots surrounded by white circles—little bull's-eyes—that are very unattractive. So, when you do this, examine your finished paintings and use the brush to smooth away any bubbles.

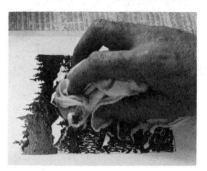

Step 4. I'm ready to print as soon as the enamel is dry. This usually takes less than half an hour, even though this enamel usually takes four hours to dry. I suppose the porous board I'm using—instead of wood—makes the difference.

When I'm ready to print (I could let the enamel dry for a week if I wished), I dip the handkerchief (or rag) in water, squeeze it slightly, and wipe the surface of the board—drawing and all—to wet the background. You'll notice, if you look closely, that most of the water applied to the

painted areas peels off by itself. Unpainted areas soak up water like a sponge. It is not necessary to remove any water that does cling to the paint. The soft brayer will do this for you when you ink the plate.

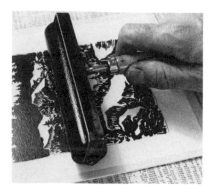

Step 5. While the board is still wet, I ink the brayer lightly and I start to roll ink onto the plate. Since the litho ink is greasy and since grease won't stick to water, the wet board won't pick up any ink. The painted marks, however, which repel water, *will* pick up ink. The incompatibility of the water and greasy ink, therefore, determines which areas of the surface will ink and which will not. (You *must* use lithography ink—no other kind will work.)

Using moderate, not heavy, pressure, I roll the brayer over the illustration board several times, adding a little ink to the brayer once in a while if necessary. I must be careful not to apply the ink too rapidly. If I use a heavily loaded brayer, some of the ink will stick to the background (lithographers call this smutting the background) and can ruin the print. Therefore, I only use a little ink on the brayer for the first couple of prints. Some smutting is inevitable, however, especially around the edges of the plate. This is one of the reasons why I left a 1"/25mm border around my drawing.

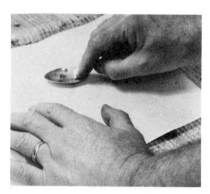

Step 6. When I think I've applied enough ink for the first print, I lay a piece of paper on the board and rub the back of the paper hard with a spoon. I'm careful to rub each spot in several directions to avoid streaks, clamping the paper to the board with my left hand as I rub with my right, since there's very little ink on the board to glue the paper to the plate.

This first print will always be much too light—you must go through the rubbing process a couple of times before the block inks properly. If I try to apply enough ink to get a dark print the first time, I'll probably smut the block.

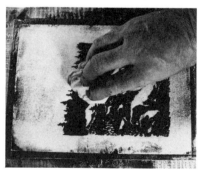

Step 7. This is my block after I pull the first print. I'm wetting the entire surface of the board again with the cloth in order to pull another one. This step is essential! Nothing causes smutting more readily than failure to wet the plate again between prints. The rubbing action of the spoon during printing dries the surface enough to accept ink.

When the surface is wet, I roll on more ink. Now I can apply a slightly heavier layer of ink—next time I will be able to apply still more. I watch the background carefully and slow down if I see heavy smutting (some light smuts are visible in the photo). If serious smutting occurs, I immediately wipe the surface gently with the wet rag. This will usually pick up the smuts. Then I reduce the amount of ink on the brayer and roll it over the surface a few more times to remove the water before making the next print. I also examine the early prints for bull's-eyes I may have overlooked earlier. If I find any, I scrape them away with a razor blade or scratchboard knife.

Step 8. Here's my fifth print. By now the plate is fully inked and is printing well. There's some background tone—slight smutting—which is almost impossible to avoid. But there's good contrast between the marks and the background. There's also some texture in the darks, a faint mottling caused by the enamel used to paint them—the enamel was a little lumpy, and its texture will show unless the plate is heavily inked. But the texture adds a softness I like.

I made twelve more copies of this print before the board started to disintegrate, even though I used less water and more ink after the board became thoroughly wet. Some of the finer white details filled in (which usually happens) but the plate was useful to the end. I switched from Speedball Printmaster's paper to lightweight bristol paper after the ninth print—bristol paper is harder and picks up more detail from an aging plate. I could have made a few more prints, but the process is limited. If I want more copies of a given design, I make another plate. Lithography on board is simple enough to make that possible.

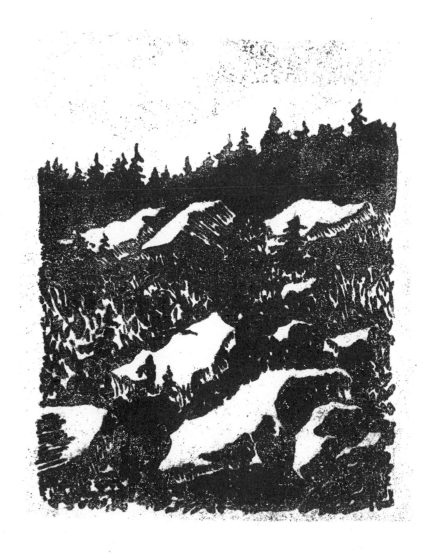

Balsam Fir *by John Bickford. Lithograph on Bainbridge board, 6" x 8" / 150mm x 205mm. If, after you've built up the ink layer in your lithograph, you ink your brayer heavily (so it crackles as you roll it across the ink plate) and then roll it gently (under its own weight) across the printing plate, you'll get the sort of effect shown here. The plate is inked only in spots but is inked heavily in those spots. The result looks something like a solarized photograph. I think that this is an interesting alternate to the silhouette effect of most simple lithographs. Remember—you should always experiment with the printing process as you develop your blocks and plates.*

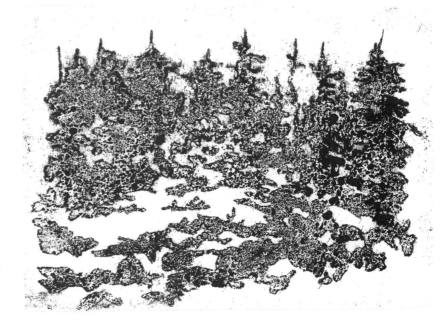

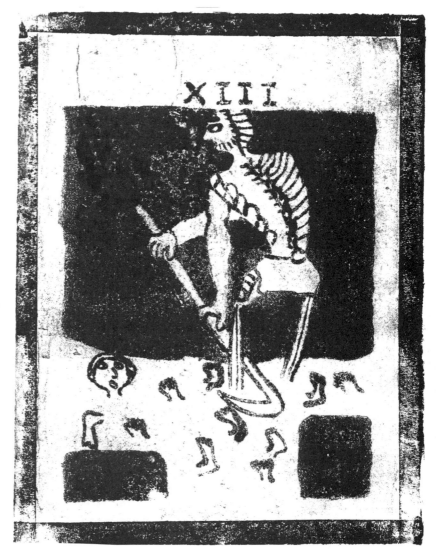

Tarot Card *by Jeff Nesmith. Lithograph on Bainbridge board, 8" x 10" / 205mm x 255mm. The artist, a middle-school student, drew heavily on an actual Tarot card for his design. But his treatment is bold, and his print shows that lithography on illustration board lends itself to both line and area designs. He's even printed the tape that he used to protect the edges of the illustration board—I think that the resulting border adds to the composition.*

FURTHER SUGGESTIONS

1. Try other illustration boards and cardboards. Bainbridge board works well; but it doesn't stand up very long. Other cardboards may be better, though some will smut unless first coated with a solution of pure gum arabic and water (see Chapter 13, page 112). I should think that old, dry wood might work, although any pitch or rosin in fresh lumber would smut. There may be other suitable building materials.

2. Household enamel isn't the only possible drawing material—anything that will repel water and that won't wash off the board as you print should work. Grease spots and the like ought to print to some extent—perhaps as background tones. I know that many other types of paint—house paints of all kinds, artists' oils, model airplane dopes, etc.—will work with varying degrees of success. Some materials seem to weaken the board a little, reducing the number of prints you can make, but some paints may be even better than the enamel I used in the demonstration, which affects the board less than the other things I've tried.

3. Apply the paint with something other than a brush. Spatters, daubs, wipes, dribbles, and jabs will print as well as brush strokes, as will paint lines drawn with a pen or stick.

4. Make brush drawings with enamel—or the equivalent—directly on Bainbridge board outdoors, in the field. You can later select—and print—your better drawings without any in-between steps. No transferring required. No need to redraw with a new tool as you make the printing plate. Your drawing is the plate.

Patterns *by Michael Augeri. Lithograph on Bainbridge board, 5¼″ x 6½″/132mm x 157mm. The slight texture in the dark patterns of this lightly inked print comes from the Bainbridge board, and it prevents the work from looking like a silhouette cut from black paper. The paint used to construct the printing plate can also be manipulated—applied in varying thicknesses, scratched with a brush handle while wet, etc.—to produce other coarser textures. Although few lines are used here, lines (and dots) can be clustered for textural effects. This is a relatively clean print because the artist built up the ink layer very slowly.*

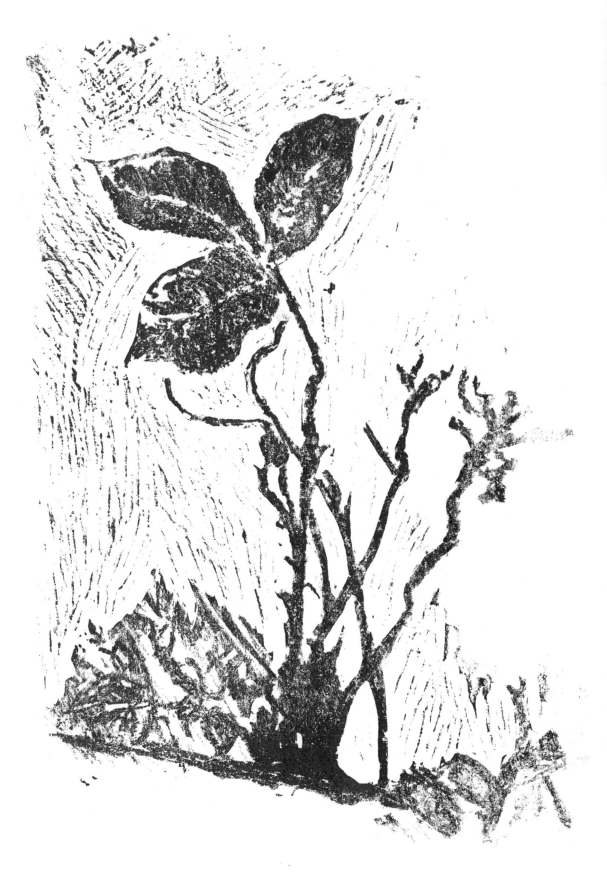

CHAPTER 13

Lithography on Plaster

Lithography can be a very complex process, and artists use many materials for it—usually slabs of stone or sheets of treated zinc and aluminum, but such things as glass and rubber have also been used. Stone gives the best results but is heavy and very expensive. A 6" x 8"/150mm x 205mm block of limestone, favored by lithographers, will cost you over $20. You can regrind it and reuse it many times, but it still isn't common, convenient, or inexpensive.

I have tried a number of materials in my attempts to find a substitute surface for simple lithographs. I've had some success with wood—although not with every kind I've tried. Wet-or-dry emery cloth (glued to a block of plywood after being painted with vinyl paint) also works—sometimes. Cloths made by some manufacturers hold up; others disintegrate under the action of the lithographic acids and/or the printing process. I'm sure, however, that wood and emery cloth would yield to further experiments.

In the last chapter you used illustration board and learned about half of the basic steps required to make a real lithograph. You were able to make only a limited number of prints. In this chapter I'll demonstrate the additional steps—using a cast plaster block instead of illustration board for the printing plate—and this time you'll be able to make as many prints as you want.

In the following chapter I'll discuss etched linoleum, another good material I've found to make lithographs. Results are different with each material, as is the procedure, which is why each one must be discussed separately. With plaster and etched linoleum I'll use the same procedure used by the artist working on stone. The printing process, however, is the same as that for illustration board—the antipathy of grease and ink still determines what will print and what will not.

TOOLS AND MATERIALS

To prepare the block
Mixing bowl
Jar of water
Cardboard strips
Sheet of glass
Window cleaner
Gooseneck lamp or oven
Por-Rok cement
Masking tape
Tablespoon

The Plant *by Roxane Manfred. Lithograph on plaster, 5" x 8"/125mm x 205mm. This simple yet effective print demonstrates many of the effects you can achieve in a lithograph on plaster: soft tones set against rich blacks and a relatively clean background; both thick and thin lines as well as large areas of tone or texture; sharp edges along the lower right-hand base of the plant and crayonlike edges in the slightly inclined horizontal ground line.*

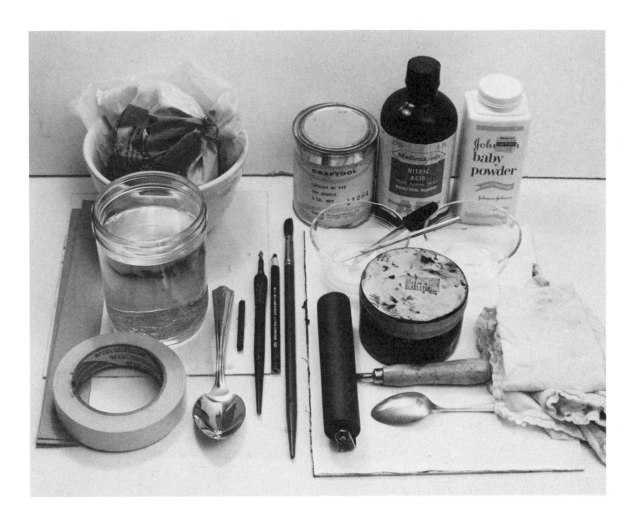

Tools and Materials. *I'll need more materials to make a lithograph on plaster than I did to make one on illustration board. From top left: bag of Por-Rok cement in mixing bowl on a sheet of glass; cardboard strips; jar of water; masking tape; tablespoon; Conté crayon; scratchboard knife; No. 1 lithographic pencil; brush; Craftool gum arabic; nitric acid; Johnson's baby powder; 2 glass dishes, one of which contains a medicine dropper and a glass stirring rod; can of lithographic ink; soft rubber brayer; teaspoon; 2 soft rags; and bond paper.*

To make the image
Conté crayon
No. 1 lithographic pencil
Scratchboard knife
Gum arabic
Talcum powder
Powdered rosin
2 glass dishes or unwaxed paper cups
Glass stirring rod
Medicine dropper
Nitric acid
Water
Soft rag
Inexpensive brush
Piece of cardboard

To make the print
Can of lithographic ink
Soft rubber brayer
Waterproof palette or ink plate
Teaspoon
Bond paper

PROCEDURE

Relief and intaglio plates are generally made with sharp cutting tools of some sort and tend to be hard-edged and crisp. Etched plates are a partial exception, but even there we get relatively crisp lines combined, perhaps, with tonal backgrounds. Some people who etch metal can get softer results than you'll get with lithographs, because the metal will produce and hold a finer texture than plaster and linoleum will. But in general, when you move to true lithography, you'll get away from hard edges. You'll work with crayons, pencils, and brushes, drawing rather than carving the printing plates. Although the lithographer who works on stone or metal can give you any kind of line you want, you'll get soft lines almost every time—this gives you an entirely new set of effects to work with.

Lithography on cast plaster plates doesn't produce lines as soft as lithography on linoleum, but plaster is worth trying because it's more difficult to smut. It's more durable, too, than illustration board and linoleum. So, while you can't get as wide a range of line or tone on plaster as you can on linoleum, it's easier to use—and thus better for young children—and a lot cheaper. A block of linoleum, in fact, costs about ten times as much as a block of plaster, such as Hydrostone, of the same size. And the lithographer's limestone costs 250 times as much as the plaster!

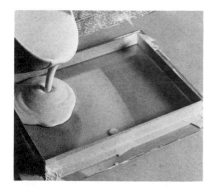

Step 1. First I must make a plaster block. I pour the freshly mixed plaster into the cardboard wall, following the same procedure I used in Chapter 5, Steps 3–6, but this time I cast a plain piece of glass. Not only is there no grease drawing on the glass, but the glass must be cleaned before use with window cleaner to make sure that it doesn't have even a film of grease or oil on it. If it were greasy, the resulting plaster plate would have a slightly greasy surface, and the lithograph would smut much more readily. Please note that the bottom side of the cast block will be as smooth as the glass—this will be my working surface.

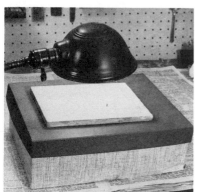

Step 2. Freshly cast plaster contains a lot of moisture. This didn't matter when we were casting relief blocks, but the greasy lithographic drawing materials won't stick well to a damp surface, and the drawing will come off of the block during printing if I don't use a dry block.

Therefore, I bake the block in an oven set at about 150° for 6 to 8 hours. To save energy I cast a dozen blocks at a time and dry them all at once, filling the oven. If I'm making only one block, though, I set it under a gooseneck lamp. I place the bulb 2″ or 3″/50mm or 75mm away from the block and bake it for, again, 6 to 8 hours. I can draw on the dried block as soon as it has cooled.

Step 3. To keep things simple, I'm going to use only one drawing tool, a No. 1 lithographic pencil. You could also use litho crayons, tusche, etc., as I do in the next chapter, but all these materials print more or less alike on plaster.

I've made a light Conté drawing—you should always use this kind of crayon if you wish to make a preliminary sketch on the plaster before using the litho pencil. Conté is completely greaseless—marks made with it will never print. Carbon paper or regular pencils will encourage smutting on plaster. Now I'm making the final drawing with the No. 1 pencil. It's better, incidentally, to use a relatively soft pencil than a harder one (they have higher numbers). And you should make each mark firmly and positively—faint lines won't print. Note that I have again left a generous border around the drawing, because the edges of a block always smut easily.

Step 4. I mix two gum solutions, placing about ½ tbsp. of powdered gum in each of two small glass dishes (you can use unwaxed paper cups instead). Then I add a tablespoon of water to each cup. Larger prints would require a larger quantity of gum solution; but this quarter-ounce I've just mixed will be enough for my 5″ x 7″/125mm x 180mm print. I stir each cup with a glass rod ½ hour or more before use. At first you'll think that the gum and water won't mix, but eventually they do, and then I add 3 drops of nitric acid to one of them, as shown above. To remember which dish has the acid and which is just gum and water, label them. If I mix a larger quantity of gum and water, I use more acid, maintaining the ratio of 3 drops of acid to ¼ oz. of gum and water.

Don't be casual when handling acid. Keep a large jar of water handy so you can rinse your hands at once if you get acid on them. If you should get any in your eyes, flush them *immediately* with large quantities of water and get a doctor. If you're going to be using a lot of acid, you should probably buy some good rubber gloves and some safety goggles—the kind intended for protection against liquids.

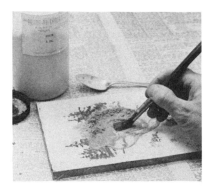

Step 5. Now come the mysterious steps, each of which is necessary and none of which is obvious. It took the genius of Senefelder to discover them. First, I dump ½ tsp. of powdered rosin onto the surface of the block and spread it around with a soft, inexpensive brush—the rosin protects my drawing from some of the chemicals I'll use later. Then I dump an equal quantity of talcum powder onto the surface and spread it around. The talc mixes with the excess rosin and makes it easier for me to brush the loose grains of both powders off the surface, which I do next.

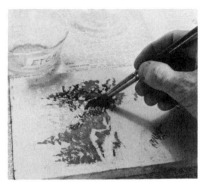

Step 6. Now I take the etching solution—the gum, water, and acid prepared in Step 4—and spread it onto the surface of the block, using the same soft brush I used for the rosin and talc. I coat the entire surface, marks, background, and borders, frequently dipping the brush into the dish to add more solution. I move this mixture around on the surface for a minute or two and then let it sit and etch. Fifteen minutes seems to be sufficient for plaster, but you can let the block sit in this condition for a week or more if you want to. This etching solution makes your drawing waterproof and the rest of the plaster surface easier to dampen.

Step 7. When I'm ready to continue, I take the same brush again (I rinsed it in warm water after the last step) and spread plain water over the surface of the block. This softens and eventually removes most of the gum applied in the last step. Then, with the block still wet with water, I use the brush once more to spread the pure gum and water solution (no acid this time) liberally over the surface.

Now I take a soft rag (an old handkerchief is ideal) and gently wipe the surface, wiping off most of the water and gum and gently buffing the rest down into the pores in the plaster. This provides a final protection to the drawing and reduces the chances of smutting the background by sealing the pores in the plaster.

Step 8. I stop wiping the buffed block when it has started to dry, and I finish the drying process by fanning the block with a piece of cardboard. I could blow on it instead, or set it in front of a fan, but I'd be kicked out of the Lithographers' League. Everyone fans his block—Senefelder must have done it this way.

At this point you can use the dried block immediately or leave it for many days or weeks. But this is the last time in the procedure where the block can be left. Once you go on to the next step you must continue to the end or abandon the print.

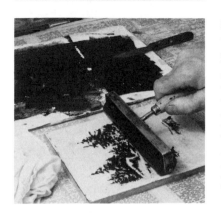

Step 9. Now to print the block. I use the same procedure I used in Chapter 12, Steps 4–7: first wetting the surface; then rolling a light layer of lithographic ink over the surface with a soft rubber brayer; making a print with a spoon; wetting the block again; inking it again; taking another print; etc. The main difference is that this time I can build up the ink layer more rapidly, because the plaster is harder to smut than the cardboard. And even if mild smutting appears, it doesn't print for some reason. Also, I can make as many prints as I want—I think some of these plaster blocks will outlive me.

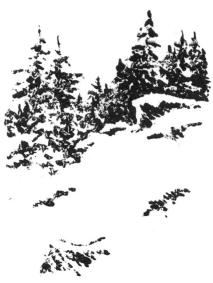

Step 10. Here's the third print from the block. As it's nearly full strength, you can see that rapid build-up of the ink is possible. But since there are some things I don't like about the composition, I'm going to make some corrections and add both blacks and whites to the block—which is something I can't do on either illustration board or linoleum. Lithographers can rework their stone or metal lithographs, but I've been unable to rework mine except when working on plaster.

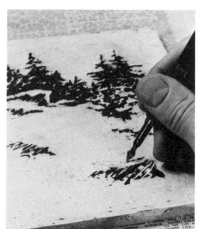

Step 11. I don't like the line over the dark object in the lower left foreground of the block, so I scrape it away with a scratchboard tool. I'm also unhappy with the placement of the four dark objects in the foreground, including the one I just altered. They're too similar in size and placement—too symmetrical. I want to add dark shapes on the left, and strengthen the nearest one to make the pattern a little more interesting. To do this, I ink the block with a brayer in the normal fashion, and then I press a heavy layer of new ink onto the block with a palette knife or brush wherever I wish to add blacks. In effect, I am purposely—and heavily—smutting the block at certain points. Then I print. Note that I do not run the brayer over the block after I have added the darks. I smut—and then print.

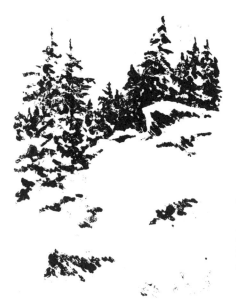

Step 12. Here's the corrected print. As you can see, both white and black corrections have registered. Although the improvement is slight, this demonstration should show you how to make corrections on your own blocks. The white corrections always work on plaster. The blacks, however, are a little more uncertain. The next time you run a soft brayer over the block you may pick up all or part of the correction you made on the previous print. If this happens, you must ink the block again and add the new blacks by hand once more before printing. I've never known a block to resist this treatment more than two or three times—but maybe you'll find one that will!

Things to note in this print: edges are soft, as in many lithographs; and there isn't much tonal variation between marks, a characteristic of lithographs on illustration board or plaster.

FURTHER SUGGESTIONS

1. Use enamel or another paint that doesn't mix with water instead of the soft litho pencil. You'll probably have to apply more than one coat so the surface of the marks is glossy—the plaster will drink up most of the first brush strokes. The paint will give you a relatively hard-edged lithograph, as in the last chapter, but you'll be able to get a lot of prints.

2. Try using both painted marks and drawn ones on one plate, combining the techniques of this and the previous chapter. The etching solution won't hurt the paint, and this gives you a slightly wider range of effects in one print.

3. Carve or scratch the plaster block mechanically to get scratchboard or relief print effects in your lithographs. In effect, you would be combining white line and black line techniques in one print.

4. Combine some of our earlier plaster techniques with lithography on plaster. You might, for example, cast various objects into the plaster block (as in Chapter 6), leaving the rest of the surface free for the lithograph. Use grease *only* around the cast objects to avoid smutting the litho surfaces. The cast objects will ink and print in relief when you run the brayer over the plate, so you'll have a combination of a collagraph and lithograph in one print.

The Tower *(Above) by David Sawargn. Lithograph on plaster, 5″ x 8″/125mm x 205mm. All toned areas in this print are built up by groups of chunky, chisellike lines of relatively uniform density. A lithograph can be a printed drawing, a purely linear work—although it may have much variation in line quality. This, plus the fact that plaster is hard to smut, makes lithography on plaster a good medium for young children.*

The Chair *by Patricia Simkowski. Lithograph on plaster, 6″ x 8″/ 150mm x 205mm. Tone is possible in lithography on plaster if you build the ink layer slowly and never ink the block heavily between prints. This also reduces the background smutting, as you can see in this soft, clean print. Some of the fine white lines in the plant were established by scratching through the drawing with a scratchboard tool. Plaster lends itself well to this kind of correction.*

Lithography on Linoleum

If you've been following all these techniques, your first lithograph was on illustration board. The procedure was simple—no powders or acids were involved—but you were only able to get a few prints. Then you tried lithography on plaster, which introduced you to the full lithographic procedure on an easy-to-use, hard-to-smut, correctable surface. Printed lines and areas were soft-edged, but were all about the same value—dark. Now you're going to make lithographs on linoleum. As you'll see, this surface will give you variations in value, and to some extent you'll be able to print faint lines as well as dark ones.

When I set out to write this book, I intended to write only about printmaking on linoleum. Plaster, illustration board, plastics, and wax weren't involved. While working on preliminary drafts, however, I learned that linoleum may disappear from our world—it's only manufactured as a floor covering and is rapidly being replaced by vinyls and other materials. Artists don't use enough to count—so I sought other materials and techniques for the book.

When I was still concentrating on linoleum, however, I sought and found—after a considerable struggle—a way to make lithographs on it. I'm glad I tried this before starting to work with other materials, because linoleum is the least likely lithographic surface I've tried. It was the hardest to conquer, but it gives the best results!

From the first, I used the lithographic process I would use on stone or metal and the same materials. I got prints right away, but the linoleum smutted so rapidly that I rarely got more than two or three (muddy) prints before I had to abandon the plate. I couldn't keep the linoleum wet enough to prevent the smutting.

Finally, when I tried roughening the surface with sandpaper to give it enough tooth to counteract the surface tension of the water, the linoleum held a film of water. I soon found that etching the surface was much more effective than using sandpaper. I could get more prints—perhaps a half-dozen or so—but each one was darker than the last, and the smuts eventually took over. The lithographer's answer to smutting is a stronger etch (more acid), so I tried adding more and more—and more—nitric acid to the gum solution. This helped, but not much. At some point I ran out of nitric acid and had to buy another bottle. The druggist was out of nitric, so, with a three-day weekend in view, and with lithography-or-bust on my mind, I brought home a bottle of *sulphuric* acid.

Woodstove *by Jeanne Mares. Lithograph on linoleum, 6" x 8"/150mm x 205mm. This is one of the first prints taken in the edition. The lines aren't fully inked and thus reveal something of the texture of the original crayon marks. This adds considerably to the cast iron look of the stove. Because linoleum can be textured, the artist can purposely introduce underlying textures not achieved by line quality alone to get various effects.*

And that did it. Now I can get long editions on linoleum—usually. Lithography is never certain. Even professionals sometimes draw a blank, and using linoleum instead of stone doesn't make things any easier. In a recent workshop—I was helping fifteen students make linoleum lithographs—fourteen people got good results; the other student, using the same materials, times, procedure, etc., got nothing. But—most of the time—it works.

Lithography on stone can have the softness of fur or the harshness of a relief cut. Its extraordinary range of tones and effects may be unsurpassed by any other printmaking technique—and may even surpass painting. Soft grays; muted blacks; toned whites; any texture the mind, hand, or brush can conceive—all are possible. To achieve them, though, the artist often must turn his blocks over to a professional printer. Only experts know how much acid to use on each portion of a block, how much ink, what consistency of ink, how much pressure, what kind of paper, etc., to coax all possible nuances from the drawing on the block.

Lithographs on linoleum fall far short of this. Delicate tones and fine lines are, I think, impossible, though I speak from only limited experience. But without doubt lithography on linoleum provides the printmaker with more do-it-at-home opportunities than any other technique I know. The artist can work with any conventional lithographic drawing material—liquid tusche, litho pencils or crayons of any hardness, rubbing ink, and so on. Each material produces a different result. In addition, since the linoleum (unlike the lithographer's stone) is soft enough to carve, you can combine lithographic and relief effects. Intaglio combinations might also be possible, if the block is large enough to allow you to ink some areas with a brayer and other areas with a putty knife.

I'm sure that my own experiments are only a faint indication of the ultimate possibilities. I feel this way to some extent about all of the techniques described in this book, but I believe that lithography on linoleum offers more potential—and challenge—than the rest.

TOOLS AND MATERIALS

To prepare the block
Mounted, uncoated linoleum
Butyrate model airplane dope
Candle
Brushes

To etch the block
Enamel photographic tray, enamel oven tray, or glass baking dish
Handful of pebbles or a pad of cloth that will just about cover the bottom of the photographic tray
Measuring cup

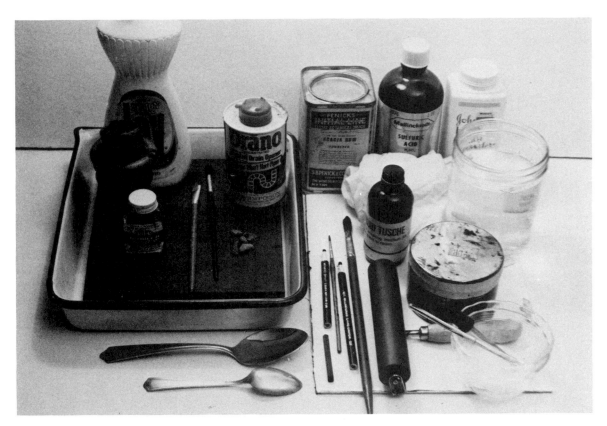

Tools and Materials. *The things I need for lithography on linoleum are very similar to those I used for lithography on plaster (from top left): Joy, candle, butyrate model airplane dope, brushes, pebbles, and Drāno sit on top of a piece of mounted, uncoated linoleum in an enamel photographic tray. Two spoons lie in front of it. To the right of the tray are: gum arabic; sulfuric acid; Johnson's baby powder; 2 soft rags; bottle of tusche; jar of water; can of lithographic ink; 2 glass dishes with a medicine dropper and glass stirring rod; soft rubber brayer; brushes; Nos. 1 and 3 lithographic pencils; and a Conté crayon.*

Drāno
Joy or another dish detergent
White vinegar

To make the image
Preliminary sketch
Conté crayon
Pencil
Nos. 1 and 3 lithographic pencils
Bottle of tusche and brush
Gum arabic
Sulphuric acid
Talcum powder
Rosin powder
2 soft rags
Water
2 glass dishes
Glass rod
Medicine dropper
Inexpensive brush

To make the print
Can of lithographic ink
Soft rubber brayer
Waterproof palette or ink plate
Teaspoon
Lithographic printing paper (see Chapter 2)
Jar of water

PROCEDURE

The procedure for making linoleum into an etched lithographic plate is basically the same as the process described in Chapter 9. And printing lithographs on linoleum is the same as printing lithographs on plaster or illustration board—you just need to take a little more care.

Step 1. Here's the etched block. Before etching it, I prepared the linoleum by painting and waxing the sides of the block as I did in Chapter 9, Step 4, to protect them from the caustic soda bath. After making sure that all traces of wax and paint were scraped from the front surface of the block (the working surface), I etched the block in the caustic bath, following the procedure illustrated in Chapter 9, Steps 5-7. Of course, I used sulphuric acid instead of nitric acid. I etched the block for about 20 minutes and then cleaned it with Joy and warm water. As there were no unetched spots, I dried the linoleum and moved on to the next step. When you do this, note that it doesn't matter much how long a block stays in the bath as long as the entire surface has become textured.

Step 2. I decided to transfer a preliminary sketch to the linoleum, so I rubbed the back of the sketch with Conté crayon and taped the sketch onto the linoleum, Conté side down. Here I'm going over the principal outlines of the drawing with a pencil. This will produce faint lines on the linoleum, which I'll strengthen with the Conté crayon, working directly on the linoleum. I can't use carbon paper instead of Conté crayon—it would smut the plate badly.

When I'm satisfied with my sketch, I'll make the final drawing with litho materials. I'll use the harder pencil, the No. 3, for the lines I want to print as faint grays. But I don't draw them as faint grays—I make each line as dark as I can. My drawing won't look like the resulting print; but I know from experience that a faintly drawn line won't print, while a heavy line drawn with a hard pencil will print faintly. To make a line print dark, I use the softer No. 1 pencil. Refer to the final print, Step 9—I used the No. 3 pencil for the faint background lines and for the lighter lines of the skeleton; I used the No. 1 pencil for the shadows on the skeleton.

Step 3. I could use the No. 1 pencil for large, dark areas, too, but I prefer to paint these on with liquid tusche, a greasy, water-soluble material used for silkscreen and lithography. It's expensive! But it makes the richest darks of all and is good for textures. Here I'm using it for the goat at the top of the drawing. Note that I don't have a border around the drawing as I did in the plaster and illustration board demonstrations. The edges of any type of block tend to smut more than the center, but this was one of my first lithographs—I didn't realize it.

Step 4. Next I mix two gum solutions, as I did in Chapter 13, Step 4. I mix the same quantity—about ¼ oz.—in each of my two containers. Since I need a really potent etch this time, I add 30 drops of sulphuric acid to the gum and water solution in one of the two dishes. Be careful when you use the sulphuric acid—it's even stronger than nitric!

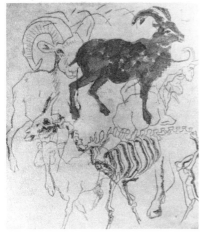

Step 5. When I'm ready to proceed (the drawing can be left on the block overnight, or longer), I spread rosin and talc over the block with a soft brush, as in Chapter 13, Step 5. Then I apply the gum-water-acid solution (Chapter 13, Step 6) and let the block etch for an hour or more. You can see my block etching in the photograph—note that I've mounted it in a printing frame. In some class situations I've proceeded after 30 minutes, but I think a longer etch is better. Lithographers vary widely on their etching procedures. Many of them etch overnight—this long an etch won't hurt the linoleum plate, but an hour is acceptable.

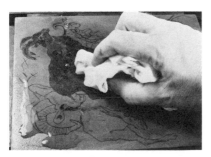

Step 6. When the block has etched, I brush it first with plain water and then with the gum and water (no acid) solution. I buff the latter and finish drying the block by waving cardboard at it. In short, I repeat Steps 7 and 8 in Chapter 13 without change. When the buffed block has dried and is ready to be printed, I take a clean rag—not the one I buffed it with—and wet it again with pure water—not the water I previously washed it with. Linoleum smuts readily—you must do everything you can to keep it clean.

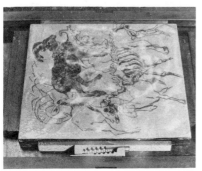

Step 7. Here's my block, ready to be inked. I roll lithographic ink onto the paper palette and start to ink the block. This time I must build up the ink layer very slowly, or the plate will surely smut. Furthermore, I must always run the brayer from one edge of the block to the opposite side on each stroke. If I start or stop the brayer in the middle somewhere, it will invariably leave a smut line. After each pass of the brayer, I examine the block for smuts. And after almost every pass—especially in my first few prints—I wet the block with my rag before rolling on more ink. Keep the linoleum wet, or you'll have to start all over!

Step 8. If I proceed cautiously enough, it will take six prints or more to build up a suitable layer of ink. If I try to rush this process—which I find very frustrating—the block always smuts. So I grit what's left of my teeth (I've been making lithographs for several years now), and carry on.

This *is* the sixth print, in fact. My drawing is starting to

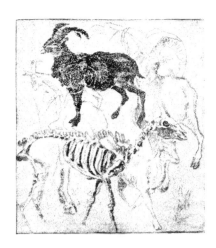

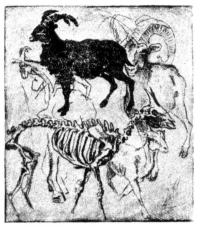

ink, but it isn't dark enough yet. The background has smutted slightly, but there's still an acceptable contrast between drawing and background. It looks as if I'll be successful—if my arm doesn't fall off! Spoon printing is always hard work, and it's hardest with lithography on linoleum because a large number of prints *must* be made to get to the good ones. This is why I usually use the printing frame when making these prints—the frame relieves some of the strain on my muscles by holding the block and paper.

Step 9. Here's print number 18. The block has been fully inked for the last several impressions. The background has darkened (and will continue to darken), but the drawing is clear above the smuts. I can—and will—make more prints before stopping. (I made twenty-two more prints of this block—and the last was only a little darker than eighteenth. I could have made more had I wished to.)

A word of caution. When you spoon print a lithograph on linoleum, you must use the spoon to produce pressure, not heat. Firm, slow strokes are best. If you rub briskly and rapidly back and forth, you'll heat the block enough to dry it. Even though you wet it again before making another print, the heat seems to encourage smutting.

One more point. When you're through printing the block, wash off the drawing and ink with turpentine or the equivalent. Then clean the surface with detergent and water. Etch the block again for 5 or 6 minutes in the etching bath, and use it for another lithograph. Since linoleum is getting more and more expensive, this is worth doing.

FURTHER SUGGESTIONS

1. Experiment a great deal with various lithographic drawing materials and tools. Make and print all sorts of lines, textures, edges, and tones.

2. Experiment with variations in the strength of the etching bath to suit variations in drawing. The professional lithographer uses a strong etch (lots of acid) on dark or heavy lines and areas; he uses a weak etch on fine or faint lines and passages. Try this yourself.

3. Try different papers, and try them both wet and dry. Most lithographs are made on damp paper, as are etchings and engravings. I haven't seen much difference between damp and dry papers in my own experiments, but I haven't obtained as wide a range of tones as I believe is possible, either.

4. Try etched metal plates instead of linoleum. These are more expensive than linoleum but cheaper than stone and can be obtained by mail from printing supply houses.

5. Try combining relief and lithographic techniques on your linoleum or plaster plates.

PART FIVE

PLASTIC
WAX AND
MIXED MEDIA

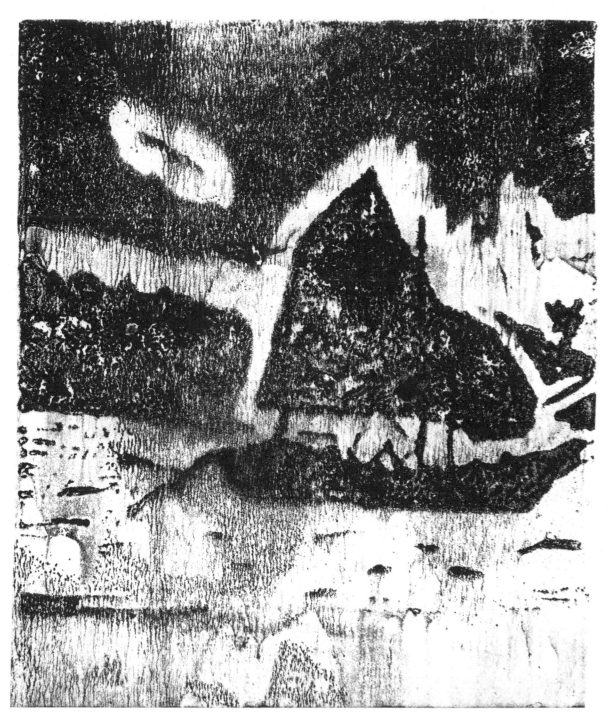

Moonlit Harbor by Steven Duncan. Transfer print from an etched linoleum block, 6″ x 6″ / 150mm x 150mm. This print was made from the same block that produced The Sailboat on page 84. If you compare the two, you'll see again that you can achieve many different effects by varying your printing technique. The Sailboat is a fairly straightforward relief; this transfer print was made by rolling a vinyl impression of the block with a brayer that had been dipped in type cleaner. The artist applied very little pressure as he rolled the brayer over the vinyl, so the image remained basically intact.

CHAPTER 15

Transfer Printing with Plastics

Like lithography, transfer printing is a planographic process. It's not as popular or versatile as lithography, but it's simpler and much less inhibiting. With transfer printing, you can achieve results that differ in every respect from those you've achieved so far. It's a new way to print relief blocks and plates made by other methods and media—cast or carved plaster, linoleum, wood, or wax. Instead of printing directly on paper, you print onto a durable, reusable, nonabsorbent material, such as vinyl plastic (which is the material I'm going to use in my demonstration), and then print onto paper.

I'll use vinyl plastic as both my transfer surface and relief block material. As a relief block, you'll see that vinyl has some of the characteristics of linoleum. As a transfer plate, vinyl is flexible enough to give an excellent impression—even of an irregular surface such as that of found objects. It's tough, furthermore, so you can manipulate inked impressions endlessly on it in many ways without damaging or changing the surface. Since you can carve vinyl plastic, you can also combine relief and transfer effects.

That's why I think that vinyl plastic is the best transfer surface. You can, however, use other materials, such as well-sized or waterproof paper—like paper palettes made for acrylic painters—linoleum, and even glass (if your relief block is dead flat or flexible).

Transfer printing can be either a black line or white line process, as you'll see in the demonstration. Because you end up with a print of a print, there is no image reversal. You can use this technique to produce hard or soft-edged prints, but soft-edged ones are more typical.

The sharp edges found in most relief blocks usually produce hard-edged prints. (Statements of this sort can always be qualified, but no book is long enough to list all the exceptions.) However, if you take a print from a flat, uncarved surface, such as a lithographic plate, the ink can spread and run over that surface to soften the edges when you apply printing pressure. An uncarved printing surface also makes things like wash effects possible—shapes with literally no edge at all.

You were exposed to some of this in the chapters on lithography, but the complexity of the lithographic process is inhibiting. Corrections are difficult to make, and the plates themselves require so much preparation that you seldom feel like experimenting. Transfer printing offers a new way to produce a printable impression on a flat surface—

and this time you can play around without destroying your primary block or plate. In fact, you'll have the freedom of the monoprint process plus enough control to make a large number of similar prints if you wish to.

Perhaps I should define monoprint for you. To make a monoprint you draw or paint a design on a flat surface—usually glass or metal. Before the painting has dried, you lay a sheet of paper on top of it and rub the back of the paper with a spoon to obtain a single (hence mono) print of the painting. The printing process destroys the picture. Each print is different from the next—and the artist usually does only one or two. However, the process leads to all sorts of interesting accidents and effects and is a very useful tool in creative drawing.

With the transfer process you print, rather than paint, an image onto the flat surface. Then you add to or subtract from the printed impression or modify it by various means. Although the result is a distortion of the original image, it's still based on the original and can be repeated if desired.

Transfer printing can show you how far you can develop a printed image by modifying and extending the printing process. As I've said several times, you mustn't accept your first prints as final with any process. You should always develop both your blocks and your procedure to get the most from a given composition. Transfer printing will help you do this. Also, it will help you save blocks that disappoint you when printed in a more straightforward manner. It will also make it possible for you to get a whole family of images from one plate. Transfer printing can lead to wild textures and effects you couldn't achieve by any other simple means—it's a significant new tool for your bag of tricks.

This technique also introduces you to the concept of a transfer—which is a very important part of commercial printing techniques such as offset lithography and xerography. Transfer makes it possible for the printer to produce high quality reproductions at low cost. As budding printmakers, you should know about this concept.

TOOLS AND MATERIALS

To prepare the block
Sheet of vinyl plastic with adhesive backing
Oil-based ink
Brushes
Scissors
Piece of pressed board
Jigsaw
Linoleum cutters

To transfer the image
Oil-based ink
Sheet of vinyl plastic
Spoon

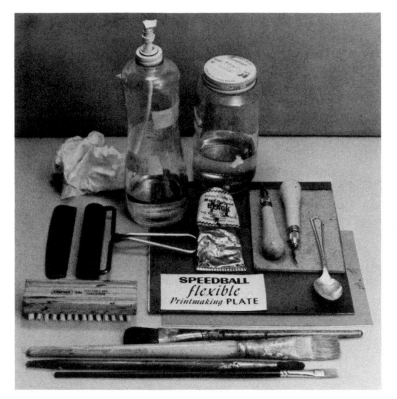

Tools and Materials. *None of the materials I'm going to use in my demonstration are essential—you can substitute something else or eliminate every one. I think this will become clear as you watch the demonstration and reconsider my opening statements. Anyway, I'm going to use (from top left to right): paper towel; spray bottle containing type cleaner (solvent for the ink); jar of type cleaner; comb; brayer; 2 sheets of vinyl plastic (Flexible Printmaking Plates); tube of oil-based ink; linoleum cutters and spoon; sheet of pressed board; vegetable brush; and assorted stiff and soft paint brushes.*

Paper palette or ink plate
Brayer
Paper towel
Type cleaner (in both a jar and spray can)
Comb
Vegetable brush
Brushes, soft and stiff

To print the block
Printing paper
Spoon

PROCEDURE

I'm going to make a relief block of vinyl plastic and print its image onto another, uncut, piece of vinyl plastic called the transfer plate. With an inked impression on the transfer surface, I'll use mechanical and/or chemical means to alter this impression—soften it, smear it, blot it, and so on. Then I'll lay the printing paper on the transfer surface to make a print. In effect, I'll be taking a print of a print. And, after I take the print on paper, I'll clean the transfer surface and repeat the process, manipulating the transfer impression in a slightly different fashion. I'm going to call these manipulations "Variations" rather than "Steps" this time.

Each new thing you do to the transferred image produces an entirely different effect. However, although I don't show it here, you can easily repeat a general effect if you want multiple prints that are similar. Even a print as loose as

Variation 3 can be repeated if, each time, you follow the same process, using the same amount of ink, solvent, etc. The resulting prints will differ from each other in detail, but will be very much alike in general effect.

Now, watch me and try your own transfer prints—they're as much fun as mud pies, and almost as messy!

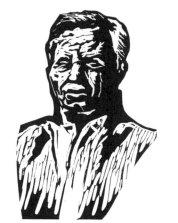

Preparing the Block. After I draw a face on one of the sheets of vinyl with ink, I cut away most of the background with a pair of scissors. Then, I remove the protective paper from the back of the vinyl to expose an adhesive coating, press the vinyl onto a piece of pressed board, use a jigsaw to cut most of that away, and use linoleum cutters to carve relief details into the vinyl. Making a vinyl plate is similar to making a conventional linoleum relief block. The vinyl is more rubbery, however, which makes it a little more difficult to carve—especially if fine detail is required. But it is a partial substitute for linoleum.

Taking a Relief Print. Here's a straightforward relief print of my finished plate, not printed by transfer. It's a good idea to do this for your first print, just to see what the image looks like.

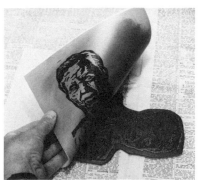

Transferring the Image. Now to use the transfer method to print this portrait study. I use a brayer in a conventional fashion to ink the carved relief plate. Then, I lay the second sheet of vinyl plastic on top of the inked plate and rub the back of the top sheet with a spoon. In effect, the top sheet of plastic is handled as if it were my printing paper. Since it's flexible, it takes a good impression of the inked relief plate.

In this photograph I've finished rubbing, and I peel the top sheet of vinyl away from the plate again, as if it were printing paper. I now have a wet, inked impression of the portrait study on the flat vinyl sheet.

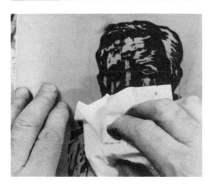

Making Variation 1. I could lay printing paper on the flat sheet of vinyl and take an impression of the inked image as is. The transfer process, however, allows me to modify and (hopefully) enhance the design by doing things to the transferred impression. I'll show you several different possibilities. Here's a simple one—I take the paper towel and drag it several times over the transfer impression, smearing the ink, blurring details, and softening edges.

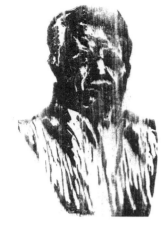

Variation 1. Here's the resulting print on relief paper—I just laid a sheet of paper on the smeared image and rubbed the back of the paper with a spoon as usual to make it. Notice the differences between this print and the straight relief print. There the edges were hard; here they're soft. Now details are blurred and there are tones in some areas. Whether or not you approve of these modifications in the image, you must admit that the print has been altered by wiping the transfer impression.

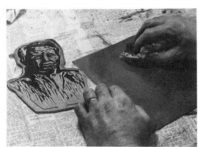

Cleaning the Transfer Surface. After I've taken the first print, I clean the transfer sheet of vinyl plastic thoroughly with type cleaner or another ink solvent to get ready for a second print. When the transfer sheet is clean, I'll ink the relief block again, make another impression on the transfer sheet, manipulate this second impression, take another print, clean the transfer sheet again, make another impression, and so on. Each time, I'll do something different to the transfer impression to show you some of the many possibilities.

Variation 2. This time I rolled a lightly inked brayer over the transfer impression before making the print. I sprayed the brayer gently with type cleaner (ink solvent) before rolling. As you can see, this breaks up the image more drastically than the paper towel did.

Variation 3. I used a soft brush to flood the transfer impression with solvent. After blotting the whole thing with a piece of bond typewriter paper that picked up most of the ink and solvent, I laid a fresh piece of paper on the transfer surface and printed.

Variation 4. I used a very light layer of ink on the relief block this time before making the transfer impression. Then I sprayed the transfer sheet once with solvent—and it was a rather coarse spray. I gave individual droplets a few seconds to soften the ink they had landed on and then made this print.

Variation 5. This time I reversed the procedure a little, while still making use of the basic transfer process. I cleaned both the relief plate and the transfer sheet. Then I rolled a light layer of ink onto the transfer sheet rather than onto the relief plate. Laying the relief plate on top of the inked transfer sheet, I rubbed the back of the relief plate with a spoon to remove ink from portions of the transfer sheet. Then I placed the printing paper on top of the transfer surface, as before, to obtain this negative or white line print of my relief carving.

FURTHER SUGGESTIONS

1. Use stiff or soft brushes of all kinds to wipe, daub, or smear the transfer image. For example, you can convert a hard-edged relief image into a stippled image by stabbing the impression over and over with a bristle brush.

2. Use soft brushes to flood the transfer image with colored or toned washes before printing. If you transfer with oil-based inks and then add watercolor washes, the wash will not soften or mix with the transfer image but will add color or texture to the print.

3. Print multiple images onto the transfer surface before taking the print. These can be overlaid or offset, of single or many colors, using various amounts of ink and/or solvent to produce a wide variety of effects.

4. Carve away portions of the transfer surface to produce some hard edges. To print, you'll have to register the relief block properly with the transfer surface each time you make the transfer impression, but this is easy to do with a printing frame (see Chapter 4). You'll be able to keep some lines and areas clear and sharp while softening and modifying others.

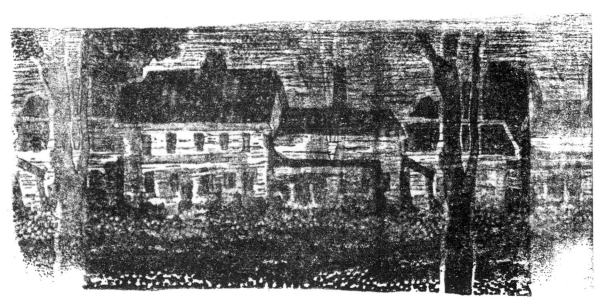

Colebrook *by John Bickford. Transfer print of a woodcut, 4" x 9"/ 100mm x 230mm. To make this print, I first made an impression of the woodcut on a sheet of vinyl plastic. Then I ran a dry, clean brayer over the vinyl, redistributing portions of the original impression. The resulting print, I think, is far more interesting than those I made directly from the wood. Many other effects are possible here, depending upon the way I manipulate the impression on the vinyl before printing on paper.*

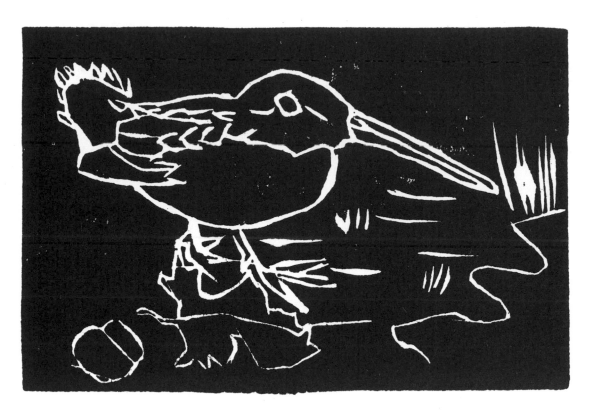

CHAPTER 16

Polyester Plastic, a Linoleum Substitute

Woodcock *(Top left) by Leila Bickford. Carved polyester plastic relief, 3¼" x 4½"/82mm x 115mm. The easiest way for young children to make a linoleum print is for them to carve the sort of linear design seen here. No background areas to cut away or to avoid while inking the block. Both the plastic linoleum substitute of this chapter and the wax of the next lend themselves to this purely linear treatment. My daughter drew directly on the block with a pencil to establish the design. She then followed the lines with a No. 1 Speedball cutter to carve the block.*

Compass *(Left) by John Bickford. Carved polyester plastic relief, 4" x 5"/100mm x 125mm. I made this quick sketch of a compass to illustrate the description of a hike a friend and I had taken in the backwoods of Maine. Just a quick study. Polyester, like linoleum, is great for this kind of thing—it's inexpensive and so easy to cut that you can work impulsively without a lot of preliminary design effort.*

I had originally intended to write several chapters on plastics, but I found myself looking at them as substitutes for other materials rather than as a route to something new—and I didn't like their feel or their smell. So I'm only going to describe two uses of plastic: the vinyl transfer process of the last chapter, and the substitute-for-linoleum process of this one. In both cases, the plastic makes it possible to do something I can't do as well with other materials.

There are several reasons why I substitute one material for another. First, the conventional materials of printmaking are often too hard to obtain or too expensive to be convenient. The lithographer's Bavarian limestone is one example; hence my search for substitutes leading to lithography on etched linoleum and cast plaster. Also, the results achieved with a substitute material will always be a little or a lot different from those achieved with the conventional material, since each material has its own set of properties. I can get effects with one that I can't get with the other, enlarging my bag of tricks. Neither of my Bavarian limestone substitutes is as good as the original, but each has some unique advantages as well as disadvantages.

Finally, in this age of future shock, many materials are endangered species, nearing extinction as manufacturers replace them with better or cheaper materials. And "better" for their purposes doesn't always mean better for ours. During the course of my experiments to develop the procedures described in this book, I've had to abandon at least five useful materials after learning that they were no longer on the market. One of my biggest disappointments was learning that a type of plastic-based house paint—that when used as a primer made it possible for me to make lithographs on wood—was no longer available. My can of paint was several years old—when I went to buy more, I found out that it had been replaced by a "better" kind, which turned out to be useless for lithography. To date I haven't found a satisfactory substitute for that paint.

Even more distressing, linoleum may not be available much longer, as I mentioned in Chapter 14. If my informants are correct, only one company in the United States still manufactures it. There are additional sources in Europe and Japan, but their products, while usable, aren't as good for printmaking purposes as the battleship linoleum

that used to be so common. Some experts predict, therefore, that in as little as five years linoleum will no longer be available to artists—and will never again reappear.

I'm an addicted linoleum printmaker, so this is a major crisis! Linoleum has long been the best—often the only—low-cost, easy-to-handle printmaking material available. And, as some of the previous chapters have suggested, it's a versatile material for printmaking at any level. No more linoleum! A good substitute *must* be found. Polyester plastic is a one good possibility, and wax (which I discuss in the following two chapters) is another.

In looking for a substitute material, you should first consider the basic properties of the one you're trying to replace. Don't just try a lot of things—first define what you're looking for, then try them. Linoleum as a relief block, for example, has an unusual set of properties that aren't easy to find in a single material; but most of which are useful for our needs. It's soft enough to be cut easily (even by school-children) but is hard enough to support satisfactory detail. It's neither brittle nor rubbery. Linoleum is relatively low-cost (although this will no longer be true as it becomes rarer) and easy to obtain at the present time. You can draw on it, or transfer drawings onto it, with ease. It stands up well under repeated printing—you can make thousands of prints from one block if you want to. And, it has no grain, making it as easy to cut in one direction as in another (which is a desirable feature for beginners).

Linoleum—again as a relief block—has disadvantages as well as advantages. It would be nice to find a substitute that had all of the latter and none of the former. First, it's difficult to add black to the relief surface (black-line corrections). You have to patch in a new, uncut piece of linoleum, and it's difficult to blend the new with the old so well that the joints don't show in the print. Patches are possible, but not easy. Also, textures and tones are generally limited to those you can produce by mechanical means—scratching, stabbing, or gouging the block repeatedly. You can also produce a texture by etching the block, but even here there is a limitation on the number of effects you can achieve.

In looking for substitutes for linoleum as a relief block, I found plastic and a wax. Blocks of both materials feel just like linoleum when you carve them. They're inexpensive and available. I found them by making and trying a number of different materials—including a number of plastics and several different wax mixtures—and testing each for its carvability. I'll discuss my search procedures at greater length in Chapter 20; in this chapter I'll demonstrate using polyester plastic.

TOOLS AND MATERIALS

To prepare the block
Talcum powder

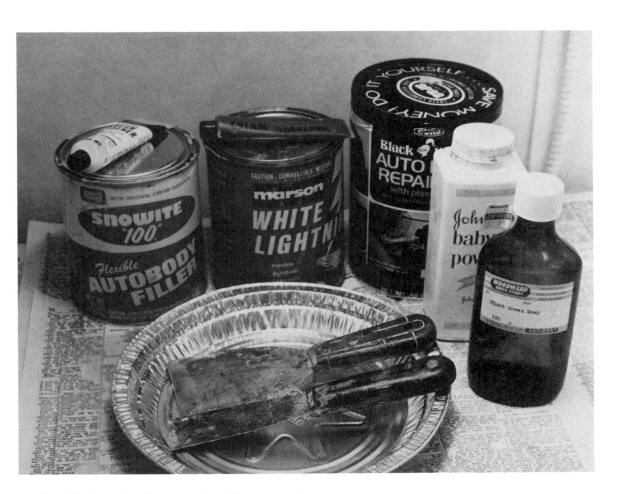

Tools and Materials. *The materials used for this process are very simple. From left to right: 3 cans of the poly-ester resin that's normally used to fill dents and holes in the body of an au-tomobile (any brand will do, and you only need one can) plus small tubes of hardener that come with the resin; sheet of glass; aluminum pie plate; putty knives; Johnson's baby powder; and a bottle of tincture of green soap.*

Tincture of green soap
Sheet of glass
Can of polyester resin and the tube of hardener that comes with it
Putty knife or wooden paddle
Aluminum pie plate
Wooden block
Matknife or the equivalent
White oil paint and brush if auto plastic is black

To make the image
Grease or lithographic pencil
Linoleum cutters

To print the block
See Chapter 10, page 86, for the materials you'll need to print the plastic relief block.

PROCEDURE

Now I'll show you how to handle the plastic to make the block. A word of caution: whenever you work with liquid plastic materials, work in a well-ventilated place and follow the manufacturer's instructions and cautions. With that in mind, let's make a plastic relief block.

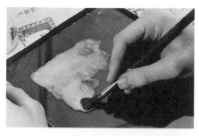

Step 1. I'm going to cast the plastic against the flat face of the glass. As the plastic will tend to stick to the glass unless I first coat the glass with a release agent, I brush on a mixture of 2 tbsp. tincture of green soap and a little talcum powder. This mixture is an excellent release agent—although I could use a silicone solution in place of it.

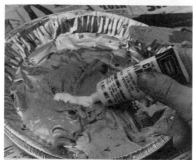

Step 2. After stirring the resin with a putty knife as if it were a can of paint, I scoop some of it out and put it into my aluminum pie plate. I use a disposable mixing pan because it will have to be thrown away when I'm done. As I'm going to make a 5" x 7"/125mm x 180mm block, I need a quantity of plastic equal to about half the size of my fist. Then, I add the hardener, following the manufacturer's directions on the small tube. It really doesn't matter how much hardener I use, but the more I add the faster the resin will harden. The resulting material is the same whether I add too much or too little hardener.

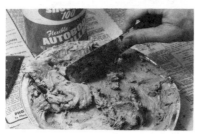

Step 3. I stir the hardener into the resin, again using a putty knife. Since the hardener and resin are usually different colors, I can tell when the two are uniformly mixed. I don't want to spend too long doing this because the plastic will harden fairly rapidly after I've added the hardener. I've only got about 2 or 3 minutes to mix and spread the ingredients onto the glass.

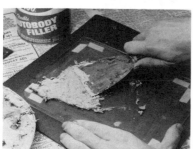

Step 4. Using the putty knife, I spread the material over the glass. A narrow putty knife will suffice for small blocks; a wider knife is better for larger surfaces. I try to deposit a layer of resin about ¼"/7mm thick (about twice the thickness of a sheet of linoleum). The resin doesn't have to be exactly the same thickness everywhere, but the more uniform the better. I cover an area of glass somewhat larger than the wooden block to make sure all edges and corners of the wood will be coated.

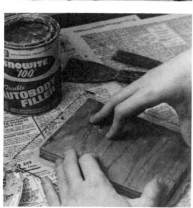

Step 5. Still working fairly rapdily, I press the wooden block down into the soft plastic. The wood will serve as the back, the main support, of the finished block. You can use the plastic unmounted, like linoleum, but you don't need as much material if it's on a block of wood.

After I've pressed down the block, I use the putty knife to force the excess plastic under and around the edges of the wood and to scrape most of the remaining plastic off the glass surrounding the wood.

Step 6. For efficiency's sake, I usually make more than one block at a time, as shown in this photograph. I coat an old broiler pan with the soap and powder mixture, cover most of the surface with the auto plastic, and press several small pieces of wood (or one large one) down into the plastic. I can easily snap off or cut apart the small blocks after the

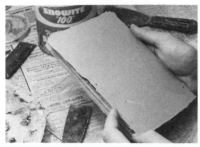

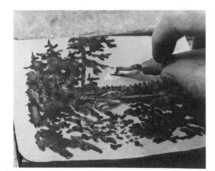

whole thing has been separated from the pan.

This blockmaking process is messy, whether you're making one block or several, but it's straightforward enough. You can clean your hands with waterless hand cleaner, and you can clean your tools by wiping them on paper towels when the plastic's still soft or by scraping them with another putty knife if the plastic has hardened.

Step 7. When the plastic has hardened—it takes about 15 minutes—I force the putty knife under one corner to lift the block away from the glass. It comes away readily, though at first you'll think it won't.

I use a matknife to trim the plastic around the edges of the wood—there will always be some sharp, ragged pieces clinging to the block. Then I soak the block for half a minute or so in tepid water and hold it under a tap to flush away the tincture of green soap and powder mixture.

Step 8. If the block is black (some auto repair plastics are light gray, some light pink, some black), I give it a coat of white oil paint so I can draw on it. Otherwise, the block is ready to use—like linoleum.

I draw a design on the plastic with grease or lithographic pencils and use linoleum cutters in the normal fashion to make a relief block out of the plastic, as I'm doing in this photograph. Dull cutters seem to slip a little more readily than they do in linoleum, but otherwise the two materials are hard to tell apart.

Step 9. One nice thing about the plastic block, though, is that it can be readily repaired if you carve away too much. Just use a putty knife or palette knife to trowel fresh plastic into the damaged area and smooth the area with the knife while the plastic is still wet (or press a piece of glass coated with tincture of green soap and powder down onto the fresh plastic). This is much easier than repairing linoleum.

FURTHER SUGGESTIONS

1. Try different kinds of plastic, and cast the polyesters or epoxies. Work with them as if they were plaster or wax. For example, you could use molten wax—or one of several plastics, including acrylics—to paint a drawing onto glass. You could then coat the drawing with soap and powder mixture or with a silicone release agent and cast an impression of the drawing, which could be printed either as a relief or as an intaglio.

2. You can engrave many plastics—the acrylics, for example—the way you engrave linoleum.

3. Make plastic collagraphs, embedding materials in the surface of the block and assembling other blocks (see Chapter 6).

4. You can tape a sketch to cardboard, make a cardboard box on glass, fill the box with a clear polyester casting resin, and lay the drawing upside down on top of the resin. When the resin has gelled—it takes a few minutes—turn the cast block over and start to carve a relief. Your drawing will show through to guide you. Cut away the larger areas right away, in the first hour, when the partially cured plastic is easy to cut. Save fine details for later, when the plastic is hard enough to support them.

Mystic Animals *(Top left) by Lisa Reeve. Carved polyester plastic relief, 6" x 7½"/150mm x 195mm. I'm not sure what this print by a middle-school student is supposed to represent, but it's very graphic, isn't it? Positive areas play against negative (is the lower creature underground?). Two equal shapes, but with enough differences to make this an image of two creatures rather than one animal and its reflection. The block was carved with conventional linoleum tools and printed on bond paper with water-based, linoleum-block ink.*

Christmas Tree *(Right) by Lisa Agnes. Carved polyester plastic relief, 5¼" x 6"/132mm x 150mm. This oriental-looking print was made by a high school student. She carved a white line design in a block of polyester plastic, using linoleum tools and techniques in a normal fashion. The block was inked with oil paint diluted with turpentine. The print shows how a simple design can be enhanced by the proper inking and printing procedure. It also shows that there's little or no difference between the effects you can achieve with linoleum and those you can achieve with the linoleum substitute of this chapter.*

Woods, Interior *(Left) by John Bickford. Carved polyester plastic relief, 4" x 5"/100mm x 125mm. I made a quick sketch of this scene during a hike on the Appalachian Trail in Maine. I then used acrylics to work out the design shown here, using both white and black paint as required to establish or correct positive and negative areas. When I was satisfied with the design, I used carbon paper to transfer it to a block of polyester plastic. I cut and printed the block with conventional linoleum tools and procedures.*

CHAPTER 17

Wax as a Relief Material

Now let's consider wax, a very interesting family of materials with some of the characteristics and properties of the thermoplastics. Like the thermoplastics, wax can be poured in liquid form and then hardened and carved. It can be remelted and reformed. Unlike the plastics, however, it doesn't have to be mixed with chemicals in order for it to harden and set. Your only tools will be a knife, a spoon, and an oven. As you'll see in this chapter, certain waxes can be used as substitutes for linoleum blocks. In the following chapter, you'll learn how to use wax in a tonal process that bears a slight resemblance to the mezzotint process (which I'll describe later). In any event, I think you'll find wax an exciting new printmaking material.

To start, I'm going to make a flat wax block that can be carved with conventional relief tools. In effect, I'll make another linoleum substitute, similar in many ways to the polyester plastic block I made in the last chapter. But there are important differences. You can easily control the hardness of the wax block, making it hard for fine detail and soft for easier cutting of large shapes. Also, wax blocks can be melted down and used over and over again endlessly. Although wax is initially a more expensive raw material than polyester plastic, it becomes much cheaper if you reuse it.

I knew very little about wax when I started experimenting with it. I was surprised to learn things like most commercial candles are not made of wax. Their main ingredient is paraffin, a petroleum substitute for true wax. True wax is made by animals—such as the bee—or by plants. There are also some mineral waxes—waxy rocks, in effect—that are mined in a few places.

I also learned that wax is used far more widely than I had realized. It's a common ingredient of such things as jelly, carbon paper, cosmetics, and vitamin pills—and so plays a significant role in our lives. Dozens of different waxes, with names like carnauba, candelilla, and ouricury are used by industry. Obtaining these things locally, however, for small-scale printmaking at home, is something else again. The sources available are mostly of the mail order variety. Nevertheless, these materials are worth the effort required to obtain them.

After all, wax can be carved like wood or linoleum; it can be cast like plaster; it can be melted and reused like no other material I'm aware of; it can be melted and mixed with a wide variety of other materials to alter its properties; it can be sawed, drilled, joined, scribed, fused—worked in a

Polar Bear *(Top left) by John Bickford. Wax relief, 4" x 6" / 100mm x 150mm. Commercially available, asbestos-filled carnauba wax can be mixed with candle wax, cast into a block, and used as a substitute for linoleum—as I did in the print. I proportioned the two waxes to make a block that was the same hardness as linoleum. (I could have also made the wax harder or softer than linoleum.) As you can see, wax, like linoleum, is an excellent white line medium.*

Magic City *(Left) by Claudia Palmer. Wax relief, 5" x 6" / 125mm x 150mm. If everyone could see the world as boldly—or perhaps as casually—as school children, we'd all be artists of sorts. There's nothing timid about this print, is there? And there's no medium in the world better for bold statements than a relief print.*

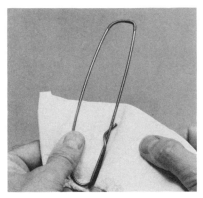

Making a Stirring Paddle. *I have to make this to blend the melted Rigidax and candle wax when they're ready to come out of the oven. Since they have different viscosities, they won't mix of their own accord.*

To make the stirring paddle, I bend a foot-long piece of heavy wire (wire from a coat hanger is perfect) into an elongated loop. Then I wrap one end in a paper towel, which I staple in place.

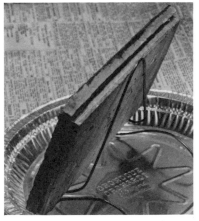

Melting Down a Wax Block When I'm Finished. *When I'm through with a wax block, I melt it down for reuse. To do this I prop the block up on a wire rack made from a wire coat hanger. I set this arrangement on a disposable aluminum pie pan and place the whole thing on a sheet of aluminum foil in a 200° oven. In about 20 minutes, the wax will slide off the block into the aluminum pan. I remove the pan from the oven, and, when the wax cools, I peel it away from the aluminum and break or cut it up into chips for the next block. I'll also reuse the wooden block.*

great number of ways. And all easily and inexpensively. No exotic chemicals or elaborate procedures. No shelf life problems. No rubber gloves. Just you and your material. I think you'll start to see some of the possibilities during the demonstration in this chapter, but this is only the starting point. No other material I've worked with offers as many different—yet simple—possibilities for the future. This versatility is more important than the specific technique I'll demonstrate here.

I was interested to learn that although wax is not an important printmaking material at the present time, it was extremely important 100 and more years ago. A man named Sidney Morse invented a wax engraving process, called cerography, which was used extensively for nearly a century to print maps. (Sidney's brother invented the telegraph.) One of the commercial attractions of cerography, apparently, was the fact that you could stamp place names into the printing plate, rather than carve them out by hand. I didn't discover all of this until I had "invented" the process I'm about to show you, so I was a little irritated to find Mr. Morse. Nevertheless, wax can be used in many ways he wasn't interested in. So—welcome to the rebirth of cerography.

The principal wax I'm going to use in this and the next chapter is a commercial product called Rigidax. It's composed of carnauba, a true vegetable wax produced by a certain type of palm tree in Brazil, and various fillers, such as asbestos. Carnauba is one of the hardest waxes, harder than linoleum, so I mix it with softer waxes (as you'll see in a minute) when I want a relief block that cuts like linoleum.

Instead of Rigidax, you might buy and use pure carnauba, which seems to be a little harder than Rigidax, melts at a slightly higher temperature, sticks to glass less readily, and doesn't support a wooden block quite as well. Also, carnauba tends to crack as it cools. Nevertheless, it's an excellent material, and after some experiments you should be able to do anything with it that I'll do here with Rigidax.

TOOLS AND MATERIALS

To make the stirring paddle
1'/305mm heavy wire, like a wire coat hanger
Paper towel
Stapler

To prepare the block
½" to ¾"/15mm to 20mm wide cardboard strips
Sheet of glass
Masking tape
Talcum powder
Tincture of green soap
Soft, inexpensive brush
Rigidax chips

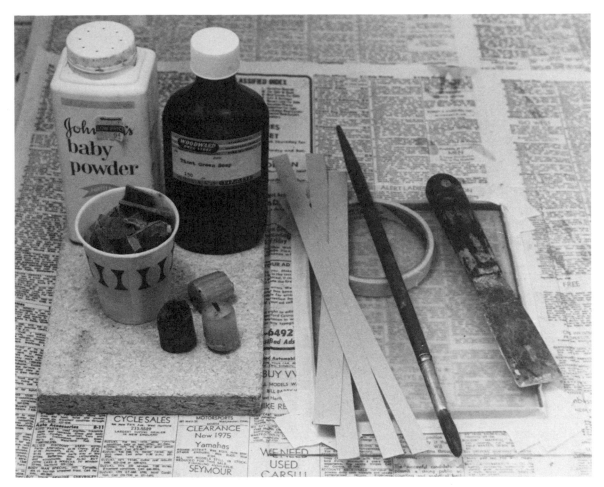

Tools and Materials. *Here are some of the simple materials I'll need to make a wax relief block (from top left): Johnson's baby powder; jar of tincture of green soap; paper cup full of Rigidax wax chips; candle scraps; piece of plywood for the back of the finished block; sheet of glass; cardboard strips; masking tape; cheap brush; and putty knife.*

Aluminum foil
Piece of plywood or wooden block
Putty knife
White oil paint or ink (optional)
Linoleum or wood-carving tools

To print the block
See Chapter 5 for the materials you'll need to print a relief block. Just be sure to use water-based ink, as wax is soluble in turpentine.

To melt the block down when you're finished
Wire rack made from wire coat hanger
Disposable aluminum pie pan
Aluminum foil

PROCEDURE

To make a wax relief block, all I do is build a cardboard wall on glass, as I did when casting plaster. I fill this box with chips of wax—using two or more types of wax—and put the whole thing in an oven. Heat does the rest, converting the chips to a block. It's easy; it's safe; it doesn't smell bad—and I like it. I think you'll like it, too.

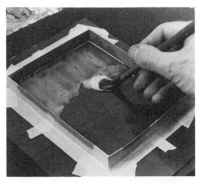

Step 1. To start making the wax block, I build a cardboard wall on a sheet of glass, just as I did when casting a plaster block (see Chapter 5, Step 3). This time the wall doesn't have to be as high—½″ to ¾″/15mm to 20mm is sufficient. Since the melted wax is almost as runny as the fresh plaster, I use two extra pieces of tape on each corner to secure the cardboard wall to the glass.

When the box is finished, I combine some talcum powder with a couple of tablespoons full of tincture of green soap—the mixture should be about the consistency and color of milk—and use this to coat the glass inside the box.

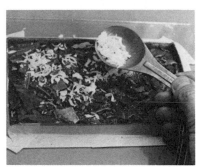

Step 2. When the first coat of this release agent—talcum powder and soap—dries, I give the glass a second coat. Rigidax, unlike plaster or polyester plastic, will stick hard to the glass if you don't brush on a heavy coating of this release agent. And I haven't found any other release agent that works. Please note that you'll only need one coat if you're using carnauba instead of Rigidax.

When the second coat dries, I prepare a heavier mixture of talcum powder and soap—this time the solution should be as thick as heavy cream. Painting a bead around the four edges of the box, I seal the cracks between cardboard and glass as shown.

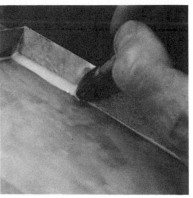

Step 3. Now I sprinkle Rigidax chips into the box. As I'm making a 5″ x 7″/125mm x 180mm block, I'll need a total of about ¾ of a cup of wax. I want a 3:1 mixture of Rigidax to candle wax, because my experiments (see Chapter 20) have told me that this ratio will give me a block that carves like linoleum. (Less candle wax would give me a harder block; more, a softer one.) It's not necessary to make exact measurements, however—it's good enough if I pour a little more than a ½ cup of Rigidax chips into the box and then sprinkle on a couple of tablespoons of candle wax.

Step 4. Here's the wax-filled "mold"—the glass and cardboard box is my mold—about to be put into the 150° over for 25 minutes. Once in a while the glass will break from the heat, so I set it on a sheet of aluminum foil. The foil will catch any wax that leaks or spills—so I won't have to clean the oven!

I also put the wooden block and my stirring paddle into the oven on a second sheet of foil, so both of these things will be as warm as the wax when I'm ready to use them.

Step 5. After 25 minutes, all of the wax has melted. I turn off the oven, open the door, and use the stirring paddle to blend the lighter (candle) wax with the heavier (Rigidax) wax. I leave the wax and mold in the oven while I do this, because it will cool and harden too rapidly if I remove it. I take care not to scrape the glass with the stirring paddle, as this would disturb the release agents and produce grooves in the surface of the final block.

When I've finished stirring the wax, I pick up the wood (it's not too hot to touch) and set it down on top of the molten wax. I pick up the mold, holding the aluminum foil, and remove it carefully from the oven. Alternatively, I could leave it in the open oven until the wax cooled.

Step 6. It takes quite a while for the wax to cool—I usually wait an hour before trying to remove it from the glass, but you can wait overnight or longer if you wish. When I'm ready, I peel away the tape that fastens cardboard to glass and force a putty knife under the edge of the wax as shown. Even with the talcum powder and soap release agent, it's often necessary for me to run the knife under all four sides of the block before it will separate. I try not to push the knife too far under the wax, as it would burnish and deform the wax somewhat. Forcing the knife under the wax may be hard work, but eventually the wax will separate from the glass.

Step 7. Here's my carved block. Before I carved it, I soaked the finished block for a minute in lukewarm water and rinsed it under a tap to wash away the remains of the release agent. Then I gave the wax a light coat of white oil paint to make it easier to draw on. Note that this step isn't essential—I could have dried and used the wax without the paint. Next, I carved my image with conventional linoleum or wood-cutting tools as if the block were linoleum, saving the chips—I'll use them for my next block.

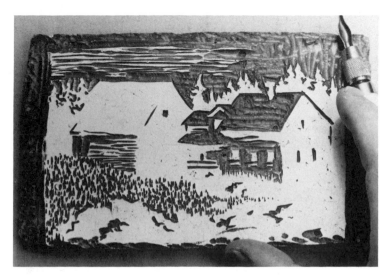

Step 8. The wax block, like the polyester plastic one, has one advantage over linoleum—it can easily be repaired. To refill a small area, I light a candle with a large diameter, let it sit until it has produced a puddle of candle wax, and then paint this wax into the hole to be filled in the block with an inexpensive, soft brush. When the wax has hardened on the block, I use a razor blade as shown to scrape that area down flat to the level of the rest of the block. Then I carve the repaired area again. I could also use pure carnauba to repair wax blocks the same way, although it will sometimes crack when it cools.

Step 9. Here's my finished print. As you can see, it looks exactly like a linoleum cut—the same amount of detail; the same blacks and whites. I had to use a water-based paint, since wax is soluble in turpentine and type cleaner.

A word of caution about wax blocks. You shouldn't make them weeks before you use them, as they get harder as they age. It's best, therefore, to make them within a few days of the time you'll carve them—or to add extra candle wax to compensate for the increase in hardness.

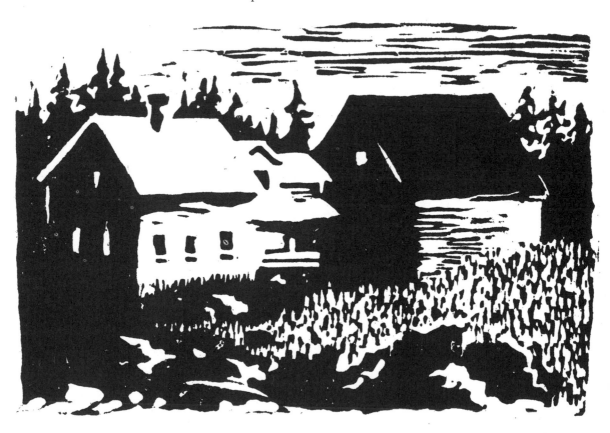

FURTHER SUGGESTIONS

1. Try making blocks with different proportions of candle wax and Rigidax wax—or with mixtures of other waxes. Microcrystaline wax is easy to obtain, and it mixes well with Rigidax or carnauba. Paraffin can be used, too.

2. You've seen that wax can be carved with linoleum tools. It can also be carved with tools you couldn't use on linoleum, such as a hot soldering iron. And you can use a press (such as the letter duplication press on page 38) to force objects into wax, embossing or coining the surface.

3. Because wax can be melted and poured, it can be combined readily with other materials. You could cast fragments of plaster or linoleum blocks or found objects in the wax. Since each material acts differently—caustic soda will etch the linoleum sections but not the wax, for example—you could combine materials to combine effects.

4. As Rigidax is soluble in turpentine and type cleaner, you can brush these solvents onto portions of the block to alter tones and soften cut edges. If a suitable resist could be found, you could probably etch wax with such a solvent.

Two Masks *(Above) by Kevin White. Wax relief, 5" x 7½"/125mm x 195mm. This vigorous portrait of two masks was carved by a middle-school student using conventional linoleum tools and techniques. There's an affinity between a good relief print and a primitive mask, I think. Both are bold, stark, severely simplified representations of natural objects. No subtleties or shadings—every mark is either there or it isn't. This print shows that wax is no more soft or hesitant than other relief materials.*

The Cove *by John Bickford. Wax relief, 4½" x 5½"/115mm x 140mm. Here's another one of my lakeshore prints. If you compare it to some of my other prints you'll see that wax forms an excellent substitute for linoleum as a relief block. The amount of detail possible and the ease of carving and printing the block are identical for the two materials.*

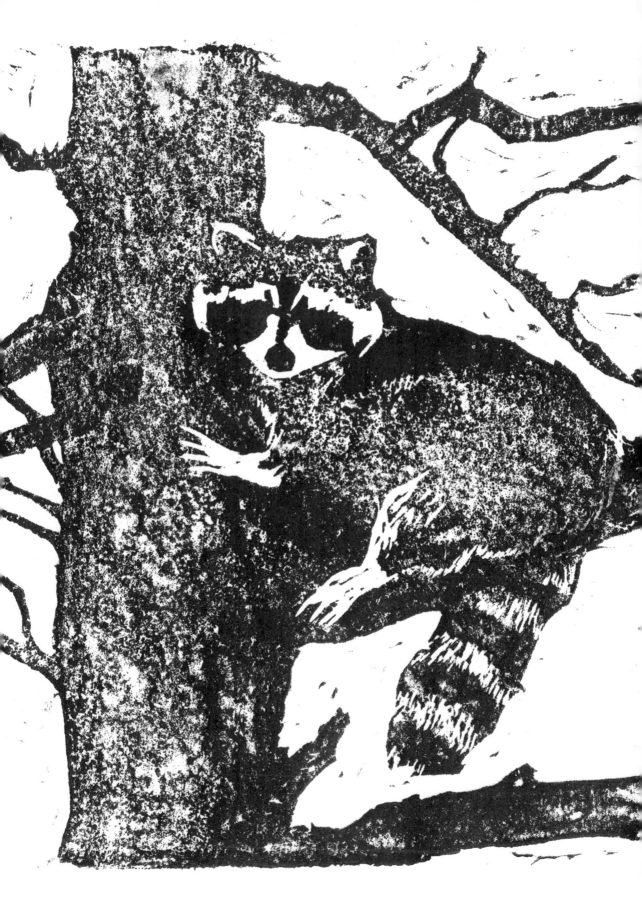

CHAPTER 18

Textured Wax Relief Process

In the previous chapter, I made a wax block that could be worked like linoleum, introducing the basic materials and steps for handling wax—release agents, wax mixtures, casting times, and temperatures. Now I'm going to try something a little more original—making a casting of a textured surface and then using the textured casting as a relief block. Wax is good for making impressions—this technique results in relief prints that look as if they had been carved in wood, stone, sandpaper, or a combination of materials. I'll cast a piece of emery cloth in this demonstration to show the process—because the emery solved a long-standing problem I had set for myself.

While I was experimenting with different materials to produce—among other things—controlled tones, Don Holden of Watson-Guptill suggested that I try to simulate the mezzotint process. In this process printmakers use a special, multi-toothed rocker or roller to produce a fine, uniform texture over the entire surface of a sheet of copper. The process takes hours of careful labor.

If the finished mezzotinted plate is inked and printed as an intaglio—and mezzotints are printed by the intaglio process—ink would be trapped uniformly over the entire surface, which would print as a uniform black (if printed in black ink). However, the artist produces lighter tones and whites by scraping and burnishing selected areas of the textured plate. The less texture he leaves, the less ink is trapped on the surface and the lighter the tone. Areas scraped flat and polished will print white, as in any intaglio process. The resulting prints can have an almost photographic tonal range. And since only mechanical tools are used, the artist has a lot of control over tone placement and value.

So I sought a process similar to mezzotint, but preferably one that avoided the special tools and tedium required to texture a costly copper plate and one that didn't need the extremely high printing pressures required to print a mezzotint. I thought that etched linoleum might serve the purpose, as it has a uniform texture. Indeed, it works to some extent, but its texture can't easily be modified for gradations in tone. I also tried plaster, cast and carved, but it was too soft to support fine tones.

Finally, I tried wax. My first experiments were failures—the waxes I used were too soft. But I knew that wax could be obtained in virtually any hardness, from that of furniture

Racoon *by John Bickford. Textured wax relief, 5½" by 6½" / 140mm x 165mm. This medium certainly lends itself to fur and bark, doesn't it? The tree trunk above certainly looks like a tree trunk. Merely letting light into the blacks lets the eye find textures and detail that I didn't specifically put there.*

polish to that of an old phonograph record. And eventually I found a perfect one—Rigidax.

Instead of producing the texture by mechanical means—which is certainly possible with wax—I produce it by making a cast wax impression of a texture that appeals to me, such as various grades of emery cloth which produce dot textures of different values. I then burnish and/or carve the textured block to produce darker and lighter tones.

I print the resulting blocks by simple relief methods, as the wax is too soft for intaglio printing. Thus the flat areas print black, not white as in mezzotints on metal. The tonal range with wax, furthermore, doesn't equal that of a true mezzotint because the wax textures are too coarse; but the range is great enough to be satisfying and is easy to manipulate. I think you'll find that the process adds an interesting new dimension to your relief work.

Tools and Materials. *To create textured wax relief prints, I'll use (from top left): Johnson's baby powder; Elmco white glue; masking tape; small block of wood; piece of plywood to make a shallow box in which the wax block will be cast; ½"/ 15mm wide strips of cardboard; tincture of green soap; small jar; measuring cup full of Rigidax wax chips; sheet of coarse emery cloth; soft brush; smaller brush; brayer; India ink; spoon; and linoleum cutters.*

TOOLS AND MATERIALS

To prepare the block
Coarse emery cloth or sandpaper
Piece of plywood larger than your block
Glue
Putty knife
Wax paper
Shellac and brush (if you use sandpaper)
½"/15mm wide cardboard strips
Masking tape
Talcum powder
Tincture of green soap
Measuring cup
1 cup Rigidax chips
Wood block
Aluminum foil

To make the image
Spoon
Carbon paper (optional)
Pencil
India ink
Candle
Soft brush
Razor blade
Wood or linoleum-cutting tools

To print the block
See Chapter 5 for the materials you'll need to print a relief block. Just be sure to use water-based ink.

PROCEDURE

The tones I'll produce by casting emery cloth are relatively simple and uniform, though they'll be far from mechanical. You might think, therefore, that they wouldn't contribute much to a simple linoleumlike relief print. But they do. It's almost like turning lights on a darkened stage—all of a sudden the foreground becomes visible. Your eye sees things—details like grass or rocks or earth—that your hand really hasn't put there. The same texture in an animal print becomes hair, as you'll see from several of the examples in this chapter. A whole new quality has been added by a fairly simple, almost mechanical, step.

Step 1. I must make a box mold in which to cast the textured wax block. This mold can be reused several times. The first step is to glue a piece of coarse emery cloth (or sandpaper soaked in water) to a sturdy, flat board larger than the plate will be. Plywood is best because it won't warp. As it's important that the surface of the glued-down emery cloth has no bumps or hollows, I spread the glue with a putty knife until the wood is coated with a smooth, even layer (see photograph). I lay the emery onto the glue, cover it with a piece of wax paper, lay books on top—or put it in a press—and let the whole thing sit for at least 24 hours before proceeding. Please note that if you use sandpaper instead of emery cloth, you must give it two coats of shellac after the glue dries.

Step 2. When the glue is dry, I build a cardboard wall on the emery (see Chapter 5, Step 3), and then give the emery two coats and a bead of the talcum powder and tincture of green soap mixture (the release agent), as described in Chapter 17, Steps 1 and 2. When all coats of that mixture dry, I pour 1 cup of Rigidax chips into the box and set the whole thing on aluminum foil in a 150° oven for 25 minutes, along with the wood block for the back.

Step 3. When the wax melts, I set the wood block down into the box on top of the wax and remove everything from the oven to cool. (I don't have to stir the wax as in Chapter 17, Step 5, because I'm not mixing two waxes together.) I let the block cool for at least an hour (days if I wish) and use a putty knife to separate it from the emery, as in Chapter 17, Step 6. Finally, I wash the wax as before.

If I inked and printed the block as a relief at this point, I would get the dot texture shown here—a fairly uniform, but certainly not mechanical, texture. If I had used a finer grade of emery, the dots would be more numerous and the overall tone would be darker. Coarser grades (available in sandpaper, but not, I believe, in emery cloth) give larger, coarser textures.

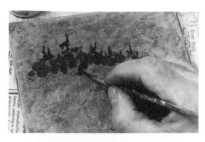

Step 4. Now to work a design into the block—carving, burnishing, and painting the block to produce tones and areas both lighter and darker than that of the cast surface.

The Rigidax has a medium green color—I could paint a coat of white ink or paint first if I wanted to, although I don't here. I use carbon paper to transfer a design onto the wax, and then I paint the darker areas of my design with India ink to keep track of what I'm doing.

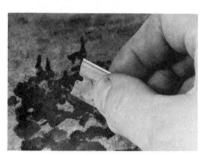

Step 5. Here I'm brushing on hot wax over the areas I just covered with India ink to create the blacks. I made the hot wax by lighting a large-diameter candle. I don't care how thick or uneven a layer of candle wax I end up with, since I can smooth it later. However, I must be sure to apply the wax while it's still hot, so I hold my block near the candle and dip my brush in the hot wax frequently. If I need a lot of wax, I heat it on the stove in a double boiler instead of using the candle.

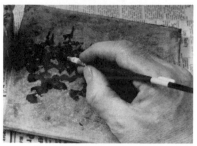

Step 6. When the candle wax has cooled (a minute or two), I use a razor blade to scrape it down to the original level of the Rigidax. This scraping will sometimes remove the India ink as well as the excess candle wax—but if you hold the block at the proper angle to a light, you'll see that the candle wax area is flat and smooth. This area will ink and print as a solid black. If all the candle wax comes off as I scrape, I repaint the area with hotter wax and scrape again. Sometimes, at this point, I pull a proof.

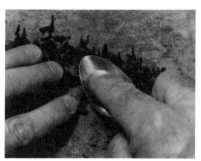

Step 7. I work on the dark grays by burnishing those areas of my design with a spoon. I press down on the dots with the spoon more than I would to take a print. I hold the block up to the light once in a while to see how coarse I've made the texture. If I've taken an artist's proof, I refer to it—it helps me see more accurately where to darken the tone of the general background. In the block made for this demonstration, I don't want much burnished tone, and I just do a little under the skyline trees.

Although I don't need it here, I could also lighten the tone of some areas by stabbing the block with a scriber or linoleum cutter or by carving lines or some other texture into the emery cloth texture.

Step 8. Finally, I cut away the whites with linoleum cutters, just as I would with a linoleum block. Rigidax and carnauba wax are harder to cut than linoleum. A long cut is difficult—it's best to hold the cutter nearly vertical and to make a series of short downward strokes. Twisting the cutter as you push also seems to help—break the wax away rather than cut it. With this sort of motion, it's no more difficult than working linoleum.

Step 9. When the block is done, I clean it thoroughly but gently with a bristle brush. Wax chips tend to stick to the block, so I examine it closely to make sure that I've re-

moved them all. Then I clean the workbench carefully, saving all the chips for the next block. When all is clean, I ink and print the block as a relief. My press is a spoon, used with normal pressure—it won't burnish the wax through the printing paper. I use water-based inks, since oil-based inks and solvents will soften the wax and eventually destroy the texture.

Here's my print. As you can see, the texture adds a great deal to a simple relief print.

FURTHER SUGGESTIONS

1. Try casting other surfaces to produce different starting textures. You can shellac a piece of wood, for example, build a cardboard wall on it, paint it with the talcum powder and soap release agent, and get a wood grain texture. Flat stones, tiles, a slab of cement, pieces of cloth glued to a board, among other things, could probably be used as well.

2. Don't forget to try other grades of emery cloth and heavily shellacked sandpaper. A wide range of textures are available. Instead of using just one, glue a collage of sandpaper to a board, so your wax block will have a variety of background tones.

3. Instead of casting the starting tone, cast a flat surface such as a sheet of glass, and then produce tones by purely mechanical means—stabbing, scratching, carving, or melting the surface.

4. Use household enamel instead of candle wax to establish the blacks. (The type of enamel you used for lithography on illustration board works well.) The enamel takes several hours to dry, but it doesn't have to be scraped. Since you can paint it on more readily than hot wax, it can be used for finer detail. I prefer candle wax for simple blacks, however, because it dries faster and because it contaminates the wax less when I melt the blocks down for reuse.

Mixed Media

Each of the methods I've discussed so far has been considered alone, isolated from any other printmaking technique. But they needn't be. The contemporary printmaker delights in combinations—mixed media—and there's no reason why you shouldn't do the same. Before you begin, though, remember that just because most of the techniques can be mixed doesn't necessarily mean that they should be mixed. The quality of a work of art can be determined by what Philip Beam has called the fitness of each element of the composition to all of the other elements and to the artist's intent. Everything must work together to produce the final effect. This doesn't mean that everything in the composition must harmonize with everything else—contrast and discord are often valid ways to provide emphasis. But contrasting elements must be used in such a way that they help, rather than hurt, each other.

As an example of what improper contrast might do, consider the works of Ben Shahn and Charles Sheeler. Shahn did a number of superb paintings of working men. Sheeler has done many equally superb but entirely different paintings of industrial landscapes. Visualize what would happen if you put one of Shahn's workers in a Sheeler landscape. The result would be ludicrous, even though each element of the composition taken separately would be a master-piece. The intent of the two artists is entirely different; the tools, colors, symbols, level of detail, amount of distortion, edges, and so on, selected by each artist fit his intent, but would create chaos if mixed indiscriminately.

So—combining media imposes an additional artistic burden on the printmaker. It also imposes the burden of extra labor as well. The printing block must be worked by several different processes, and/or several blocks must be made to produce the final print.

WORKING WITH ONE BLOCK

If you decide to work one block by several processes, make sure that all sections of the block can be printed by a single process—by either the relief or the intaglio method, for example. Working with the relief process, one possibility would be to use the plaster collagraph techniques of Chapter 6 to combine pieces of textured wax, linoleum, and cast plaster (Chapter 5). You could then burnish and stab the wax, carve and etch the linoleum, and print the final block as a relief. If you were to build on the intaglio process in-

Pelvis by John Bickford. Mixed media, 8½" x 11"/220 mm x 280mm. See page 157.

stead of the relief process, you might combine etching, engraving, and sugar lift in a single composition (see *Mixed Intaglio Block* and *Mixed Intaglio Print* below).

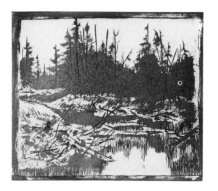

Mixed Intaglio Block. Here's a printing plate that has been worked by a combination of intaglio methods. The lines were cut or scribed into the plate—in this case, linoleum—using the engraving techniques of Chapter 8. The main masses of foliage were established by etching the linoleum with a caustic soda solution, following the procedure in Chapter 10. Instead of exposing the entire surface of the plate to the caustic solution, however, I built a dam of painted candle wax around the foliage area and then filled the selected area with the caustic solution. The candle dam was then scraped and washed away when I finished the etch.

Mixed Intaglio Print. Here's a print made from the mixed intaglio plate shown at left. The foliage area is nearly solid black because I've inked it heavily. The general texture produced by the caustic etch trapped the ink fairly uniformly. I did, however, wipe certain portions of the foliage to produce lighter tones, and I scratched some lines into the etched area to suggest tree trunks and/or darker areas. The rest of the tones in the print were established by collections of lines.

You can also produce a mixed-media composition on one block by combining various things you can do to a given base material—linoleum, plaster, plastic, and wax. In the *Lithographic Relief Block* and *Lithographic Relief Print* below, for example, I take advantage of the fact that I can make a lithograph on plaster and can also carve plaster to produce relief effects. I could do the same with linoleum. With linoleum, in fact, I might also combine intaglio and relief effects if the areas to be printed by different techniques are separated from each other on the block.

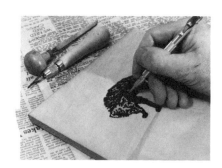

Lithographic Relief Block. Plaster can be carved for relief effects. It can also be used as a base for a lithograph. Relief effects (hard edges, pure whites, etc.) can, therefore, be combined with lithograph effects (soft edges, toned background, range of tones, and so on). Carving is especially useful if you want to preserve fine white-line detail in a dark area; fine white lines are difficult to preserve in a pure lithograph on plaster because the inked areas tend to spread, filling the lines.

Here I'm using a linoleum cutter to carve details into the block used to make the print at right.

Lithographic Relief Print. All the details of the face and body were established by shallow relief cuts in the plaster after the lithographic drawing was completed. The outlines of the fox and of the foreground shapes were established by the lithographic pencil alone and so can be softer.

WORKING WITH SEVERAL BLOCKS

If you want to combine techniques by printing several blocks on one sheet of paper, you can either print the blocks on top of or beside each other (see *Mixed Media on Linoleum Block* and *Print* below). You can also assemble several finished prints into a collage. You can get some especially interesting effects if you use translucent paper and print the same or different blocks on different sides of the paper. The images printed on the back show through enough to have a definite affect on the composition, which, however, will tend to be dominated by the image printed on the front.

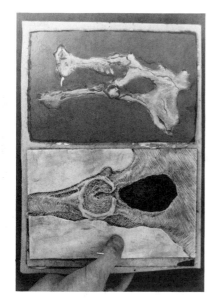

Mixed Media on Linoelum Block. Here's the block with which I made the print used as the frontispiece for this chapter. I've taken two separate linoleum plates, worked, proofed, and developed separately, and have glued them to a piece of heavy cardboard to form the final printing plate. Now I can ink and print them together, in proper registration, without need for a press or registration frame.

Mixed Media on Linoleum Print (see page 154). *Pelvis* combines a number of linoleum techniques. I etched and carved the linoleum section at the top and printed it as a relief, while I engraved the lower section and printed it as an intaglio. I was able to print one block by combined intaglio and relief methods only because the two sections were isolated from each other.

Multiple printing usually requires registration of one block to another and hence is easier to do in a printing press or printing frame of some sort, as illustrated in *Multi-Impression Printing Procedure* below. If exact placement of one compositional element to another isn't required, however, you can get by with any tool that allows you to position the blocks in their approximate locations, such as a ruler, a marker guide or map to which you tape the printing paper and blocks, or even your eye.

Multiple printing is perhaps more "dangerous" from an artistic standpoint than the other types of mixed media, since it's possible for you to combine anything with anything. Be careful!

Multi-Impression Printing Procedure. A printing press or frame comes in handy if you're overprinting one or more blocks and accurate registration is required. Here I'm using a frame to make the print shown at right. Remember that it's not just the second or later blocks that must be registered in multiple-impression prints. The first block must also be positioned accurately.

Always make a few extra prints at each stage of your multiple-impression edition. These extras will help you set up the gage pins for the following blocks—this is always a trial-and-error process that "spoils" the first few prints.

Multi-Impression Print. I used two different blocks to make this multiple-impression print: a polyester plastic block for the background, and a linoleum cut for the single tree in the foreground. Both are relief blocks. I inked the background block very lightly to make the foreground tree stand out. After trying a number of different arrangements for the two blocks, I settled on this composition. The final prints were made in the printing frame so I could repeat the selected composition exactly.

I hope you realize that there's nothing final about any of the methods I've discussed. The things I did with plaster can, with some variation, be done with wax or plastic and vice versa. You can, therefore, mix media by using the procedures of one or more chapters with the materials of another (see *Combining Techniques of Different Materials* below). You can even print blocks made as reliefs by the intaglio process, or vice versa, to produce negative effects. You could also do a multiple-impression print combining the negative with the positive in the final print using one block.

Combining Techniques of Different Materials. One way to mix media is to combine the techniques of one chapter, usually with some modifications, with the materials and techniques of another. This print, for example, combines the plastic material of Chapter 15 with the textured wax process of Chapter 17. I laid a sheet of emery paper face up on glass, spread auto plastic onto the emery, and pressed a board down into the plastic, as in Chapter 16, Step 5. When the plastic hardened, I peeled the emery cloth away from the plastic and soaked and scrubbed the plastic with a bristle brush in warm water to remove the emery particles. Now I had a textured plastic block that could be carved, burnished, filled with candle wax, etc., just as if it were a textured wax block.

PURPOSE OF MIXING MEDIA

We learn many different printmaking techniques because each allows us to achieve effects we can't achieve with the others. We mix media for the same reason—a combination of effects can say something we couldn't say by using only a single technique. The mixed-media print can be more complex, richer. This richness can only be achieved by additional effort, however—some contemporary printmakers do so much mixing that it takes them months to produce a single print, but the resulting effects couldn't be achieved by any shorter route.

Mixing is important to the development of new printmaking processes, too. No method can ever be perfect for everyone who tries it. Each of us must find our own combination of materials, tools, and procedures to suit our own personality and message. The concept of mixing helps open the door to procedures that are uniquely yours.

PART SIX
APPENDIX

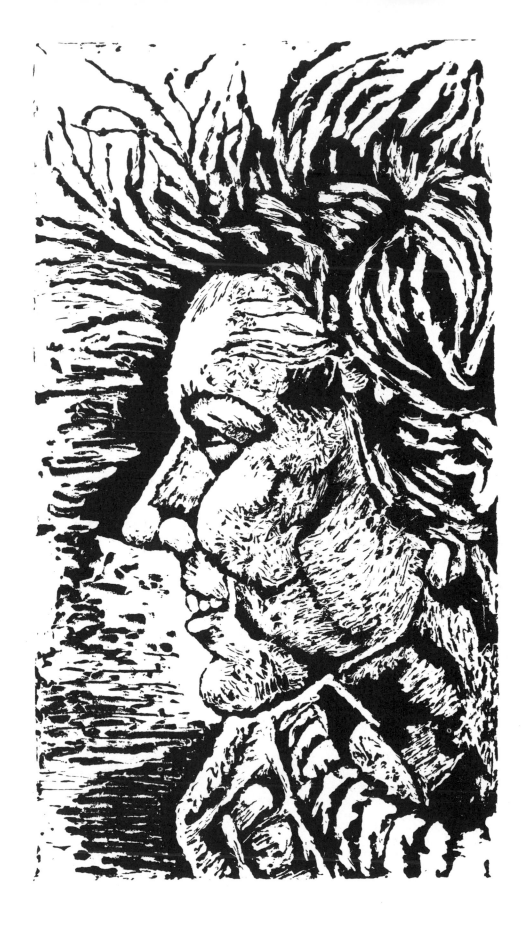

CHAPTER 20

On Your Own

So now we come to the end. Together we've made prints of various kinds by a number of different techniques, some appealing, some less so. Each method has been illustrated in a step-by-step fashion that often, I'm sure, made it seem like a finished, unalterable process. But any useful technique is a starting point only, to be modified, developed, and improved by each artist who uses it. I hope that my methods have opened your eyes to the large number of ways you can make prints at home or school without fancy equipment and exotic materials. Now it's time for you to set my procedures aside and show what can really be done with wax, plaster, or linoleum.

As we go our separate ways, I suggest once more that you concentrate on the basic, underlying concepts of printmaking. A relief block isn't a block of wood or linoleum that has been carved with a gouge—it's any printable surface that has two or more levels. Any means of producing the variations in level—etching, casting, assembling, and so on, as well as carving—are valid relief techniques. Think, for example, of what you might do with wax, a material that can be poured, bent, scribed, cut, cast, extruded, embossed, pressed, joined, textured, gouged, melted and remelted, filled with fibers or chips of other materials, mixed in virtually any hardness, and poured around inserts.

Or, now that you know that a lithograph is possible whenever you make marks that repel water on a surface that accepts water, you should be able to find all sorts of combinations of materials from which to make lithographs. And the marks needn't be made by greasy materials, either—they can be made by purely mechanical means. Etched linoleum, for example, accepts water; unetched linoleum smuts rapidly, which means it will print black. You should, therefore, be able to determine which portions of a piece of linoleum will print, and which will not—lithographically—by etching the sections that will *not* print. Keep your eye on the basics and ignore the normal materials or steps, and you'll see many unusual possibilities.

I've introduced you to a variety of materials and ways to make blocks, print blocks, and achieve tones. These things should be seen as separate building blocks from which you can assemble new procedures or as analogies to suggest related, but new, techniques of your own. Keep breaking it all down and putting it back together in new ways, and you'll have no trouble developing your own procedures.

As I leave you, I thought it might be of passing interest to

Self Portrait Study *by Carol Ann Bieber. Cast plaster relief, 9½" x 17"/245mm x 430mm. All of the texture in this print was obtained by manipulation of the grease-ink used to establish the design. The artist, a University of Connecticut student, responded well to the fluidity of the drawing medium without losing the boldness that is such an important feature of most successful relief work. This is a relatively large work, compared to the others reproduced in this book—the cast plaster relief process does nothing to limit the size of prints you can make. If you like them big, make them big.*

suggest how you might proceed from here—a few general suggestions on how to go about modifying my techniques or inventing your own. It's very dangerous to suggest that invention is a step-by-step process, and there's certainly no magic formula in the suggestions I'm going to make. But those of you who have never tried to develop a new technical process of your own might be less intimidated by the idea after you've read the material that follows. It will be relatively easy for you to produce at least modest inventions once you see the process in its true light and not, as popularly misconceived, as something only possible by an Edison or a Picasso. In effect, I'll be telling you about the sort of things I did to develop the techniques described earlier in this book.

STARTING POINTS FOR EXPERIMENTATION

There are many possible starting places, each of which leads to a slightly different kind of activity—at least at first. Don't try to start with an answer in mind—just know that you're looking for something, without much idea of what it is. Here are some of the things you might do:

Explore a new material. Select a material that interests you and look for ways to use it in printmaking. I did this with plastics, which I knew nothing about. I obtained a collection of plastics (see illustration) from local stores—art supply stores, auto supply stores, etc.—and started experimenting.

Overcome a problem. Any problem or annoyance with a known method can serve as another starting point. For example, I wanted to make some lithographs but felt that the cost and complexity of the normal procedure would create problems for most people. So I tried to find ways to make lithographs with a simpler procedure and less expensive equipment.

Seek a specific effect. Another way to get started is to try to find a way to produce a specific effect—a black line, a special texture, or a wider range of tone, for instance. This is a little more challenging than the other starting points because there are so many possible paths to follow, but it works. My search for a mezzotint effect, as I mentioned in Chapter 18, led me from plaster through linoleum to wax before I had even partial success.

Question a general idea. You might start with a general question that's too vague to point to any specific area but that interests you. I was impressed, for example, with Senefelder's invention of lithography, in which he found a new printing technique based on the antipathy of water and oil. But I didn't like lithography much! So I wondered if there was any other way to take advantage of the oil-water situation to make prints. This question led, by devious and

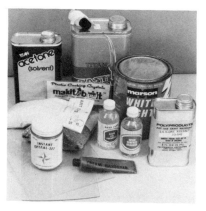

Collection of Plastics. *Here are the materials I assembled to start my assault on plastics. I knew little or nothing about most of them; I merely bought whatever was available in the local art, hardware, and auto supply stores. I'm sure that you'll find, as I do, that it's easier to invent something by playing with new materials or tools than by trying to conceive a new technique solely in your head.*

sometimes frustrating paths, to the cast plaster technique in which water-based plaster takes an impression of oil-based grease-ink.

CONTINUING YOUR EXPERIMENTATION

After you have a general idea of what you're trying to do, then you can go on to the next stages of exploration.

Choose your materials. Decide what materials might help in your quest and go out and get them. Take a look at the Chapter 20 section of *Supplies and Suppliers* at the end of this book for material suggestions. Make some simple, quick, informal experiments with the material. I find it least frustrating to do this without any attempt to end up with a work of art at all. It's upsetting to spend the time required to develop a full composition and then lose the whole thing because you had the oven set at the wrong temperature or something. Instead, play with the materials. Be casual, loose. You can't make mistakes at this stage, so don't worry about looking silly.

I usually get so loose in this phase that I get sleepy and bored. I only half pay attention to what I'm doing or what the results are. Yet this initial exploration quickly gives me an essential feel for unfamiliar materials or techniques.

In one of my early experiments with wax (see illustration), I mixed several different waxes together in different proportions, added sawdust and other things to some of the mixtures, put each mix in a separate compartment of a muffin tin, and set them all in the oven to melt. In other words, I made a number of "new" materials to try in a single experiment. I carved, broke, scribed, and stabbed each sample to get a general idea of how it would behave in a print block. You can cover a lot of ground in a hurry if you do it this casually.

Keep a record of your experiments, materials, and results. Unless your memory is a lot better than mine, it's very useful to keep some sort of informal record of what you've done during each phase of your search. Record the proportions of the materials you've used, the oven temperatures, the etching times, the kind of ink you used, the results you achieved, and so on, so you can repeat your successes and avoid repeating your failures. And don't just record what you think are successes at the time you made the experiment. A later experiment combined with an earlier "failure" may be the answer you're looking for.

I keep some of my records in a ring-bound notebook and on 4" x 6"/100mm x 150mm cards (see illustration). Note that I have (in the notebook) a sample print from each experiment that gets far enough for me to have a print. I print my experimental blocks whenever possible to gain the additional insight they give me into a new material or process.

Early Experiment with Wax. *I always start with simple experiments rather than full-blown attempts to produce works of art. This photograph shows one of my first efforts to find ways to use wax in printmaking. I mixed various waxes together in different proportions, adding plaster and sawdust to some of the mixes as well, put each mix in a separate compartment in a muffin tin, put the tin into an oven, and in one shot made a dozen new materials to test.*

My Records. *I record cookbook information that will help me repeat an experiment in the future (if it's worth repeating!)—amounts of materials used, process times and temperatures, problems encountered, results achieved, and so on.*

Reading Material. *If you're following a new path, you won't find any published information that tells you exactly what to do. You'll always, however, be able to find more general information about materials, related procedures, the traditional way of doing things, and so on. Books, magazines, and manufacturers' literature are all worth obtaining. This photo shows some of the material I found helpful in my study of plastics.*

Read books and magazines. Don't hesitate to read anything you can get your hands on that may lead to more information about the material or process you're struggling with. You won't find books or articles on how to make prints this way with this material—if you did there would be no need for your exploration. But you'll find books, articles, and manufacturer's literature telling how other people use the material for other things. When I started my exploration of plastics, I read all sorts of things (see illustration) from *American Artist* to an encyclopedia.

This isn't cheating. All invention is based on the past—don't be ashamed to use it. My most original technique—I think it's cast plaster—is obviously based on other peoples' inventions of casting, plaster, palette-knife painting, relief printmaking, lithography, and probably a hundred more. If you're trying to modify a known process, as I did with lithography, you'll obviously want to read and try what others have done before experimenting with changes.

Ask yourself questions. Get in the habit of questioning everything. Why is it done this way? How else could it be done? Why did I get these particular results? What change in procedure would have made a difference? And so on. Don't just accept things—dig at them.

There are a few groups of questions that often turn out to be especially useful in the struggle to find a new way of doing things. Here are some of them.

1. What's my problem? If you're trying to do or find something you can't do or find as yet, the factors that prevent you from doing it are problems. Examine the problems. Why are they problems? What is the problem behind the problem? And the one behind that?

Here's an example: I wanted to make a lithograph on linoleum. Why couldn't I make a lithograph on linoleum? Because the linoleum smutted heavily when I printed (the problem). Why did it smut? Because it didn't stay wet enough when I rolled it with ink. (Possible problem behind the problem.) Why won't it stay wet? Because it's smooth and non-absorbent. (Problem behind the problem behind the problem.) And so forth. Each layer of problem suggests other questions or problems until eventually you get down to a layer you can cope with. If you have more than one problem in a given layer, you'll have to try different things to find the one that's truly a problem. It's not hard once you get into it.

2. How can I redefine what it is I'm trying to accomplish? Each definition (like each new layer of problem) calls forth a new group of possible answers. Let's assume, for example, that you've decided to find a new way to make a relief block. That's so general it's difficult to know where to start. So you rephrase it, finding approximations to the original definition of your task. Here are some possibilities:

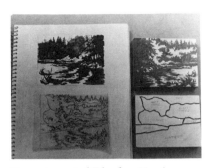

Experimental Blocks. *Here's an original sketch and some blocks-in-process for an early etching experiment. I carved a conventional black and white linoleum block. Then I used a brush dipped in a caustic solution to etch portions of a second block, which printed tones in selected portions of the image. I felt that the process was too tedious and the results not worth the effort. But, through unsuccessful experiments of this sort, I learned a great deal about etched linoleum.*

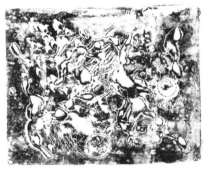

Nonobjective Experimental Print. *Most of my early experiments with a new medium are nonobjective doodles that serve to introduce me to the new materials and methods. The print shown here, one of my first experiments with wax, will show you the kind of thing I'm talking about. By this sort of doodling, you can explore textures, edges, and sharpness of detail, as well as fundamental problems and possibilities with the new technique.*

I'm trying to achieve new relief effects.

I'm trying to find a new material that will lend itself to relief.

I want a new way to work a block.

I want to make a bi-level block.

I want to find objects that would print well in relief.

3. What does this material or process remind me of? Would the things I compare it with be useful in printmaking? What is the material or process unlike? Does a point-by-point comparison of similarities or differences suggest something new?

4. Can I combine steps, techniques, materials, to accomplish something different? Do I have two partial successes—or even two failures—that can be put together to produce a useful whole? Can I combine some of my ideas with a traditional idea or material?

PRINTING YOUR EXPERIMENTAL BLOCK

In all of the above, you've been collecting data and probing in corners. You're not sure what you're looking for—you just want to find something new. After a while, however, you'll start to conceive some possible steps to a new or modified printmaking technique. They'll be pretty vague at first, but you'll suspect you might get something worthwhile if you did this, followed by that, with a little guesswork thrown in for good luck. Now's the time to try a complete—though not too ambitious—print.

Work up a composition you think might be appropriate. Execute it by your new technique. Carry it through to the end, even if you hit unexpected problems along the way. You'll often find that what seemed easy in a small sample is difficult or impossible full scale. Problems you hadn't anticipated will always crop up. Some you can solve as you go along; others will require a lot of additional work. You may find that the approach you've tried is hopeless, but more often you'll find that it has some possibilities but needs more work. More small experiments, perhaps. More reading. More questions. Even after all the preparation you've done, it's unlikely you'll get fully satisfactory results the first time you try a full print. Don't give up! No one else does it the first time, either (see illustration of *Experimental Blocks*).

Your first full prints, incidentally, will be easier as abstractions—nonobjective designs—than as accurate renditions of a subject (see illustration of *Nonobjective Experimental Print*). It takes work to find a way. It takes a lot of extra time to master that way well enough to bend it to the difficult art of representation. (Which may be why so many of the prints made by student printmakers are just designs, textures, and effects—with a title added after the returns are all

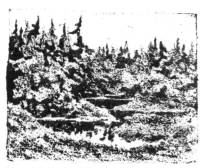

Experimental Lithography with Emery Cloth. *In my search for methods to include in this book, I tried a lot of things that were totally unsuccessful. I also tried many things that were almost successful and that might yield to further experimentation. One of them is shown here—it's an attempt at lithography on a naturally textured material, emery cloth. I glued the emery cloth to a piece of plywood and painted it white. Then I drew with lithographic crayons and tusche and printed the block by the procedure described in Chapter 14. Unfortunately, I was unable to obtain consistent results.*

Experimental Lithography with Painted Wood. *Here's another attempt at lithography on a naturally textured material, in this case painted wood. The grain of the wood is clearly visible, which I think is desirable. I had great hopes for this technique but again was unable to obtain consistent results. Some pieces of wood (with less resin than the others?) gave me excellent results; others smutted so rapidly that I got no prints at all. Lithography on wood is possible—but I don't understand all the variables yet.*

Though unsuccessful, these experiments with wood and emery cloth led to successful techniques.

in!) Most methods, however, will lend themselves to a reasonable degree of control if you persevere.

CONCLUSION

Somewhere along the way I find it very helpful to let it all soak in for a while. For overnight, or a week, or a few months. I keep a card file of new thoughts that occur to me—sometimes at the most awkward times—during this period. But a record is not essential. The mind chews and digests all the stuff you've fed it, and then, perhaps when you're most relaxed, it will suddenly pop forth a new suggestion. I've sometimes gone to sleep on a steady string of failures and awakened with a successful process. Lithography on linoleum worked that way—after a frustrating six months of failure.

Relax. Don't be afraid of making mistakes, looking silly, or wasting your time. There's no race. The world won't stop if you don't find a new approach—nor if you do. Your small failures today may lead to a triumph later on with another material, perhaps (see *Experimental Lithography* illustrations).

Always question everything—look behind every reason and be purposely unreasonable or illogical once in a while. Remember, it's of, for, and by *you*. One of the appeals of any art is that we can each pursue our own goals at our own pace. When I draw, paint, or print, I feel strongly that I'm communicating—but not with the public, artists, or critics. I'm communicating with my subjects—trees, rocks, lakes—and learning to see them, listen to them, and understand them better. I have no illusions about the importance of the results to others, but they are vitally important to me. And the best techniques for me are those that best fit my motives and allow some representation, intimacy, and starkness (because my subjects tend to be stark).

Each of you will have different motives, different goals, different desires which can be transposed into images by different techniques. I hope that this book will help you satisfy some or all of your needs. Experiment, discover, and enjoy the new media available to you for inexpensive printmaking.

SUPPLIES AND SUPPLIERS

Throughout this book I've tried to use only materials that are readily available. I think that I've been fairly successful in this, but I've had to use a few things that aren't common; and many of the common things I've used aren't necessarily familiar to everyone. I thought it might be useful, therefore, to include the following list of sources for tools and materials.

Addresses for known manufacturers are given at the end of the list to save much repetition. Where ever possible I've tried to give the type of store in which you might find the item rather than the specific name of a company who manufacturers it. I name specific manufacturers when there's anything *uncommon* about an item, and when you might have trouble finding it locally.

I think my type-of-store descriptions will probably be understandable to most people, but a brief explanation might be helpful. By discount store, for example, I mean a fairly large store that sells hard goods such as clothing, housewares, building supplies, paint, auto supplies, and hardware. By Sears, Roebuck I mean Sears *and* its competitors. By auto supply store I mean any store that sells automobile parts, accessories, paint, waxes, and so on.

Chapter 2. Tools and Materials

Miscellaneous printmaking supplies, such as paper, ink, brayers, linoleum, wood and linoleum-cutters, engraving tools, bench hooks, inking brushes, and so on:
 Artist supply store
 Graphic Chemical and Ink Co.—especially good for ink and printmaking paper
 Arthur Brown
 F. Weber Co.
 The Craftool Co.—especially good for printmaking paper
 Hunt Manufacturing Co. (Speedball)
 Sam Flax
 Rembrandt Graphic Arts Co.—especially good for printmaking paper
Printers supplies—commercial letterpress ink, presses, composing sticks, type cases, type-cleaner, anti-picking compound, other ink additives:
 The Kelsey Co.

Printmaking paper:
 Technical Papers Corp.
Commercial paper—bond, utility cover stock, bristol, and so on:
 The Kelsey Co.
Saber saw or jigsaw and putty knives:
 Hardware store
 Discount store
 Sears, Roebuck
Waterless hand cleaner—Quickie, Goop, or the equivalent:
 Grocery store
 Supermarket
 Paint store
 Hardware store
Scribers:
 Hardware store
 Sears, Roebuck
 Machinist supply store
 General Hardware Manufacturing Co.
 Brown and Sharpe Manufacturing Co.

Chapter 3. Low-Cost Printing Presses

Barens:
 Artist supply store
 Hunt Manufacturing Co.
 The Craftool Co.
Linoleum Press:
 Artist supply store
 Hunt Manufacturing Co.
 Arthur Brown
C-clamp:
 Hardware store
 Discount store
Office press (sometimes called a copying press):
 Arthur Brown
Clamshell letterpress:
 The Kelsey Co.
Clothes-wringer press and miniature etching press:
 The Craftool Co.
Proofing press:
 The Craftool Co.
 The Kelsey Co.

Chapter 4. Printing Frames

Chase, quoins, furniture, and tympan paper:
 The Kelsey Co.

Piano hinge, Skotch wood joiners, bolts, washers, nuts, and so on:
 Hardware store or discount store

Chapter 5, 6, and 7. Plaster Relief Techniques

Casting plaster (such as Hydrostone) or patching cement (such as Por-Rok) works equally well. Plaster is less expensive but comes in larger quantities. Both materials are available from some lumberyards, hardware stores, building supply stores, or paint stores. They're also sold by the manufacturers.
Por-Rok:
 Lehn & Fink Industrial Products
Hydrostone:
 U.S. Gypsum Co.
 Hydrostone is also boxed and sold in smaller quantities through artist supply stores and sold as casting plaster by the Stewart Clay Co. (Warning: not *all* casting plasters supplied by this or other companies are as hard as Hydrostone.)
Automobile grease (typical example—Quaker State Multi-Purpose Lubricant-B)
 Auto supply store
 Discount store
 Sears, Roebuck
White, oil-based ink:
 Artist supply store
 The Kelsey Co.
 Hunt Manufacturing Co.
 Graphic Chemical and Ink Co.
Metal type:
 The Kelsey Co.
Bristle and soft brushes, paper stumps (sometimes called tortillions):
 Artist supply store
 Arthur Brown
 F. Weber Co.

Chapter 8. Engraving on Linoleum

See sources listed under Chapter 2.

Chapters 9, 10, and 11. Etched Linoleum

Caustic soda flakes (sodium hydroxide):
 Drugstore
 Brand-Nu Laboratories
 The Drackett Products Co.
 Grocery store or supermarket (Drāno)
Model airplane dope:
 Hobby shop, or hobby department of discount store or department store
 Model airplane or model railroad supply store
 Paint store
 The Testor Corp.

Photographic tray:
 Photographic supply store or photo department in larger store
Alcohol-based varnish:
 Artist supply store
 Bocour Artists Color
Brushes, ink, paper, putty knives, linoleum, etc.
 See sources listed under Chapter 2.

Chapters 12, 13, and 14. Lithography

Bainbridge Board:
 Artist supply store
 Stationery store
 Charles T. Bainbridge's Sons
Lithographic ink:
 Artist supply store
 Graphic Chemical and Ink Co.
 Sam Flax
 The Craftool Co.
Soft rubber brayers:
 Artist supply store
 Hunt Manufacturing Co.
 The Craftool Co.
Gum arabic and powdered rosin:
 Drugstore
 Artist supply store
 The Craftool Co.
 Graphic Chemical and Ink Co.
Nitric acid:
 Drugstore
 Arthur Brown
 Sam Flax
 Graphic Chemical and Ink Co.
 Mallinckrodt Chemical Works
Sulphuric Acid:
 Drugstore
 Mallinckrodt Chemical Works
Lithographic pencils, crayons, tusche, etc.:
 Artist supply store
 Arthur Brown
 Sam Flax
 F. Weber Co.
 The Craftool Co.
 William Korn
Conté crayons:
 Artist supply store
 Sam Flax
 Arthur Brown

Chapter 15. Transfer Printing with Plastics

Flexible printmaking plate (vinyl):
 Artist supply store
 Hunt Manufacturing Co. (Speedball)
Pressed board, plywood, or heavy cardboard:
 Lumberyard

Oil-based ink, linoleum cutters, brayer, type cleaner, etc.:
See sources listed under Chapter 2.

Chapter 16. Polyester Plastic, a Linoleum Substitute

Polyester plastic (autobody repair plastic or polyester resin) and hardener:
Auto supply store
Discount or department store with auto supply department
Marson Corp.
Sears, Roebuck
Go-Jo Industries
Woodhill Chemical Sales Corp.
Tincture of green soap:
Drugstore
McKesson Laboratories

Chapters 17 and 18. Wax

Rigidax:
M. Argueso & Co.
Carnauba wax:
Walter H. Jelly & Co.
Microcrystaline wax:
Polyproducts Corp.
Petrolite Corp., Bareco Division
Tincture of green soap:
See sources listed under Chapter 16.
Linoleum cutters, scribers, brushes, brayer, etc.:
See sources listed under Chapter 2.
Emery cloth or sandpaper:
Hardware store
Paint store
Discount store
Auto supply store

Chapter 19. Mixed Media

There aren't any new materials involved here, just combinations of previously discussed materials.

Chapter 20. On Your Own

Here are sources of materials I haven't used in the book, but which I'm sure could be used in printmaking. Get some and try them!

Plaster and/or cement. The United States Gypsum Co. makes a wide range of casting and art plasters including USG No. 1 Casting Plaster, USG White Art Plaster, USG Molding Plaster, Tuf-Art Plaster, and White Hydrocal Gypsum Cement. This company also publishes a pamphlet discussing the properties and uses of each of those plasters.

There's a product called dental plaster I've never seen or used, but which University of Connecticut printmakers say is very hard and dense. It should be suitable.

Several companies make products that are competitors of Por-Rok. I've never used any of these, but I suspect that they would work well. Instarok by the Metalcrete Manufacturing Co. is one example.

Plastic. There are many plastics that could be used. A good way to get started here is to obtain the informative catalog published by the Polyproducts Corp., which discusses the properties and typical applications of a wide variety of polyester resins, epoxies, waxes, fillers, hardeners, additives, mold materials, and so on. Since Polyproducts caters to artists, all of these materials are available in small quantities and with full instruction sheets.

You can also obtain plastic materials, though sometimes only in rather large quantities, from such companies as:
DuPont Co.
Reichhold Chemcials

Wax. Your choice of wax is almost as great as your choice of plastics. The following companies sell a number of different kinds:
M. Argueso & Co.
Walter H. Jelly & Co.
Petrolite Corp., Bareco Division
Sun Oil Co.
Polyproducts Corp. sells a couple of different waxes. More important for your wax experiments, however, they sell a variety of fillers—such as asbestos, fiberglass, and walnut shell powder—that are intended for used with plastics but that would extend the range of properties you could obtain from wax. Carnauba wax mixed with asbestos, for example, might be a better substitute for Rigidax than pure carnauba alone.

The DuPont Co. also makes materials—Elvax vinyl resins, for example—that can easily be blended with certain waxes to improve their toughness, flexibility, and adhesion.

In general. Your experiments may lead you to a material you can't obtain locally. A good place to find sources for the unknown is to look in *The Thomas Register*, a large 11-volume catalog published annually by the Thomas Publishing Company. This catalog can be found in the purchasing departments of most manufacturing companies and in many libraries as well. It's an invaluable source of where-to-buy-it information.

SUPPLIERS ADDRESSES

M. Argueso & Co. (Ridigax)
441 Waverly Avenue
Mamaroneck, New York 10543

Charles T. Bainbridge's Sons
20 Cumberland
Brooklyn, New York 11205

Bocour Artists Color
1 Bridge Street
Garnerville, New York 10923

Brand-Nu Laboratories
P.O. Box 178
30 Maynard Street
Meriden, Connecticut 06450

Arthur Brown
2 West 46th Street
New York, New York 10036

Brown and Sharpe
 Manufacturing Co.
Precision Park
North Kingston
Rhode Island 02852

Stewart Clay Co.
137 Mulberry Street
New York, New York 10013

The Craftool Co.
1 Industrial Road
Woodbridge, New Jersey 07075

The Drackett Products Co.
5020 Spring Grove Avenue
Cincinnati, Ohio 45232

DuPont Co.—Plastics
 Department
Polymer Products Division
350 Fifth Avenue
New York, New York 10001

Sam Flax
25 East 28th Street
New York, New York 10016

General Hardware
 Manufacturing Co.
82 White Street
New York, New York 10013

Go-Jo Industries
144 Cuyahoga
Akron, Ohio 44309

Graphic Chemical and Ink Co.
P.O. Box No. 27
728 North Yale Avenue
Villa Park, Illinois 60181

Hunt Manufacturing Co.
1405 Locust Street
Philadelphia
Pennsylvania 19102

Walter H. Jelly & Co.
2822 Birch Street
Franklin Park, Illinois 60131

The Kelsey Co.
38 Cross Street
Meriden, Connecticut 06450

Ko-Rec-Type
Eaton Allen Corp.
67 Kent Avenue
Brooklyn, New York 11211

William Korn Inc.
111 Eighth Avenue
New York, New York 10011

Lehn & Fink Industrial Products
Division of Sterling Drug
90 Park Avenue
New York, New York 10016

Mallinckrodt Chemical Works
2nd and Mallinckrodt Streets
St. Louis, Missouri 63160

Marson Corp.
 ("White Lightnin' ")
130 Crescent Avenue
Chelsea, Massachusetts, 02150

McKesson Laboratories
Division of Foremost-McKesson
Crocker Plaza
San Francisco, California 94104

Metalcrete Manufacturing Co.
2446 West 25th Street
Cleveland, Ohio 44113

Petrolite Corp.
Bareco Division
P.O. Drawer K
Tulsa, Oklahoma 74115

Polyproducts Corp.
13810 Nelson Avenue
Detroit, Michigan 48227

Reichhold Chemicals
RCI Building
523 North
White Plains, New York 10602

Rembrandt Graphic Arts Co.
The Cane Farm
Rosemont, New Jersey 08556

Sun Oil Co.
Industrial Products Department
1608 Walnut Street
Philadelphia
Pennsylvania 19103

Technical Papers Corp.
729 Boylston Street
Boston, Massachusetts 02116

The Testor Corp.
620 Buckbee Street
Rockford, Illinois 61101

Thomas Publishing Co.
461 Eighth Avenue
New York, New York 10001

United States Gypsum Co.
101 South Wacker Drive
Chicago, Illinois 60606

F. Weber Co.
Division of Visual Art
 Industries
2000 Windrim Avenue
Philadelphia
Pennsylvania 19144

Woodhill Chemical Sales Corp.
 ("Black Knight")
18731 Cranwood Parkway
Box 7183-A
Cleveland, Ohio 44128

BIBLIOGRAPHY

I believe that almost all of the techniques described in this book are new and are not described elsewhere. But each, obviously, owes a great deal to the conventional print-making technique it imitates. My techniques, furthermore, are intended to be low-cost introductions to the more versatile and sophisticated techniques they're based on. It seems pertinent, therefore, to include a bibliography that will lead you, not to more information about the techniques I've described, but to more information about their important predecessors. I think you'll find the books and articles listed below stimulating and helpful.

BOOKS

Beam, Philip C. *The Language of Art.* New York: The Ronald Press, 1958.

Biggs, John R. *Woodcuts.* London: Blandford Press, 1958.

Boeck, Wilhelm. *Picasso Linoleum Cuts, Bacchanals, Women, Bulls and Bull fighters.* New York City. Harry N. Abrams, 1962.

Brommer, Gerald. *Relief Printmaking.* Worcester, Massachusetts: Davis Publishing, 1970.

Cook, Malcolm. *Discovering Brasses and Brass Rubbing.* Tring, Herts., England: Shire Publications, 1971.

Duncan, David Douglas. *The Private World of Pablo Picasso.* New York: The Ridge Press, 1958.

Elam, June. *Introducing Linocuts.* New York: Watson-Guptill, 1969.

Flight, Claude. *The Art & Craft of Lino Cutting and Printing.* London: B. T. Batsford, Ltd., 1934.

Lino-Cuts. New York: Dodd, Mead & Co., 1928.

Ghiselin, Brewster. *The Creative Process.* New York: New American Library, 1952.

Green, F. N. *The Art and Practise of Linocutting.* London: University of London Press, 1948.

Heller, Jules. *Printmaking Today..* New York: Holt, Rinehart, and Winston, 1958.

Henri, Robert. *The Art Spirit.* Ed. Margery A. Ryerson. Philadelphia: J. B. Lippincott Co., 1960.

Hubbard, Hesketh. *Colour Block Print Making From Linoleum Blocks.* Breamore (near Salisbury), England, 1927.

Ivins, W. W., Jr. *How Prints Look.* Boston: Beacon Press, 1943.

Jacobs, G. Walter. *Stranger Stop to Cast An Eye, A Guide to Stones & Rubbings,* Marblehead, Massachusetts (2nd edition): Oldstone Enterprises, 1972.

Kafka, Francis J. *Linoleum Block Printing.* Bloomington, Illinois: McKnight & McKnight, 1955.

Karshan, Donald H. *Picasso Linocuts.* New York: Tudor Publishing, 1968.

Kaupelis, Robert. *Learning to Draw, A Creative Approach To Expressive Drawing.* New York: Watson-Guptill, 1970.

Kent, Cyril, and Cooper, Mary. *Simple Printmaking.* London: Studio Vista, and New York: Watson-Guptill, 1966.

Knigin, Michael, and Zimiles, Murray. *The Technique of Fine Art Lithography,* New York: Van Nostrand Reinhold, 1970.

Lieberman, J. Ben. *Printing as a Hobby.* London: Oak Tree Press Ltd., 1963.

McGee, William, J. A. *Reproducing Relief Surfaces.* Privately Printed, 1972.

Meiloch, Dora Z. *Printmaking.* New York: Pitman Publishing, 1965.

Newman, Thelma R. *Plastics as an Art Form.* Philadelphia: Chilton Book Co., 1964.

Polk, Ralph W. *Essentials of Linoleum Block Printing.* Peoria, Illinois: Manual Arts Press, 1927.

Rasmussen, Henry. *Printmaking with Monotype.* Philadelphia: Chilton Co., 1960.

Romano, Clare, and Ross, John. *The Complete Printmaker.* New York: The Free Press, 1972.

Rothenstein, Michael. *Linocuts and Woodcuts and Related Ways of Print Making.* Rochester, England: Studio Books Ltd., 1962.

Rothenstein, Michael. *Relief Printing.* New York: Watson-Guptill, 1970.

Linocuts and Woodcuts. New York: Watson-Guptill, 1964.

Smith, Charles. *Experiments in Relief Print Making.* University of Virginia Press, 1954.

Sprague, Curtiss. *How To Make Linoleum Blocks* (2nd ed.). Pelham, New York: Bridgmore Publishers, 1928.

Sternberg, Harry. *Woodcut.* New York: Pitman Publishing, 1962.

Watson, Ernest W. *Linoleum Block Printing.* Springfield, Massachusetts: Milton Bradley Co., 1929.

Watson, E.W., and Kent, N. (ed.). *The Relief Print Woodcut, Wood Engraving and Linoleum Cuts.* New York: Watson-Guptill, 1945.

Wengenroth, Stow. *Making a Lithograph.* New York: The Studio Publications, 1937.

MAGAZINES

Artist's Proof—The Annual of Prints and Printmaking. Brooklyn: Pratt Graphic Center, any issue.

Hoehn, Harry. "Dry Lithography—A New Planographic Process." *American Artist,* Vol. 37, January 1973, p. 38, ff.

Romano, Clare, and Ross, John. "The Collagraph Print." *American Artist,* Vol. 36; No. 364, November 1972, p. 57 ff.

Watson, Ernest W. "Technique of My Color Prints." *American Artist,* Vol. 28, No. 278, October 1964, p. 48 ff.

INDEX

Edited by Ellen Zeifer
Designed by Bob Fillie
Composed in 11 point Elegante by Publishers Graphics, Inc.
Printed and bound by Interstate Book Manufacturers